D1133400

Art Center College of Design
Library
1700 Lida Street
Pasadena, Calif. 91103

ART CENTER COLLEGE OF DESIGN

3 3220 00235 4244

BETWEEN THE EYES

ESSAYS ON PHOTOGRAPHY AND POLITICS

Art Center College of Design
Library
1700 Lida Street
Pasadena, Calif. 91103

770.1
S9126
2005

DAVID LEVI STRAUSS

BETWEEN THE EYES

ESSAYS ON PHOTOGRAPHY AND POLITICS

INTRODUCTION BY JOHN BERGER

Art Center College of Design
Library
1700 Lida Street
Pasadena, Calif. 91103

aperture

Front cover: Jim Goldberg, *Dave and Cookie Jonesin*, from *Raised by Wolves*, 1995
Cover design: Francesca Richer

Copyright © 2003 Aperture Foundation, Inc.; essays copyright © 2003 David Levi Strauss; introduction copyright © 2003 John Berger.

Unless otherwise noted, all photographs are courtesy and copyright the artists: pp. 4 and 43, photographs by Sebastião Salgado, courtesy the artist and Contact Press Images; p. 52, photograph by Joel-Peter Witkin, courtesy the artist and Ricco/Maresca Gallery, New York; pp. 107 and 193, photographs by Miguel Rio Branco, courtesy the artist and D'Amelio Terras, New York; p. 125, photograph by Francesca Woodman, courtesy and copyright © George and Betty Woodman; p. 135, photograph by Hannah Villiger, courtesy and copyright © the Estate of Hannah Villiger.

All rights reserved under International and Pan-American Copyright Conventions. No part of this book may be reproduced in any form whatsoever without written permission from the publisher.

Library of Congress Control Number: 2002110816

Hardcover ISBN: 1-931788-10-3
Paperback ISBN: 1-931788-88-X

Editor: Diana C. Stoll; *Designer*: Wendy Byrne; *Production*: Lisa A. Farmer; *Assistant Editor*: Michael Famighetti

The staff for *Between the Eyes: Essays on Photography and Politics* at Aperture Foundation includes: Janice B. Stanton, *Deputy Executive Director*; Robert Morton, *Editor-in-chief, Books*; Melissa Harris, *Senior Editor*; Daniel Buckley, *Work-scholar*

Printed and bound by Tien Wah Press, Singapore

First paperback edition 2005 10 9 8 7 6 5 4 3 2 1

Aperture Foundation books are
available in North America through
D.A.P./Distributed Art Publishers
155 Sixth Avenue, 2ND Floor
New York, N.Y. 10013
Phone: (212) 627-1999
Fax: (212) 627-9484

Aperture Foundation books are
distributed outside North America by:
Thames & Hudson
181A High Holborn
London WC1V 7QX
United Kingdom
Phone: + 44 20 7845 5000
Fax: + 44 20 7845 5055
Email: sales@thameshudson.co.uk

aperturefoundation
547 West 27th Street
New York, N.Y. 10001
www.aperture.org

The purpose of Aperture Foundation, a non-profit organization, is to advance photography in all its forms and to foster the exchange of ideas among audiences worldwide.

CONTENTS

Art Center College of Design
Library
1700 Lida Street
Pasadena, Calif. 91103

CONTENTS

WHERE ARE WE?

BY JOHN BERGER

This brilliant book by David Levi Strauss is subtitled *Essays on Photography and Politics*. Yet when the eighteen essays are placed together, it's clear that they're about something else too: they are about pain, the pain of the world. Often the way they are written, their style, is like the breathing of someone in pain. Meanwhile there is not a trace of self-pity and there is nothing maudlin in this deeply impressive and troubling book.

Strauss, who is a poet and storyteller as well as being a renowned commentator on photography (I reject the designation *critic*) looks at images very hard. That's to say he studies them for a long while before allowing words to come into his mind. As Paul Valéry once said, and Strauss quotes elsewhere: "The eyes are organs of asking."

The first answers to such asking are visual not verbal, precise yet inexplicable, familiar yet strange. Appearances contain more messages than we ever allow them to tell us—except perhaps when we are in love.

Strauss looks very hard at the photographs he writes about and comes face-to-face with the unexplained. Again and again. The unexplained that he encounters has only little to do with the mystery of art and everything to do with the mystery of countless lives being lived. This is how he arrives at the pain existing in the world today.

———————

Consumerist ideology, which has become the most powerful and invasive on the planet, sets out to persuade us that pain is an acci-

dent, something that we can insure against. This is the logical basis for the ideology's pitilessness.

Everyone knows, of course, that pain is endemic to life, and wants to forget this or relativize it. All the variants of the myth of a Fall from the Golden Age, before pain existed, are an attempt to relativize the pain suffered on earth. So too is the invention of Hell, the adjacent kingdom of pain-as-punishment. Likewise the discovery of Sacrifice. And later, much later, the principal of Forgiveness. One could argue that philosophy began with the question: Why pain?

Yet, when all this has been said, the present pain of living in the world is perhaps in some ways unprecedented and the essays that follow either address this question or emerge from it.

I write in the night, although it is daytime. A day in early October, 2002. For almost a week the sky above Paris has been blue. Each day the sunset is a little earlier and each day gloriously beautiful. Many fear that before long, U.S. military forces will be launching the "preventive" war against Iraq so that the U.S. oil corporations can lay their hands on further and supposedly safer oil supplies. Others hope that this can be avoided. Between the announced decisions and the secret calculations, everything is kept unclear, since lies prepare the way for missiles. I write in a night of shame.

By *shame* I do not mean individual guilt. Shame, as I'm coming to understand it, is a species feeling, which, in the long run, corrodes the capacity for hope and prevents us looking far ahead. We look down at our feet, thinking only of the next small step.

People everywhere—under very different conditions—are asking themselves: Where are we? The question is historical not geographical. What are we living through? Where are we being taken? What have we lost? How to continue without a plausible vision of the future? Why have we lost any view of what is beyond a lifetime?

The well-heeled experts answer: Globalization. Postmodernism. Communications Revolution. Economic Liberalism. The terms are tautological and evasive. To the anguished question of Where are we? the experts murmur: Nowhere!

Might it not be better to see and declare that we are living through the most tyrannical—because the most pervasive—chaos that has ever existed? It's not easy to grasp the nature of the tyranny, for its power structure (ranging from the two hundred largest multi-national corporations to the Pentagon) is interlocking yet diffuse, dictatorial yet anonymous, ubiquitous yet placeless. It tyrannizes from offshore—not only in terms of Fiscal Law, but in terms of any political control beyond its own. Its aim is to delocalize the entire world. Its ideological strategy—beside which Bin Laden's is a fairy tale—is to undermine the existent so that everything collapses into its special version of the virtual, from the realm of which—and this is the tyranny's credo—there will be a never-ending source of profit. It sounds stupid. Tyrannies *are* stupid. This one is destroying at every level the life of the planet on which it operates.

Ideology apart, its power is based on two threats. The first is intervention from the sky by the most heavily armed state in the world. One could call it Threat B-52. The second is of ruthless indebtment, bankruptcy, and hence, given the present productive relations in the world, one could call it Threat Zero.

The shame begins with the contestation (which we all acknowledge somewhere but, out of powerlessness, dismiss) that much of the present suffering could be alleviated or avoided if certain realistic and relatively simple decisions were made. There is a very direct relation today between the minutes of meetings and minutes of agony.

Does anyone deserve to be condemned to certain death simply because they don't have access to treatment that would cost less than two dollars a day? This was a question posed by the Director of the World Health Organization last July. She was talking about

the AIDS epidemic in Africa and elsewhere, from which an estimated 68 million people will die within the next eighteen years.

I am talking about the pain of living in the present world.

Most analyses and prognoses about what is happening are understandably presented and studied within the framework of their separate disciplines: economics, politics, media studies, public health, ecology, national defense, criminology, education, etc. In reality each of these separate fields is joined to another to make up the real terrain of what is being lived. It happens that in their lives, people suffer from wrongs that are classified in separate categories, and suffer them simultaneously and *inseparably*.

A current example: some Kurds, who fled last week to Cherbourg and have been refused asylum by the French government and risk to be repatriated to Turkey, are poor, politically undesirable, landless, exhausted, illegal, and the clients of nobody. And they suffer each of these conditions at one and the same second!

An interdisciplinary vision is necessary in order to take in what is happening, to connect the "fields" that are institutionally kept separate. And any such vision is bound to be (in the original sense of the word) political. The precondition for thinking politically on a global scale is to see the *unity* of the unnecessary suffering taking place. This is the starting point.

I write in the night, but I see not only the tyranny. If that were all I saw, I would probably not have the courage to continue. I see people sleeping, stirring, getting up to drink water, whispering their projects or their fears, making love, praying, cooking something while the rest of the family is asleep, in Baghdad and Chicago. (I see too the ever invincible Kurds, four thousand of whom were gassed—with U.S. compliance—by Saddam Hussein.) I see pastry cooks working in Tehran, and the shepherds, thought of as bandits, sleeping beside their sheep in Sardinia, I see a man in the Friedrichshain quarter of Berlin sitting in his pajamas with a bottle of beer reading Heidegger and he has the hands of a proletar-

ian, I see a small boat of illegal immigrants off the Spanish coast near Alicante, I see a mother in Mali—her name is Aya, which means *Born on Friday*—swaying her baby to sleep, I see the ruins of Kabul and a man going home, and I know that, despite the pain, the ingenuity of the survivors is undiminished, an ingenuity that scavenges and collects energy, and in the ceaseless cunning of this ingenuity, there is a spiritual value, something like the Holy Ghost. I am convinced of this in the night, although I don't know why.

The next step is to reject all the tyranny's discourse. Its terms are crap. In the interminably repetitive speeches, announcements, press conferences, and threats, the recurrent terms are: Democracy, Justice, Human Rights, Terrorism. Each word in the context signifies the opposite of what it was once meant to. Each has been trafficked, each has become a gang's code-word, stolen from humanity.

Democracy is a proposal (rarely realized) about decision making; it has little to do with election campaigns. Its promise is that political decisions be made after, and in the light of, consultation with the governed. This process is dependent upon the governed being adequately informed about the issues in question, and upon the decision makers having the capacity and will to listen and take account of what they have heard. Democracy should not be confused with the "freedom" of binary choices, the publication of opinion polls, or the crowding of people into statistics. These are its pretenses.

Today the fundamental decisions, which effect the unnecessary pain increasingly suffered across the planet, have been and are made unilaterally without any open consultation or participation.

For instance, how many U.S. citizens, if consulted, would have said specifically Yes to Bush's withdrawal from the Kyoto Agreement about the carbon dioxide greenhouse effect that is already provoking disastrous floods in many places, and threatens, within

the next twenty-five years, far worse disasters? Despite all the "media-managers of consent," I suspect it would be a minority.

It was a little more than a century ago that Antonín Dvořák composed his Symphony *From the New World*. He wrote it while directing a conservatory of music in New York, and the writing of it inspired him to compose, eighteen months later still in New York, his sublime Cello Concerto. In the symphony the horizons and rolling hills of his native Bohemia become the promises of the New World. Not grandiloquent but loud and continuing, for they correspond to the longings of those without power, of those who are wrongly called simple, of those the U.S. Constitution addressed in 1787.

I know of no other work of art that expresses so directly and yet so toughly (Dvořák was the son of a peasant and his father dreamed of his becoming a butcher) the beliefs that inspired generation after generation of immigrants who became U.S. citizens.

For Dvořák the force of these beliefs was inseparable from a kind of tenderness, a respect for life such as can be found intimately among the governed (as distinct from governors) everywhere. And it was in this spirit that the symphony was publicly received when it was first performed at Carnegie Hall (December 16, 1893).

Dvořák was asked what he thought about the future of American music and he recommended that U.S. composers listen to the music of the Indians and the blacks. The Symphony *From the New World* expressed a hopefulness without frontiers, which, paradoxically, is welcoming because centered on an idea of home. A utopian paradox.

Today the power of the country that inspired such hopes has fallen into the hands of a coterie of fanatical (wanting to limit everything except the power of capital), ignorant (recognizing only the reality of their own fire-power), hypocritical (two measures for all ethical judgments: one for us and another for them) and ruthless

B-52 plotters. How did this happen? How did Bush, Murdoch, Cheney, Kristol, Rumsfeld, et al.—like Brecht's Arturo Ui—get where they did? The question is rhetorical, for there is no single answer; and it is idle, for no answer will dent their power yet. But to ask it in this way in the night addresses the enormity of what has happened. We are talking about the pain in the world.

The political mechanism of the new tyranny, although it needs highly sophisticated technology in order to function, is starkly simple. Usurp the words *democracy, freedom*, etc. Impose—whatever the disasters—the new profit-making and impoverishing economic chaos everywhere. Insure that all frontiers are one-way: open to the tyranny, closed to others. And eliminate every opposition by calling it *terrorist*.

I have not forgotten the couple who threw themselves from one of the Twin Towers instead of being burned to death separately.

There is a toylike object that costs about four dollars to manufacture and that is also incontestably terrorist. It is called the antipersonnel mine.

Once launched, it is impossible to know whom these mines will mutilate or kill, or when they will do so. There are more than 100 million lying on, or hidden in, the earth at this moment. The majority of victims have been or will be civilians. (Read Strauss's furious essay on pages 56–64.)

The antipersonnel mine is meant to mutilate rather than kill. Its aim is to make cripples, and it is designed with shrapnel that, it is planned, will prolong the victim's medical treatment and render it more difficult. Most survivors have to undergo eight or nine surgical operations. Every month, as of now, two thousand civilians somewhere are maimed or killed by these mines.

The description *antipersonnel* is linguistically murderous. Personnel are anonymous, nameless, without gender or age. Personnel is the opposite of people. As a term it ignores blood, limbs, pain,

amputations, intimacy, and love. It abstracts totally. This is how its two words, when joined to an explosive, become terrorist.

The new tyranny, like other recent ones, depends to a large degree on a systematic abuse of language. Together we have to reclaim our hijacked words and reject the tyranny's nefarious euphemisms; if we do not, we will be left with only the word *shame*.

Not a simple task, for most of its official discourse is pictorial, associative, evasive, full of innuendoes. Few things are said in black and white. Both military and economic strategists now realize that the media play a crucial role—not so much in defeating the current enemy as in foreclosing and preventing mutiny, protests, or desertion. Any tyranny's manipulation of the media is an index of its fears. The present one lives in fear of the world's desperation. A fear so deep that the adjective *desperate*—except when it means dangerous, and refers to someone else—is never used.

Without money each daily human need becomes a pain.

Those who have filched power—and they are not all in office, so they reckon on a continuity of that power beyond presidential elections—pretend to be saving the world and offering its population the chance to become their clients. The world consumer is sacred. What they don't add is that consumers matter only because they generate profit, which is the only thing that is really sacred. This sleight of hand leads us to the crux.

The claim to be saving the world masks the plotters' assumption that a large part of the world—including most of the continent of Africa and a considerable part of South America—is irredeemable. In fact, every corner that cannot be part of their center is irredeemable. And such a conclusion follows inevitably from the dogma that the only salvation is money, and the only global future is the one their priorities insist upon, priorities that, with

false names given to them, are in reality nothing more nor less than *their* benefits.

Those who have different visions or hopes for the world, along with those who cannot buy and who survive from day to day (approximately 800 million), are backward relics from another age, or, when they resist, either peacefully or with arms, terrorists. They are feared as harbingers of death, carriers of disease or insurrection.

When they have been "downsized" (one of *their* key words), the tyranny, in its naïveté, assumes the world will be unified. It needs its fantasy of a happy ending. A fantasy that in reality will be its undoing.

Every form of contestation against this tyranny is comprehensible. Dialogue with it is impossible. For us to live and die properly, things have to be named properly. Let us reclaim our words.

This is written in the night. In the night by the light of his intelligence and compassion David Levi Strauss talks about what has been forgotten, what is being systematically erased, and what we need to remember for tomorrow.

In war, the dark is on nobody's side, in love the dark confirms that we are together.

The most political decision you make
is where you direct people's eyes.
In other words, what you show people,
day in and day out, is political....
And the most politically indoctrinating
thing you can do to a human being
is to show him, every day,
that there can be no change.

—Wim Wenders, *The Act of Seeing*

THE DOCUMENTARY DEBATE: AESTHETIC OR ANAESTHETIC?

Or, What's So Funny About Peace, Love, Understanding, and Social Documentary Photography?

So, what does a photograph expose? It exposes, says Derrida, the relation to the law. What he means is that every photo poses itself as this question: Are we allowed to view what is being exposed?
—Avital Ronell, interviewed by Andrea Juno in *Angry Women*

It is excellent that people should be starting to argue about this again.
—Opening line of Ernst Bloch's defense of Expressionism
(contra Georg Lukács), 1938

The relation between aesthetics and politics was a matter of great contention at the end of the twentieth century. Although too much of the discussion about it consisted of apodictic pronouncements and invective dismissals, it was good to have people arguing about it again. From where there is heat there may occasionally come some light.

When the "Culture Wars" in the United States spread to censorship battles over the photographs of Robert Mapplethorpe, Andres Serrano, and David Wojnarowicz, the documentary veracity and political content of aesthetic images were put on public trial. From the beginning of these conflicts, the right recognized what the real stakes were in this "war between cultures and . . . about the meaning of 'culture'" (per Indiana Republican Representative Henry Hyde); they recognized the subversive nature of art and responded accordingly. On the other hand, one of the left's most articulate

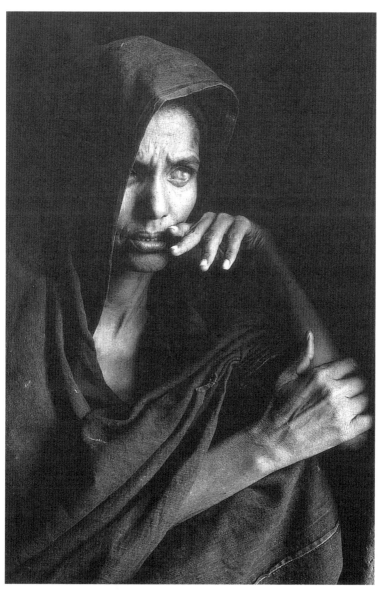

Sebastião Salgado, Mali, 1985

antecedents to this trial was the "anti-aesthetic" branch of post-modern criticism, which Hal Foster characterized in 1983 as questioning "the very notion of the aesthetic, its network of ideas," including "the notion of the aesthetic as subversive," claiming that "its criticality is now largely illusory."[1]

During this same time, the theory and criticism of photography was being transformed by the emergence of a new, strong materialist analysis of photography by writers such as Martha Rosler, Allan Sekula, Abigail Solomon-Godeau, and John Tagg, among others. One of the most trenchant and persistent critiques arising from this tendency was that of "social documentary" photography, focusing especially on the aestheticization of the documentary image. One measure of the success of this critique is the extent to which its assumptions and conclusions were accepted and absorbed into mainstream writing about photography.

The September 9, 1991 issue of the *New Yorker* carried an article by Ingrid Sischy, titled "Good Intentions," on the work of Brazilian photographer Sebastião Salgado. Sischy upbraids Salgado for being too popular and too successful, and also for being too "uncompromisingly serious" and "weighty"; for being opportunistic and self-aggrandizing, and also too idealistic; for being too spiritual, and also for being "kitschy" and "schmaltzy." But Sischy's real complaint about Salgado's photographs is that they threaten the boundary between aesthetics and politics. The complaint is couched in the familiar terms of a borrowed political critique:

> *Salgado is too busy with the compositional aspects of his pictures— and with finding the "grace" and "beauty" in the twisted forms of his anguished subjects. And this beautification of tragedy results in pictures that ultimately reinforce our passivity toward the experience they reveal. To aestheticize tragedy is the fastest way to anaesthetize the feelings of those who are witnessing it. Beauty is a call to admiration, not to action.[2]*

The substantive critique upon which this by now conventional criticism is based can be found in the classic debate within German

Marxism that occurred from the 1930s to the 1950s, involving Ernst Bloch, Georg Lukács, Bertolt Brecht, Walter Benjamin, and Theodor Adorno.[3]

The principal source for the "aestheticization of tragedy" argument is Walter Benjamin's essay "The Author As Producer," in which he speaks of "the way certain modish photographers proceed in order to make human misery an object of consumption."[4] What is often forgotten by those who appropriate this critique is its historical context within this debate. Benjamin's criticisms here specifically refer to certain products of the Neue Sachlichkeit (New Objectivity) movement in literature and art, which was itself a reaction against Expressionism, professing a return to objectivity of vision. When Benjamin charges that "it has succeeded in turning abject poverty itself, by handling it in a modish, technically perfect way, into an object of enjoyment," he is referring to the well-known picture book by Albert Renger-Patzsch titled *Die Welt ist schön* (The world is beautiful). And he is expressly referring to the New Objectivity as a literary movement when he says that "it transforms political struggle so that it ceases to be a compelling motive for decision and becomes an object of comfortable contemplation." There are contemporary photographers who are heirs to the New Objectivity, but Salgado is not one of them, and to apply these criticisms to his work is a politically pointed inversion.

The distinction is made eloquently, and in a way that Benjamin would surely have appreciated, by Uruguayan writer Eduardo Galeano in his essay "Salgado, 17 Times," which appeared in the San Francisco Museum of Modern Art's catalog to the 1990 Salgado show:

Salgado photographs people. Casual photographers photograph phantoms.

As an article of consumption poverty is a source of morbid pleasure and much money. Poverty is a commodity that fetches a high price on the luxury market. Consumer-society photographers approach but do not enter. In hurried visits to scenes of despair or

violence, they climb out of the plane or helicopter, press the shutter release, explode the flash: they shoot and run. They have looked without seeing and their images say nothing. Their cowardly photographs soiled with horror or blood may extract a few crocodile tears, a few coins, a pious word or two from the privileged of the earth, none of which changes the order of their universe. At the sight of the dark-skinned wretched, forsaken by God and pissed on by dogs, anybody who is nobody confidentially congratulates himself: life hasn't done too badly by me, in comparison. Hell serves to confirm the virtues of paradise.

Charity, vertical, humiliates. Solidarity, horizontal, helps. Salgado photographs from inside, in solidarity.[5]

Are Galeano and Sischy looking at the same images? What is the political difference in the way they are looking? In another part of his essay, Galeano (who was forced into exile from his native Uruguay for having "ideological ideas," as one of the dictator's functionaries put it) locates Salgado's transgression: "From their mighty silence, these images, these portraits, question the hypocritical frontiers that safeguard the bourgeois order and protect its right to power and inheritance."[6]

This is the disturbing quality of Salgado's work that so divides viewers. Like all politically effective images, the best of Salgado's photographs work in the fissures, the wounds, of the social. They cause those who see them to ask themselves: *Are we allowed to view what is being exposed?* In an essay on "Active Boundaries," the poet Michael Palmer relates Salgado's work to that of Paul Celan, and notes:

The subject of Salgado's photojournalism, we must continually remind ourselves, is not there, *is not in fact the visible but the invisible: what has been repressed and will not be spoken. It appears always at the edge of the frame or in the uneasy negotiation among the space of origin, the framed space of the work, and the social space to which it has been removed, which is also a cultural space, of the aesthetic.*[7]

7

The anti-aesthetic tendency can easily become an anaesthetic one, an artificially induced unconsciousness to protect oneself from pain, and to protect the "hypocritical frontiers" of propriety and privilege. It is unseemly to look right into the face of hunger, and then to represent it in a way that compels others to look right into it as well. It is an abomination, an obscenity, an ideological crime.

When one, anyone, tries to represent someone else, to "take their picture" or "tell their story," they run headlong into a minefield of real political problems. The first question is: what right have *I* to represent *you*? Every photograph of this kind must be a negotiation, a complex act of communication. As with all such acts, the likelihood of success is extremely remote, but does that mean it shouldn't be attempted? In his magnificent defense of Modern art against Lukács, Brecht wrote:

> *In art there is the fact of failure, and the fact of partial success. Our metaphysicians must understand this. Works of art can fail so easily; it is so difficult for them to succeed. One man will fall silent because of lack of feeling; another, because his emotion chokes him. A third frees himself, not from the burden that weighs on him, but only from a feeling of unfreedom. A fourth breaks his tools because they have too long been used to exploit him. The world is not obliged to be sentimental. Defeats should be acknowledged; but one should never conclude from them that there should be no more struggles.*[8]

A documentary practice that tries to avoid the difficulties of such communication is not worthy of the name. After the aestheticization argument made social documentary photography of any kind theoretically indefensible, a number of articles appeared calling for its recuperation as "new documentary." In his essay "Toward a New Social Documentary," Grant Kester wrote:

> *If social documentary can be recuperated as a new documentary, it is precisely because it was never entirely aestheticized in the first place. There must be a core of authentic practice in documentary. It seems clear that this authenticity rests in its ability to act not only*

as art, but also in the kind of concrete social struggles that gave it its original character. [9]

The assumptions here are clear: the "aestheticized" (art) is not "authentic," but always already supplementary, added on to the "core of authentic practice." It is also supplementary—perhaps even antithetical—to "concrete social struggles." Isn't this just the flip side of the right's view of art: that art is inauthentic and supplementary and politically suspect? The doctrinaire right contends that politics has no place in art, while the doctrinaire left contends that art has no place in politics. Both takes are culturally restrictive and historically inaccurate.

The idea that the more transformed or "aestheticized" an image is, the less "authentic" or politically valuable it becomes, is one that needs to be seriously questioned. Why *can't* beauty be a call to action? The unsupported and careless use of "aestheticization" to condemn artists who deal with politically charged subjects recalls Brecht's statement that "the 'right thinking' people among us, whom Stalin in another context distinguishes from creative people, have a habit of spell-binding our minds with certain words used in an extremely arbitrary sense."[10]

To represent is to aestheticize; that is, to transform. It presents a vast field of choices but it does not include the choice *not* to transform, not to change or alter whatever is being represented. It cannot be a pure process, in practice. This goes for photography as much as for any other means of representation. But this is no reason to back away from the process. The aesthetic is not objective and is not reducible to quantitative scientific terms. Quantity can only measure physical phenomena, and is misapplied in aesthetics, which often deals with what is *not* there, imagining things into existence. To become legible to others, these imaginings must be socially and culturally encoded. That is aestheticization.

When Benjamin wrote that "the tendency of a work of literature can be politically correct only if it is also correct in the literary sense," he meant that the way something is made (its poetics) is

political. Carried over into photography, that might mean that being politically correct doesn't signify much unless the work is also visually and conceptually compelling, or rather that these two things are not mutually exclusive, nor even separate. To be compelling, there must be tension in the work; if everything has been decided beforehand, there will be no tension and no compulsion to the work. In the latter kind of imagery, the viewer's choice is reduced to acceptance or rejection of the "message," without becoming involved in a more complex response. Such images may work as propaganda (the effectiveness of which is quantitatively measurable), but they will not work at other points on the spectrum of communication.

Aestheticization is one of the ways that disparate peoples recognize themselves in one another. Photographs by themselves certainly cannot tell "the whole truth"—they are always only instants. What they do most persistently is to register the relation of photographer to subject—the distance from one to another—and this understanding is a profoundly important political process, as Marx himself suggested: "Let us suppose that we had carried out production as human beings. . . . Our products would be so many mirrors in which we saw reflected our essential nature."[11]

1992

NOTES

1 Hal Foster, "Postmodernism: A Preface," in *The Anti-Aesthetic: Essays on Postmodern Culture*, ed. by Foster (Port Townsend, WA: Bay Press, 1983), p. xv.

2 Ingrid Sischy, "Good Intentions," *The New Yorker*, September 9, 1991, p. 92. When I read this passage to the poet Susan Thackrey, she said, "And what is she going to do with King Lear?"

3 *Aesthetics and Politics*, Afterword by Fredric Jameson, translation ed. by Ronald Taylor (London and New York: Verso, 1980).

4 Walter Benjamin, "The Author As Producer," in *Thinking Photography*, ed. by Victor Burgin (London: Macmillan, 1982), p. 24.

5 Eduardo Galeano, "Salgado, 17 Times," trans. by Asa Zatz, in *Sebastião Salgado: An Uncertain Grace* (New York: Aperture, in association with the San Francisco Museum of Modern Art, 1990), p. 11.

6 Ibid., p. 12.

7 Michael Palmer, "Active Boundaries: Poetry at the Periphery," unpublished manuscript, 1992. Later published in *Onward: Contemporary Poetry and Poetics*, ed. by Peter Baker (New York: Peter Lang Publishing, 1996), p. 265.

8 *Aesthetics and Politics*, p. 74.

9 Grant Kester, "Toward a New Social Documentary," *Afterimage* vol. 14, no. 8 (March 1987), p. 14.

10 *Aesthetics and Politics*, p. 76.

11 Karl Marx, "Comments on James Mill" (1844) in the *Collected Works*. Quoted by W.J.T. Mitchell in *Iconology: Image, Text, Ideology* (Chicago and London: University of Chicago Press, 1986), p. 186.

Art Center College of Design
Library
1700 Lida Street
Pasadena, Calif. 91103

PHOTOGRAPHY AND PROPAGANDA

Richard Cross and John Hoagland in Central America and in the News

Richard Cross and John Hoagland were photojournalists who worked and died in Central America—Cross in 1983, at age thirty-three, returning from a Contra camp on the Honduras/Nicaragua border, and Hoagland in 1984, at age thirty-six, in a firefight just south of Suchitoto, El Salvador. Both men were idealists who believed strongly in what they were doing. They were also highly skilled professionals, regarded by many of their peers as two of the best in the business.

Richard Cross had a degree in magazine journalism from Northwestern University and had done graduate work in visual anthropology at Temple University. After spending four years as a Peace Corps volunteer in Colombia in the mid 1970s, he coauthored, with Colombian anthropologist Dr. Nina Friedman, *MaNgombe: Guerreros y Ganaderos en Palenque* (Warriors and cattlemen of the Palenque; Bogotá: Carlos Valencia Editores, 1979), an ethnographic study of a black farming society, which includes 260 of his photographs. At this time he also won the Freedom of the Press Award from the Inter-American Press Association. As part of his studies in visual anthropology he went to Tanzania, where he produced a documentary film and a limited-edition book on Ilparakuyo Maasai people engaged in specific dispute and settlement interaction.

In 1979 Cross went to Nicaragua. His photographs covering the Sandinista revolution for the Associated Press were nominated for a Pulitzer Prize. His understanding of and deep feeling for the revolution led to his collaboration in 1981 with poet and future minister of culture of Nicaragua Ernesto Cardenal on the book *Nicaragua: La Guerra de Liberación* (Nicaragua: The war of liberation; Managua:

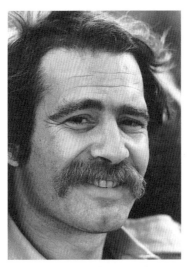 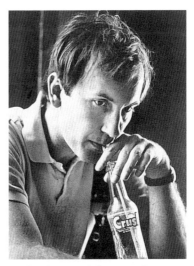

John Hoagland (photograph by Susan Greenwood)

Richard Cross (photograph by Gary Cameron)

Ministerio de Cultura, 1981). Printed in East Germany, this is a mostly photographic record and celebration of the Nicaraguan war of liberation. Later, Cross covered the Salvadoran elections, Pope John Paul II's visit to Central America, and other events for Gamma-Liaison photo agency, AP, and United Press International. His photographs appeared regularly in *Newsweek, Time, U.S. News & World Report*, the *New York Times*, the *Los Angeles Times*, and many other publications in the United States and around the world.

John Hoagland studied art at the University of California in San Diego and was a conscientious objector to the Vietnam War. Following the assassination of Martin Luther King, Jr., he joined in forming the Tuesday the Ninth Committee to explore solutions to the mounting racial tensions on campus. Using borrowed UCSD video equipment, he recorded the police confrontation at the Chicano Moratorium in Los Angeles in 1970. Like Cross, Hoagland went to Nicaragua in the summer of 1979 to photograph the Sandinista revolution for AP. In 1980 he moved to El Salvador, shooting for UPI, Gamma-Liaison, and, under contract, for *Newsweek*.

Hoagland's name appeared on a right-wing death list during the 1982 Salvadoran elections. He was twice wounded in ambushes in which colleagues were killed. He received numerous death threats and was arrested by the Salvadoran police at one point, but he refused to leave El Salvador. On March 16, 1984, serving as a scout for a group of reporters tracking a fight just south of Suchitoto, Hoagland was killed when a round from a U.S.–made M-60 machine gun ripped through his lung.

Unlike the "shooters" who go down to cover the wars for three days or three weeks and remain in linguistic and cultural isolation, Hoagland and Cross were both committed to El Salvador and its people. Hoagland had married a Salvadoran woman and spoke of staying on in El Salvador after the war was over.

My own interest in Hoagland and Cross began in November 1985, when the Eye Gallery in San Francisco mounted a show of their work. This show, curated by David Helvarg for the families and friends of Hoagland and Cross, and by Andrew Ritchie and Rupert Jenkins for Eye Gallery, included fifty photographs mounted under glass in the gallery, along with a back room where the work of Hoagland and Cross was displayed as it had actually appeared originally, in the national and international press.

The contrast between these two contexts was a revelation. We see photographs like these every day. They are anonymously absorbed into our superficial reading of "the news." Ubiquitous, unremarkable, they pass unquestioned into our sense of the world. And yet we are profoundly affected by these images, in context. There is a particular kind of photographic education going on all around us, every day, in the mass media.

In the catalog of the Eye Gallery exhibition, there appeared this statement by John Hoagland:

> *I don't believe in* objectivity. *Everyone has a* point of view.
> *But what I say is I won't be a* propagandist *for anyone.*

The medium of photography has had to struggle with the question of "objectivity" since Niépce and Daguerre first uncovered the

process that "gives Nature the power to reproduce herself" (in Daguerre's words). Hoagland knew that there is no objectivity in photography, in political terms. There are only *choices*, based on one's point of view. And the deceptive illusion of objectivity. As Brecht wrote:

> *The tremendous development of photojournalism has contributed practically nothing to the revelation of the truth about the conditions in this world. On the contrary, photography, in the hands of the bourgeoisie, has become a terrible weapon against the truth. The vast amount of pictured material that is being disgorged daily by the press and that seems to have the character of truth serves in reality only to obscure the facts. The camera is just as capable of lying as the typewriter.[1]*

Journalists working for the largest news media outlets in America operate under the institutional myth of objectivity in journalism. Sociologist Herbert J. Gans, in his study of how the national news media portray America, registers surprise at the extent to which professional journalists believe their product to be "outside ideology."[2] Journalists and editors that he talked to associated ideology with extremism and defined their own motivations tautologically, to exclude ideology. One top editor (for either *Newsweek* or *Time*) told Gans that the primary task in story selection is "to tell the readers this is what we think is important, and we hope they'll feel the same way, but our aim isn't ideological."[3] Gans recognizes the delusion in such remarks: "The exclusion of conscious values implies the exclusion of conscious ideology, but the ways in which journalists reject ideology and deal with it when it appears provide further insight into the workings of objectivity—and an understanding of how unconscious values, and thereby unconscious ideology, enter into news judgement."[4]

In his concluding chapter, calling for a new emphasis on "Multiperspectival News," Gans unmasks the stated public purpose of the news ("to inform the audience"), to reveal its actual purpose: "I would argue that the primary purpose of the news derives from the journalists' functions as constructors of nation and society, and as

managers of the symbolic arena. [Emphasis added.] The most important purpose of the news, therefore, is to provide the symbolic arena, and the citizenry, with comprehensive and representative images (or constructs) of nation and society."[5]

Before 1880 illustrations in the popular press were limited to engravings. Since the first halftone was produced on March 4, 1880 (for an image titled *Shantytown* in the *New York Daily Herald*), photographs have functioned in the news as "evidence" to support the contentions of the accompanying text. "A picture is worth a thousand words"— the pure "objective" truth.

John Berger, in his book with photographer Jean Mohr, *Another Way of Telling*, points out the fallacy on which this practice is based and begins to uncover the motives for sticking to it:

> *The way photography is used today both derives from and confirms the suppression of the social function of subjectivity. Photographs, it is said, tell the truth. From this simplification, which reduces the truth to the instantaneous, it follows that what a photograph tells about a door or a volcano belongs to the same order of truth as what it tells about a man weeping or a woman's body.*
>
> *If no theoretical distinction has been made between the photograph as scientific evidence and the photograph as a means of communication,* this has been not so much an oversight as a proposal.[6]

This proposal, that photographs as communication are somehow more "objective" (less "ideological") than words, has so far assured the continued use of photography in contemporary news magazines. They operate as objective quotes, and they combine with other news imagery, advertising images, and words, to produce a unified effect in the symbolic arena.

Hoagland and Cross were photographers, but the context in which their work operated in the mass media was always one of words and images. As Roland Barthes pointed out, though we live in a media environment saturated with visual imagery, these images

are almost always accompanied by words. "It is not very accurate to talk of a civilization of the image—we are still, and more than ever, a civilization of writing, writing and speech continuing to be the full terms of the informational structure."[7]

Even television news is to a large extent not visual. It consists mostly of "talking heads" reading texts. In print news, headlines, captions, and text all serve to resolve the innate ambiguity of photographs and to suppress the central photographic paradox that results from their combination of iconic and symbolic modes of signification. The construct is there to tell you what you are seeing and to tell you what it means.

Another way of enhancing the illusion of objectivity (and suppressing the subjective function) of photographs is to present them as more or less anonymous. While writers are at least sometimes given bylines, photo credits—if they appear at all—are nearly invisible. No one took these photographs. Or *Newsweek* took them. No one decided what and when. No one died making them.[8]

"The facts we see depend on where we are placed and the habits of our eyes," said Walter Lippmann.[9] How does an individual photographer's point of view affect the news photographs he or she makes? Does that point of view change over time? How is it affected by experience, including the experience of taking war photographs? How is the point of view of the photographer obscured in photographs appearing in a "news context"? What is the relation between the individual photographer and the mechanisms through which his or her photographs are manufactured into "news"?

The third significant term in Hoagland's statement, *propaganda*, is the most difficult one—the one that calls photographic communication, indeed all communication, into question. In his book *Literature and Propaganda*, A. P. Foulkes writes: "If we refer to the nineteenth century as the Age of Ideology, then it seems even more appropriate to regard the present century as the Age of Propaganda. Twentieth-century propaganda . . . is worldwide and all pervasive."[10]

Though the literature on modern propaganda is vast and has grown rapidly in the past fifteen years, the popular misconceptions

persist. When one mentions propaganda, many people will think of Leni Riefenstahl or Joseph Goebbels; fewer will think of Sylvester Stallone or William Paley. Propaganda is what "the other side" does. Reagan accused Gorbachev of using propaganda, as Gorbachev accused Reagan of using propaganda. When Nicaragua announced in 1986 that Eugene Hasenfus would be tried by a People's Tribunal, the U.S. State Department said that "a fair trial was impossible and that the proceeding would be a propaganda exercise."[11] When Nicaragua later released Hasenfus, that too was described as an exercise in propaganda.

Clinging to the old sense of propaganda as essentially untrue only paves the way for the new propaganda's effectiveness. One rule in contemporary propaganda is that lies should not be used except about completely unverifiable facts. No good propagandist will prefer a lie to the truth, *if the truth will get the job done.* The equation of propaganda to lies assures that contemporary propaganda is not recognized as propaganda by those who are being influenced by it.

Another reason for contemporary propaganda going unrecognized is that it is largely "agreeable." Foulkes writes: "The recognition of propaganda can be seen as a function of the ideological distance which separates the observer from the act of communication observed."[12] We can easily see the mote in the Other's eye, but that's not the mote that's blinding us.

Jacques Ellul's book *Propaganda*, originally published in French in 1962, was the first comprehensive treatment of modern propaganda as a pervasive force in contemporary life. Ellul recognized propaganda not as a "sinister invention of the military caste," or of a few evil men, but as "the expression of modern society as a whole."[13] Rather than picturing the propagandee as innocent victim and prey "pushed into evil ways by the propagandist," Ellul says the propagandee "provokes the psychological action of propaganda, and not merely lends himself to it, but even derives satisfaction from it. Without this previous, implicit consent, without this need for propaganda experienced by practically *every* citizen of the technological age, propaganda could not have spread."[14]

Ellul's analysis takes propaganda not as an isolated historical technique, but as an inevitability arising from a technological society: "Mass production requires mass consumption, and there cannot be mass consumption without widespread identical views as to what the necessities of life are."[15] It was the rapid rise and tremendous sophistication of product advertising and publicity that ushered in the new Age of Propaganda.

Ellul's sense of propaganda is as "an enterprise for perverting the significance of events" behind a façade of unassailable "factuality."[16] He makes distinctions between "political propaganda" and "sociological propaganda" ("the penetration of an ideology by means of its sociological context"), and between "agitational propaganda" (prerevolutionary) and "integration propaganda" (postrevolutionary). One of the main instruments of integration propaganda (a propaganda of conformity and consent) is a biased but seemingly objective news system.

In recent years, the main centralized news organizations in the United States, such as CBS, NBC, *Newsweek*, and *Time*, have all adopted the techniques of product advertising to the point where there is little distinction between ads and news. In the print media, it is now effectively impossible to tell where advertising ends and "news" begins. Information is a commodity and what is being sold is "the American Way of Life." A recent radio ad for the *CBS Evening News* encapsulates the ideology of news selling:

AMERICANS
> *We* like *straight talk.*
> *We* want *hard facts.*
> *We* demand *the truth.*
> *We* know *who we are.*
> *And when it comes to news,*
> > *we* know *who we trust.*
> > *Dan Rather on the* CBS Evening News.
> > *Weeknights on the CBS Television Network.*
> *We keep AMERICANS on top of the world.*

"The news," as Edward Said has noted, "is a euphemism for ideological images of the world that determine political reality for a vast majority of the world's population."

I said in beginning that John Hoagland and Richard Cross were idealists. I meant that they were idealists in the tradition of earlier press photographers, who believed that by showing the horror and desolation of war they could hasten the end of war; by "photographing the truth," they could influence public opinion and public policy, and change the world. Hoagland and Cross came of age and were politicized during the time when U.S. news coverage of the war in Vietnam *did* mobilize people against the war. Both of them went to Nicaragua to see a real popular revolution and were sympathetic in the same way that a previous generation of writers and photographers had been sympathetic to the Spanish Republican cause. Cross once wrote: "Covering the Nicaraguan revolution was the turning point, giving me a sense of direction and purpose, and feeling that the mass media can help shape man's history."[17]

It was only later, near the end of his short life, that Cross began to speak out about the severe limitations of the news media as communication, and to question the powers of photography to exceed those limitations. In a story titled "Photographers of the Vanguard" in *News Photographer* magazine (September 1981), Cross is quoted as saying:

> In [news] photographs, the priority seems to be on getting good shots, so to speak, shots of the news moment. And it's a sort of unwillingness to come to terms with what is going on down there in a systematic way.
>
> I think photographers sometimes are very short-sighted in looking at causes. They are interested in the more dramatic symptoms of the problem rather than the cause of the problem. There's this sort of refusal to look at patterns.
>
> I would opt much more for telling the story with lots of images and text that tries to relate what has been going on in El Salvador

with what has been going on in the last 50 years in the world—things like the decline of neo-colonialism and the rise of independent nation-states.

What is needed, Cross continued, is

good in-depth photojournalism. Which means that a person has to be dedicated enough to spend quite a long time with a story. And photographers have to take the initiative to try to have more control over the use of their photographs and they have to get more interested in the potential for combining images to make stories and to combine images with text.[18]

In fact, Cross did explore that potential in the three completed books, and in tapes, films, and numerous other projects he worked on outside of his mainstream photojournalist role. In the Introduction of the catalog to a memorial exhibition of Cross's photographs from Tanzania, "Maasai Solutions," at the Paley Library at Temple University in 1983, anthropologist Richard Charen (Cross's academic advisor) wrote:

[Richard Cross's] interest in visual anthropology was motivated on two accounts. First, he expressed a keen curiosity for learning more about how photographs "worked" as a communicative medium—not simply as a technical process involving optics, grain structure, chemicals, or even in aesthetic terms—but more importantly, in cognitive, social, political, economic, and cultural contexts.

As a young thinking photojournalist, Richard was not satisfied with merely getting the "right" picture—an image that conformed to an often unarticulated set of editorial decisions, sometimes aesthetic, sometimes political, as imposed by photo agencies and staffs of popular publications. It became clear that Richard felt a growing sense of responsibility for images he "took from" people and "gave to" the viewing public. The political context of image publications became an increasingly important problem in his practice of photography.

In the distinction between *communication* as an inclusive, inquisitive process, and *propaganda* as a deliberately manipulated communication ("which does not release self-reliance but limits it"—Ellul), we can recognize the photographs made by the individuals Hoagland and Cross as communication, and the uses of these same photographs in the mass media as propaganda.

The following reading of Hoagland and Cross images in context is not a comprehensive or systematic content analysis, but rather an informal reading of the effects of the propaganda context (Goebbels: "We do not talk to *say* something, but to obtain a certain *effect*." And Ellul: "Whoever handles this instrument [propaganda] can be concerned solely with effectiveness"[19]). This reading arises from a desire to articulate some of the cultural and political meanings produced by this kind of image context in order, however briefly, to break the flow of propaganda, or at least to provide some interference in a process that is so pervasive as to have become invisible.

A reading of the images used in the news magazines begins with a reading of looks and glances (Fig. 1). In this layout from *Newsweek* (May 9, 1983) President Reagan looks strong and determined as he appeals for support. Despite his assault rifle (chopped in cropping Hoagland's original image), the young Salvadoran soldier looks frightened and defensive. Father and unruly son. "Reagan on the Hill" is "stressing the high U.S. stakes in America's backyard," while Salvadoran troops give "our thanks for U.S. aid." In the *Newsweek* poll at the bottom of the page, respondents are given two choices to describe "the greater cause of unrest in Central America": "subversion from Cuba, Nicaragua and the Soviet Union, or poverty and the lack of human rights in the area." These pages are the scene of the real "battle for hearts and minds," in which choices are severely reduced to ensure a certain outcome.

In the next spread (Fig. 2) the smaller photograph on the right was taken by Hoagland a few months after his move to El Salvador. He was one of the news photographers who discovered the shallow common grave of four American churchwomen—three nuns

and a lay volunteer—who had been raped and shot. The story says these were "the first known American victims of the political violence that has claimed nearly 8,500 lives," and quotes Sister Christine Rody as saying, "Jean [Donovan, the lay volunteer who was killed] used to joke that blue-eyed blondes were the safest people in El Salvador, because they were so American-looking and no one would kill Americans. I guess she was wrong." The caption reads, "Atrocity: Bodies are removed from grave, and other nuns pray over them."

By themselves, these photographs are terrifying images—the nuns' bodies sprawled in the dirt, sheathed in transparent white cotton, with freshly cut branches laid over them, as if to retain modesty in death.

In this *Newsweek* layout, the atrocity competes with a new brand of cigarettes for the reader's attention. In this equation, the horror of the event in El Salvador is thus reduced to the communicative level of an advertisement, while the new cigarette brand is inflated into "news" as part of the "enterprise for perverting the significance of events."

Newsweek, January 16, 1984—cover by Hoagland (Fig. 3). Another row of dead bodies; on the back cover, "For all the commitments you make." A photograph of a young boy and an old man fishing, and a photograph of nine dead bodies somewhere far away—two emanations of one referent, graphically equalized. Photographs exist and operate on an axis of selection meaningful in relation to other photographs in proximity.

> *Commitment is giving a child the most precious gift of all, your time. Providing the learning experience every child needs, to guide him in the years ahead. Commitment is the key to making our family, home and business what we want them to be, and many commitments worth keeping require thoughtful protection. . . . We provide all lines of insurance . . . to help those who make commitments keep them.*

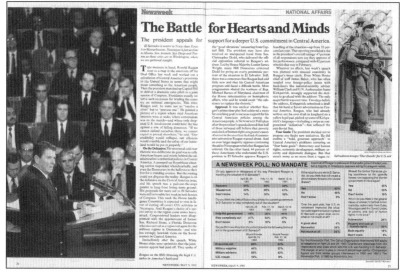

Figure 1: *Newsweek*, May 9, 1983

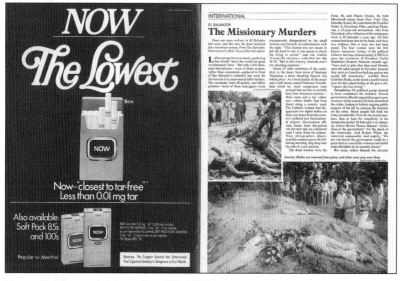

Figure 2: *Newsweek*, December 15, 1980

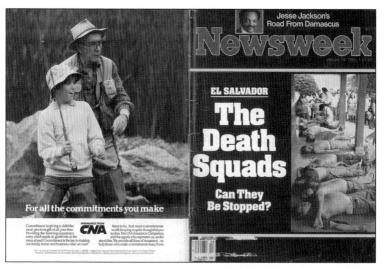

Figure 3: *Newsweek*, January 16, 1984, front and back covers

John Berger has written of the way publicity images "belong to the moment but speak to the future."[20] They refer to a continually deferred fulfillment of all the spectator-consumer's fantasies of wealth and power—to make the spectator-consumer envious on the way to becoming *enviable*. If we are able to read the language common to all publicity images, we come to the one general proposal made in all such images: that we transform our lives by buying something more.

> *The purpose of publicity is to make the spectator marginally dissatisfied with his present way of life. Not with the way of life of society, but with his own within it. It suggests that if he buys what it is offering, his life will become better. It offers him an improved alternative to what he is.*[21]

IN THE MODERN IMAGE WORLD, CONSCIOUSNESS IS MAPPED BY POINTS OF ATTENTION ALONG A CONTINUUM OF DESIRE. . . .[22]

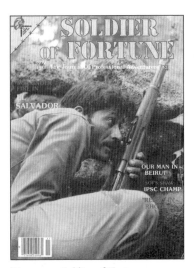

Figure 4: *Soldier of Fortune*, November 1981, front cover

News photographs appearing in this world have two functions: (1) to encourage feelings of distance and superiority in the spectator-consumer, and (2) to provide vicarious thrills and chills for the spectator-consumer.

In November 1981, a photograph by Hoagland appeared on the cover of *Soldier of Fortune* (Fig. 4). *Soldier of Fortune:The Journal of Professional Adventurers* (SOF) functions mostly as a sort of pornography for the powerless. The fantasies being promulgated here certainly overlap with those of *Newsweek*, and the effects of the imagery in propaganda terms are very similar.The motivations and intentions are, however, less veiled in *SOF* and the techniques less sophisticated.

This issue begins with an "Open Letter to President Reagan" from *SOF*'s executive editor Bob Poos:

Dear Mr. President:

I truly hope you read this, because it will be a rare opportunity to read the truth about the situation in El Salvador.You can't read it in the Washington Post *or* New York Times *because they are in the corner of the communist guerrillas who are seeking to overthrow the moderate government of President Jose Napoleon Duarte, along with the other civilian and military members of the junta now guiding El Salvador's destiny.*

The liberal Eastern Seaboard press, Mr. President, will not print the other truly accurate reports coming from El Salvador, which are from UPI's John Newhagen and Newsweek/UPI *freelancer John Hoagland.*

Hoagland joked a lot about this appearance. He said the article was an almost complete fabrication, another armchair-mercenary fantasy, but that appearing in *SOF* was seriously useful for him inside El Salvador. He had already been singled out as a leftist by the government and had received numerous death threats from the army. This appearance increased his credibility in the eyes of the Salvadoran military.

"Life in the Rebel Zone" vs. The Good American Life. "Guerrilla" vs. Spectator-Consumer. The ad copy on the right (Fig. 5) reads: "82° F. That's the average mean temperature in the summer in the American paradise. With trade winds blowing almost without exception from an easterly direction. (Now that doesn't sound mean at all!) See your travel agent."

In this context, the "news" from behind the lines in El Salvador (a future "American paradise"?) becomes a sort of cultural voyeurism, an ad-venture. The Rebel in Hoagland's photograph is as far away as the gaze of the beautiful woman on the right. The man in the photograph on the right, who has put aside his book (information), desires the Virgin, who "goes native" and looks to the future. All is put off, deferred in the circuit of exchange. The man on the left, clutching his weapon, is in an *unenviable* primitive state—the state of political struggle. On these pages, as the spectacle of mass consumption is played out around the news, we see the image's double position in an economic and ideological circuit of exchange. "News" and "information" bolstering up and being bolstered by the demands of commerce.

> *Where the instruments of public enlightenment are wholly under the domination of the active elite of power, the controllers of the media develop a fantasy world in which the images communicated to the people have little relationship to reality. The stream of public communication becomes dogmatic and ceremonial to such a degree that it is inappropriate to think of communication management as a propaganda problem. It is more accurate to think of ritualization than propaganda.*[23]

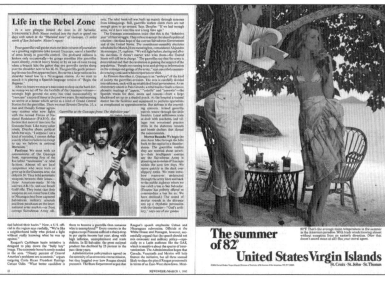

Figure 5: *Newsweek*, March 1, 1982

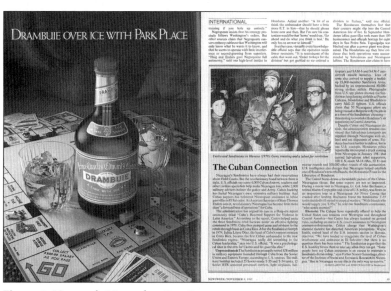

Figure 6: *Newsweek*, November 8, 1982

Figure 7: *Newsweek*, March 1, 1982

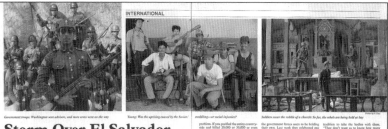

Figure 8: *Newsweek*, March 16, 1981

After Cross's coverage of the Sandinista revolution, when the new ruling junta was welcomed in Cuba in July 1979, the Sandinistas asked him to cover the meeting. One of the resulting photographs, picturing Castro and two Sandinista leaders, became an AP bestseller. It was used in magazines and newspapers all over the United States to signify the "Cuban Connection" to events in Nicaragua. In Figure 6, *Newsweek* uses it in November 1982, more than three years after it was taken—and in Figure 7, in the previous March.

Articles in *Newsweek* are usually put together in the form of point-counterpoint. An assertion is balanced (canceled) by a denial:

> *Administration officials say that the flow of arms and other aid from [Nicaragua] to the Salvadoran rebels has reached its highest level since the guerrilla's ill-fated "final offensive" early last year.*
>
> *Castro and the Sandinistas scoff at Washington's charges. "Half-truths and lies in a propaganda campaign," declares Sergio Ramirez Mercado, a member of the Nicaraguan junta.*

"Facts" are lined up on "each side" of every question. This is thought to ensure "objectivity." In fact, the style is confusing, resulting in a kind of info-vertigo in the reader. One must go to great lengths to decode this kind of information. By alternating contradictory statements, the reader is kept off-balance, and is then more vulnerable to the overall ideological impact of the material.

In theory, photographs are used to back up or "prove" contentions made in the article. They are the visual evidence, the facts in the matter. In actuality they needn't perform that role. They only need to appear, to give the *appearance* of evidence. Beyond this they can do anything. Their factualness is never questioned.

The photograph of Salvadoran government troops in the upper-left corner of the spread in Figure 8 is Cross's (here using the credit line "R. Cruz"). It is his best-known and most widely circulated photograph. After this appearance in the March 16, 1981 issue of *Newsweek* (a highly unusual layout for *Newsweek*—three photo-

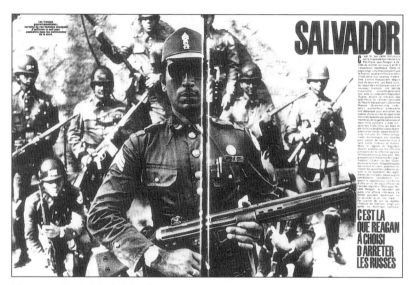

Figure 9: *Paris Match*, March 27, 1982

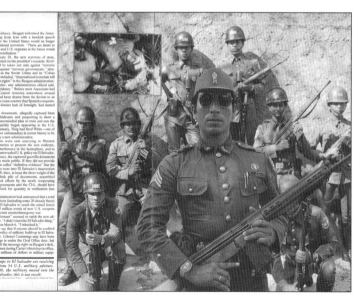

Figure 10: *Mother Jones*, June 1981

graphs by one photographer, the closest they ever come to a photo essay), it appeared in a number of other publications in the United States and throughout the world (Figs. 9 and 10). A slightly different version appeared one year later on the cover of the *Economist* of London (Fig. 11). This single photograph really came to "stand for" the Salvadoran government troops and for Reagan's controversial support of them.

It should be mentioned here that for every Cross photograph published in the United States, five appeared in the Latin American press, but this one was apparently little used in Latin America. I suspect that it did not read the same there. It gave the government troops a look of authority that was not believable. It was read as a propaganda photograph *for* the Salvadoran military. In the United States and Europe, however, it was read as an ironic and horrific image—"With friends like these. . . ." It is such an apparently calculated image, making the men look so menacing and so malevolent, like storm troopers, that one would think Cross set it up that way. In fact, Cross said, the soldier in the foreground set the shot up

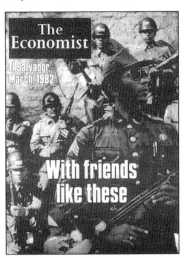

Figure 11: *The Economist*, March 27–April 2, 1982

himself—getting everyone dressed and arranged and then virtually *demanding* that Cross take the picture. The soldier was reportedly very pleased with the result. As John Berger has written:

A photograph is a meeting place where the interests of the photographer, the photographed, the viewer and those who are using the photographs are often contradictory. These contradictions both hide and increase the natural ambiguity of the photographic image.[24]

Figure 12: *Newsweek*, July 4, 1983

Every photograph is an act amid a complex structure of choices. These choices, which extend beyond the time of the photograph, influence the photograph before, during, and after its instant. Reading photographs in context is a participation in this complex.

Hoagland and Cross were cultural workers in the factories of the Consciousness Industry. They did not *own* the pictures they made any more than a worker in a munitions factory owns the weapons he makes while employed.

Cross's last assignment (for *U.S. News & World Report*) was to look into reports that Honduras was being used by U.S.-backed rebel forces to mount sporadic attacks on Nicaraguan troops. The image in the upper left of Figure 12 is one of the last photographs Cross made. It is captioned "Nicaraguan contras at the Honduran frontier: Opening a new shooting gallery." It was in this gallery, known as "Blood Alley," that Cross and *Los Angeles Times* bureau chief Dial Torgerson were caught in the crossfire. The photograph on the right, of Salvadoran troops, is by

Figure 13: *U.S. News & World Report*, July 4, 1983

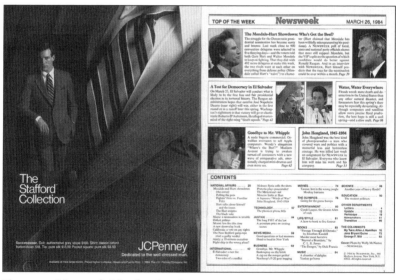

Figure 14: *Newsweek*, March 26, 1984

Hoagland, who continued to cover the conflict for another nine months, until he too was caught in the crossfire.

When Cross and Hoagland were killed, they became newsworthy, and their employers rushed to eulogize them (Figs. 13 and 14). There were charges and countercharges and considerable debate as to *which side* was responsible for their deaths (Figs. 15 and 16). Hoagland passed from one kind of anonymity (in the photo credits) to another by becoming the real-life model for photojournalist characters in two Hollywood films: Roger Spottiswoode's 1983 *Under Fire*, and Oliver Stone's 1986 *Salvador*. These films propagate the image of the photojournalist as spectator-hero, in the same way that *Blow-Up* (1967, by Michelangelo Antonioni) signaled the public fascination with the heroic image of the photographer-witness twenty years ago.

After they were killed, both Hoagland and Cross were given photo spreads in the news magazines (Figs. 17 and 18).

In Cross's last appearance in this context, the complexities of the struggle in Central America, which few outsiders knew better than he, were once again reduced to two: violence and poverty. "A sensitive photographer, the 33-year-old Cross shot pictures not only of the military side of the conflict but also of the poverty that breeds revolutionary violence in Central America." And "Poverty of peasantry is one source of Central America's turmoil."

U.S. Photographer Killed in Salvador

San Salvador

John Hoagland, an American photographer working on contract for Newsweek magazine, was killed yesterday during a gunbattle between leftist guerrillas and army troops north of the capital.

Hoagland was with Time magazine photographer Robert Nickelsberg, traveling on a road to cover a guerrilla attack on Suchitoto, 27 miles northeast of the capital, when they were caught in a crossfire.

Nickelsberg said they they had walked about a mile with the soldiers when they were ambushed by guerrillas.

"We got sprayed with bullets and one of them got him. We were pinned down for 45 minutes more, the soldiers retreated and they left us behind," Nickelsberg said.

Nickelsberg said Hoagland passed out within 10 seconds after he was hit and never regained consciousness. "He said, 'I've been hit.' That's all."

The Time photographer said he was unable to move Hoagland until an hour after the shooting — when guerrillas arrived and told him he could take Hoagland away.

Nickelsberg and members of a nearby CBS crew carried Hoagland to their car and took him to a hospital, where he was pronounced dead on arrival.

Nickelsberg said that because of the very heavy fire he was uncertain which side fired the shot that killed Hoagland, but he added: "It could very well have been the guerrillas. It came at an unexpected angle."

Hoagland, 36, a native of San Diego, was the second Newsweek photographer killed in El Salvador.

He turned to photography after working for several years in San Francisco as a structural steel welder.

He had been working in Central

JOHN HOAGLAND
He worked for Newsweek

America for about five years. He was also employed by the Gamma-Liaison photo agency. He was divorced and had one son.

He traveled among guerrillas and government troops alike, and was frequently in combat areas. He was wounded in El Salvador in 1981, when a car in which he was traveling hit a mine.

He was jailed in San Salvador in April 1982 in a $12,000 civil dispute, but was released nine days later through the efforts of U.S. Representative Ron Dellums, a Berkeley Democrat. Hoagland had worked for the Associated Press as a freelancer, covering the civil war in Nicaragua that ended with the overthrow of President Anastasio Somoza by the leftist Sandinista National Liberation Front in July 1979.

Newsweek's Pam Jones said in New York that four of Hoagland's photographs have appeared in the magazine's cover in the last six months.

Associated Press

Figure 15: AP, March 17, 1984

ART CENTER COLLEGE OF DESIGN LIBRARY

Figure 16: *Time*, July 4, 1983

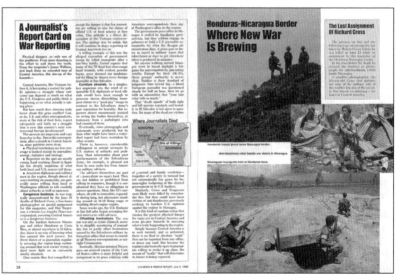

Figure 17: *U.S. News & World Report*, July 4, 1983

John Hoagland: June 15, 1947–March 16, 1984

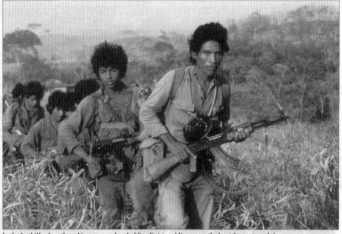

In the foothills of northern Nicaragua, a band of Sandinista soldiers go on the hunt for contra rebels

Photos by John Hoagland—Gamma-Liaison

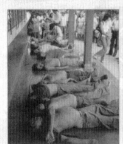

Victims of El Salvador's death squads

A Salvadoran refugee clings to her last possessions—and a symbol of faith

From every capital and backwater in Central America, the odd-hours phone calls would come jangling in. "What's cookin' this week?" the easygoing voice would ask. And ringing off, John Hoagland would sprint to one more hot spot. At 36, he was a lean man with a bag of cameras, inquisitive eyes and a friendly grin that betrayed his don't-tread-on-me mustache. When his name appeared on death-squad hit lists in El Salvador, he said, "This is my home," and stayed, covering wars, politics and the sufferings of ordinary people with a masterful lens and a bottomless store of courage. He died last week on a road near the town of Suchitoto, killed in a fire fight between Salvadoran troops and rebels. His family, his friends and his colleagues at NEWSWEEK will miss the power of his work and the gift of his company.

Figure 18: *Newsweek*, March 26, 1984, John Hoagland obituary

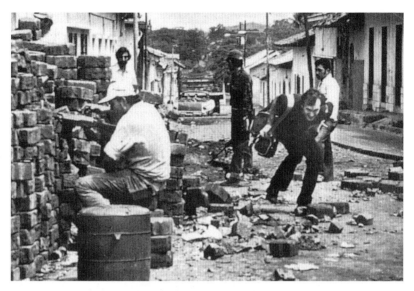

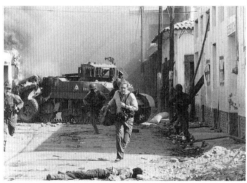

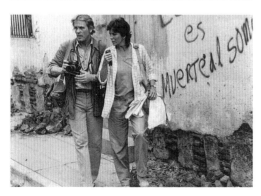

Above: John Hoagland,
*Richard Cross Runs
for Cover,* 1979
Left and bottom:
Stills from Roger
Spottiswoode's 1983
film *Under Fire*

Information is power, and it *will* be manipulated by the powerful. The genius of contemporary postmodern propaganda lies in its ability to appropriate the signs of individual choice, with a view to limiting that choice to such a narrow spectrum as to render the choice meaningless.

Figure 19: *U.S. News & World Report*, July 4, 1983

Publicity has another important social function. The fact that this function has not been planned as a purpose by those who make and use publicity in no way lessens its significance. Publicity turns consumption into a substitute for democracy. The choice of what one eats (or wears or drives) takes the place of significant political choice. Publicity helps to mask and compensate for all that is undemocratic within society. And it also masks what is happening in the rest of the world.

Publicity adds up to a kind of philosophical system. It explains everything in its own terms. It interprets the world.[25]

In the nineteenth century, the problem of opinion formation through the expression of thought was essentially a problem of contacts between the State and the individual, *and a problem of* acquisition of a freedom. *But today, thanks to the mass media, the individual finds himself outside the battle. . . . What we have is mastery and domination by the State or by some powerful groups over the whole of the technical media of opinion formation . . . the individual has no access to them . . . he is no longer a participant in this battle for the expression of free ideas: he is the stake.*[26]

1987

NOTES

1 Statement by Bertolt Brecht in 1931, in the tenth anniversary issue of *A-I-Z* magazine, quoted in Douglas Kahn, *John Heartfield: Art & Mass Media* (New York: Tanam Press, 1985), p. 64.

2 Herbert J. Gans, *Deciding What's News: A Study of CBS Evening News, NBC Nightly News, Newsweek, & Time* (New York: Pantheon, 1979).

3 Ibid., p. 182.

4 Ibid., p. 190. We are reminded here of Louis Althusser's warning in "Ideology and Ideological State Apparatuses (Notes Towards an Investigation)": "[T]hose who are in ideology believe themselves by definition outside ideology: one of the effects of ideology is the practical denigration of the ideological character of ideology by ideology: ideology never says, 'I am ideological.'"

5 Ibid., p. 312.

6 John Berger with Jean Mohr, *Another Way of Telling* (New York: Pantheon, 1982), p. 100.

7 Roland Barthes, *Image-Music-Text* (New York: Hill and Wang, 1977), p. 38.

8 It is very difficult to track the appearances of a particular photographer's images in magazines and newspapers. There is no listing or index by name in the photo credits. If the name "John Hoagland" or "Richard Cross" is entered in the available data files, one receives only their obituaries. Finally the images must be traced by reference to their commodity status, in the sales records kept by photo agencies.

9 Walter Lippmann, *Public Opinion* (New York: Free Press, 1965), p. 54.

10 A. P. Foulkes, *Literature and Propaganda* (New York: Methuen, 1983), p. 1.

11 Andrew Selsky, "Nicaraguan 'people's court' to try American," *San Francisco Examiner*, October 17, 1986.

12 Foulkes, *Literature and Propaganda*, p. 6.

13 Jacques Ellul, *Propaganda: The Formation of Men's Attitudes* (New York: Vintage, 1973), p. 118.

14 Ibid., p. 121.

15 Ibid., p. 103.

16 Ibid., p. 58.

17 Richard Cross, letter to James Vance, publisher of the *Worthington* (Minnesota) *Daily Globe* and Cross's first employer. The quote appears in "His Last 'Hurrah': Experienced Freelancer Richard Cross Unlikely Victim of Central American War," *News Photographer*, January 1984, p. 14.

18 Jim Gordon, "Photographers of the Vanguard," in *News Photographer*, vol. 36, no. 8 (September 1981), p. 20.

19 Ellul, *Propaganda*, p. x.

20 John Berger, *Ways of Seeing* (New York: Penguin, 1977), p. 130.

21 Ibid., p. 112.

22 Paul Berger, *Seattle Subtext* (Rochester, NY: Visual Studies Workshop and Real Comet Press, 1984).

23 H. D. Lasswell, in Carl J. Friedrich, ed., *Totalitarianism* (New York: Grossett and Dunlap, 1964), p. 367.

24 John Berger with Mohr, *Another Way of Telling*, p. 7.

25 John Berger, *Ways of Seeing*, p. 149.

26 Jean Rivero, "Technique de formation de l'opinion publique," in *L'Opinion Publique* (1957), quoted by Ellul in *Propaganda*, p. 237.

EPIPHANY
OF THE OTHER

The light was there, illuminating the roses and the portrait, and flags around them, perhaps, bundled up, in the humblest popular solemnity. . . .

—Pier Paolo Pasolini, *The Divine Mimesis*[1]

The photographs of Sebastião Salgado leave remarkably durable afterimages that reappear long after one walks away from them. One that recurs to me often is from a Mexican cemetery. Centered in the foreground is a mongrel dog, seated like a sphinx on the raised concrete slab of a gravestone. Lighted tapers and funereal flowers surround him as several cloaked mourners move off into the mist above. The closest mourner glances over her shoulder at the devoted dog, whose humble offering has stopped time. It is an image of great solemnity, but it is not at all ponderous or stale. The dog will soon rise and trot away, sniffing the bases of the stones, and the other mourners will begin their long work days, as usual.

In one of Salgado's magnificent images from the Serra Pelada gold mine in his native Brazil, one worker pauses briefly amid the hiving bodies in the pit. The resting worker's stance—feet together and arms folded, backed against an upright timber—evokes a crucifixion, and the Boschian spectacle of the mine confirms this solemn evocation. But at the same time, and equally, the foregrounded man is never more nor less than a worker at rest. This extraordinary balance of alterity and likeness, of metaphoric and documentary functions, is part of the Salgado signature. It allows his subjects to be themselves and more than themselves at once.

Like the mud-covered miners of Serra Pelada, Salgado's images come up out of the earth, bringing the earth with them. From the

Sebastião Salgado, Cemetery of the town of
Hualtla de Jiménez. Mexico, 1980

sands of the Sahel to the mountains of Ecuador and Bolivia, his frames are filled with earth and the people who live close to the earth, who know how hard it is to make a living from it.

One of the most telling differences between these photographs and those of one of Salgado's principle progenitors, W. Eugene Smith, is the comparative *cleanliness* of the latter's images. Even when photographing the smudged faces of coal miners in Wales, Smith made the lines clean and the contrasts sharp. Despite all the "Family of Man" rhetoric applied to Smith's oeuvre, he was an illuminator of contrasts more than of commonalities. Most of his essays tend to focus on individual heroes rising above the mediocrity that surrounds them. Smith's subjects are pulled up out of relation into his photographs, while Salgado's subjects are seen only and always *in relation*.

If there is a family of man today, most of its members live in the Third World, and Salgado is its family photographer. He has said that the world's goods are produced by "one family" that is spread out all over the world, and for his epic documentation of the end of large-scale manual labor in mining and other industries due to mechanization, he has photographed laborers in the Soviet Ukraine, Brazil, Cuba, India, Bangladesh, Poland, and Venezuela. This massive undertaking, which Salgado calls "the archaeology of the industrial age," is intended to be "a kind of homage to the working class and the old ways of producing that are disappearing."[2] He works at a grueling pace, obsessively driven to document the workers of the world before they disappear, as the second industrial revolution sweeps them before it like sand. Like all great documentarians, Salgado has a passion to *save* an image of these people and these particular ways of living before they vanish forever. The impulse is essentially conservative. But unlike lesser practitioners who are drawn only to the drama and the tragedy of loss, Salgado's understanding of the geopolitical and economic backgrounds of the situations he documents gives his images an urgency of address. Single images may appear nostalgic, but relations among the images in Salgado's ongoing essays reveal a conflicted and often concealed history.

44

Behind the epic grandeur of the Serra Pelada images lies the history of European exploitation of Latin America. Greed for gold and silver motivated the Conquest. On October 13, 1492, one day after stumbling upon the New World and discovering he was lost, Columbus wrote in his diary: "I was attentive and worked hard to know if there was any gold." Later on he refers to the purpose of his trip as "our activity, which is to gather gold."[3] Gold and slave labor have always gone together. It was Brazilian gold that allowed England to confront Napoleon. As Eduardo Galeano concludes: "The Indians have suffered, and continue to suffer, the curse of their own wealth; that is the drama of all Latin America."[4]

> *Everyone knows that when the exploiters (by means of the exploited) produce goods, in reality they produce human beings (social relations).*
>
> —Pasolini, *Lutheran Letters*[5]

The exploitation that Pasolini decried in Italy is now happening on a global scale. Pasolini identified a guiding principle common to both the old Fascism in Italy and what he called the "new Fascism" of consumerist conformism, namely, "the idea that the greatest ill in the world is poverty and that therefore the culture of the poorer classes must be replaced by the culture of the ruling class."[6]

Most photojournalism and "social documentary" photography originating in the United States begins from this assumption. The photographer operates as a distanced, superior, "objective" witness to war, poverty, labor, and exotic cultural practices in other parts of the world. There is a big market for this kind of photography. As Galeano notes: "Poverty is a commodity that fetches a high price on the luxury market."[7] Photographs taken from this position may elicit pity, sorrow, or guilt in their viewers, but they will never provide information for change. They only work to reinforce the construction of the center and the periphery; north and south, rich and poor, superior and inferior. It cannot be otherwise. As Salgado says: "You photograph with all your ideology." [8]

What sets Salgado's images apart from most social documentary work is his relation to the other. Because of his background in Brazil and his understanding, as an economist, of the social and political background of the people and situations he photographs, his relation to his subjects is substantially different, and he has found a way to register this difference photographically.

The exploitation of the other that occurs in most (North American and European) documentary photography is partly a result of the political relation of photographer to subject. The difficult questions arising from such representations do not disappear with Salgado's images; they are in fact intensified, clarified, and made more insistent. The static that allows us to turn away from other photographs of starving people, for instance—their exploitation, crudity, and sentimentality—will not protect us from Salgado's images. We are, in turn, put in a different position in relation to the faces in these photographs, and we are forced to acknowledge that relation.

At the same time, Salgado's devotion to the people he photographs often transforms them into images of the sacred. A coal miner in India, with his lighted hat and pilgrim's staff, could be Saint James in a fifteenth-century illumination, and the skeletal corpses of the Sahel in their winding clothes resemble the ones fought over by guardian angels and demons in a medieval Book of Hours. The three angels of Juazeiro do Norte, the Condor-men of Ecuador, and Lot's wife in Mali in 1985 (see page 4) are all depicted in transformation, as aspects of the divine.

The spiritual issues involved in the struggle between cultures are dealt with in Salgado's many depictions of spiritual practices, from Coptic burial rites in Ethiopia to Tarahumara trance and animal sacrifice; from first communion in Brazil to a thanksgiving prayer to the Mixe god Kioga in Oaxaca.

These images of spiritual transcendence are perhaps the most troublesome for contemporary North American viewers, who are accustomed to that materialist dualism that finds a contradiction between radical politics and metaphysics, between history and mythology, between justice and transcendence. This materialist fix does not

hold away from the center. The Argentinian philosopher and historian Enrique Dussel might have had Salgado's photographs before him when he wrote:

> *Beyond phenomenology the road of epiphany opens: revelation (or apocalyptic) of the other through the other's face, which is not merely a phenomenon or manifestation, a presence, but an epiphenomenon, vicarious, trace or vestige of the absent, of the mysterious, of one beyond the present. Ontology (phenomenology) gives way to metaphysics (apocalyptic epiphany of the other). . . . epiphany fulfills itself as a revelation of the one who makes decisions beyond the horizon of the world or the frontier of the state.* [9]

The sacred lies behind nearly every image in Salgado's most difficult series: his photographs from the famine-ravaged Sahel region of Africa in 1984 and 1985. Salgado did not set out to make sacred images, any more than the military photographers who documented the liberation of the death camps in Poland did. He set out, as a dedicated documentarian, to show the world what was going on so that they would pressure their governments to put a stop to it. Unlike the hundreds of "shooters" from all over the world who dropped in to "cover" the famine, Salgado became involved at a different level. The political repression following the military coup in Brazil in 1964 forced Salgado to flee to Paris with his wife in 1969. A radical student activist, Salgado's passport was revoked and he was not allowed to return to Brazil for ten years. Having already begun his education as an economist in Brazil, he continued this course of study in France, earning his doctorate at the University of Paris in 1971. He went to work for the International Coffee Organization, attempting to aid in the diversification of coffee production in Africa, in collaboration with the European Development Fund, the United Nation's Food and Agriculture Organization, and the World Bank. At some point, he took a camera he had borrowed from his wife to Africa and at age twenty-nine he made the decision that he could do more good for the people he was trying to help as a photographer than as a development economist. His first photographic assign-

ment was a report on starvation in Africa for the World Council of Churches in 1973. He began to work extensively in Latin America and other parts of the world for the Sygma and Gamma photo agencies, finally joining Magnum in 1979.

While working on a series documenting the effects of famine in northern Brazil, Salgado realized that this was a world problem and needed to be approached as a world problem. In 1984, the French medical relief group Médecins sans Frontières (Doctors Without Borders) asked Salgado to return to Africa to record the famine relief work they were doing. He photographed in the huge refugee camps in the Sudan and elsewhere in Ethiopia, Chad, and Mali for fifteen months, traveling with medical teams and living with the dying. In an interview dealing with his experiences in Ethiopia, Salgado said:

> *What I found was beyond my imagination. In the first camp I visited, there were 80,000 people. They were starving. You would see the debris of the dying—bodies of men and women and many, many children. More than 100 people were dying every day.*
>
> *In the first few days at a camp like this, making photographs was impossible, because of the emotional situation. You are too stunned to shoot. But after a few days you stop crying. And after a few more days you know you have a job to do. It is a job just like the job of the doctors who have come to treat the sick or the engineers who have come to build housing.*[10]

It is not easy to look at these documents from the Sahel, but looking, one realizes how very different they are from other photographs of starving people in Africa. Whereas those other images end at pity or compassion, Salgado's images begin at compassion and lead from there to further recognitions. One of the first of these further recognitions is that starvation does *not* obliterate human dignity. A young boy, naked and gaunt, stands nevertheless tall, supported by a walking stick, rhyming shadows with a tree. A mother in an Ethiopian refugee camp, her bald skull mapped with pain, cradles her clear-eyed child and waits, defiantly. Salgado did not photograph passive victims, and pity does not suffice.

Salgado desperately wanted these images to be published and widely distributed at the time they were made, to raise a cry of alarm. Even though by that time, 1985, Salgado was winning prize after prize and his work was being published in all the top news magazines (his inconsequential photograph of John Hinkley's inept assassination attempt on Ronald Reagan was published thousands of times all over the world), the photographs from the Sahel were judged to be "unsaleable" in most markets. Though they were published as a book in France under the title *L'Homme en détresse* (Man in distress) in 1986, and in Spain as *El Fin del Camino* (The end of the road) in 1988, very few of them were published in the United States at the time (aside from two pages in the *New York Times* and four pages in *Newsweek*). Salgado's editor, curator, and collaborator, Fred Ritchin, has commented on the irony that these documents, which were judged by publishers and most magazine picture editors to be "too disturbing" when they were made, can only now, five years later, be seen, in a museum retrospective exhibition of a "famous" photographer.[11] Ritchin calls this evidence of "an unfortunate tendency to elevate the messenger while denying the message."[12]

At a time when the "message" and even the evidential veracity of documentary photography itself is disappearing into the pixels of digital imaging, and the efficacy of social documentary photography is being fundamentally questioned, the photographs of Sebastião Salgado appear almost as a new kind of document, with a very different address and relation to the other, and yielding quite different information about difference. Eschewing entirely the vaunted "objectivity" of photojournalism, Salgado works in the realm of collective subjectivities, aspiring to that "transcendence of self which calls for epiphany of the Other."[13] It is an aspiration that could breathe new life into the documentary tradition.

1991

NOTES

1 Pier Paolo Pasolini, *The Divine Mimesis*, trans. by Thomas Erling Peterson (Berkeley: Double Dance Press, 1980), p. 5.

2 Sebastião Salgado, in an interview with John Bloom, *Photo Metro 9*, November 1990, p. 4.

3 Tzvetan Todorov, *The Conquest of America: The Question of the Other*, trans. by Richard Howard (New York: Harper & Row, 1984), p. 8.

4 Eduardo Galeano, *Open Veins of Latin America: Five Centuries of the Pillage of a Continent*, trans. by Cedric Belfrage (New York: Monthly Review Press, 1973), p. 59.

5 Pier Paolo Pasolini, "Intervention at the Radical Party Congress," *Lutheran Letters*, trans. by Stuart Hood (London: Carcanet, 1983), p. 123.

6 Ibid., p. 16.

7 Eduardo Galeano, "Salgado, 17 Times," trans. by Asa Zatz, in *Sebastião Salgado: An Uncertain Grace* (New York: Aperture, in association with the San Francisco Museum of Modern Art, 1990), p. 11.

8 Salgado, quoted in Fred Ritchin, "The Lyric Documentarian," in *Sebastião Salgado*, p. 147.

9 Enrique Dussel, *Philosophy of Liberation*, trans. by Aquiliana Martinez and Christine Markovsky (Maryknoll, NY: Orbis Books, 1985), p. 58.

10 Salgado, in "The Sight of Despair," *American Photo*, January/February 1990, p. 40.

11 If then NEA chairman John Frohnmayer had had his way, they may not have been seen there either. I refer to a statement Frohnmayer made in August of 1990 that a display of images that "leads to confrontation . . . would not be appropriate for public funding." Asked to clarify, he gave the example of a photograph of Holocaust victims displayed "in the entrance of a museum where all would have to confront it, whether they chose to or not." ("Don't Confront the Holocaust?" *Time*, August 13, 1990).

12 Ritchin, "Lyric Documentarian," p. 149.

13 Emmanuel Levinas, *L'Humanisme de l'autre homme* (Montpelier: Fata Morgana, 1972).

AN ALCHEMICAL
DISTURBANCE

I was young, I don't remember how young exactly—old enough to read. In the public library one day I happened upon something called the "picture file." Near the front of the first drawer was a folder marked "Atrocities," and inside were five murky photographs from Nazi concentration camps. Bulldozers moved mountains of dead bodies, naked and tangled, toward large open graves. The photographs had been copied and recopied many times from already old, spotted prints, but enough of their dark light remained to hold me spellbound.

I came back to these photographs again and again. I examined them, I stared at them, I imagined them when my eyes were closed. My attraction to these images was not prurient or political (I didn't know what they referred to), but religious. I knew that they held truths far beyond what Mrs. Zeiss had been teaching us in Sunday school, and I hoped that by looking at them long enough and hard enough, these truths would be revealed to me.

We're here, we're living, because we're not completely clear, we have to become clear. The darkness within us sometimes is so dark that for me it becomes very fascinating.

What I really want is this really humble, individual connection, not with a religious institution, but with the living Christ. Whatever it takes in a positive way to get there, I'll get there. The best means, it seems, of getting there is the aesthetic means of photography.

—Joel-Peter Witkin in *Interview*, July 1985

I first saw Joel-Peter Witkin's photographs in 1977, in the "Photo-erotica" show at Camerawork Gallery. The show generated a book,

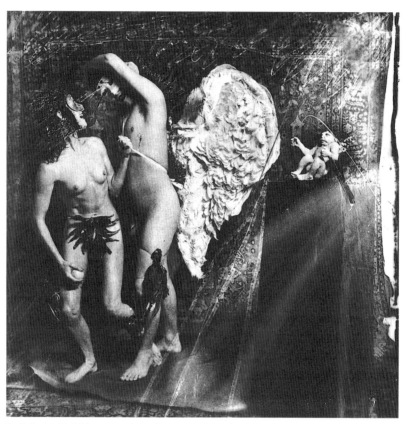

Joel-Peter Witkin, *Expulsion from Paradise of Adam and Eve,* 1981

Eros & Photography, edited by Donna-Lee Phillips and Lew Thomas, which featured Witkin's "erotic dream" images on the cover and inside. After numerous individual and group shows, his solo exhibition at the San Francisco Museum of Modern Art in 1985 (traveling to Chicago, Brooklyn, Milwaukee, and La Jolla), four books published by Twelvetrees Press, numerous catalogs, and a major retrospective curated by Germano Celant at the Guggenheim Museum in 1995, Witkin has now reached a wide audience.

His photographs have always operated by causing disturbances in the viewer. These disturbances derive from the inherent properties of the medium. People *believe* what they see in photographs. The imagination is thought to be yoked to the material world, to "reality," in a quite different way than with painting. And responses to Witkin's work, varied as they are, always address the fact that they are *photographs* and thereby represent the *actual*. People ask: Who are these people? Why are they doing these things? What is the relationship between these people and the photographer? Is that dog alive or dead? Did this hurt? And these questions are asked differently and have a different weight than if they were asked of the work of Bosch or Goya or Bacon.

Christian Metz points out that it is "the powers of silence and immobility which belong to and define all photography," and which allow the emergence of the *fetish*. "The photographic *take* is immediate and definitive, like death and like the constitution of the fetish in the unconscious, fixed by a glance in childhood, unchanged and always active later."[1]

Witkin has said he wants his photographs to be as powerful as the last thing a person sees or remembers before death. His often-repeated "first conscious recollection," of an encounter with a freshly severed head at age six on the way to church with his mother, would fit quite neatly into the Freudian model of the origin of the fetish and with the definition of fetishism as "aberrant habitual sexual excitement associated with an inanimate object or a bodily part." But that doesn't necessarily bring us any closer to understanding our own responses to the photographs.

Most of the responses I've heard to Witkin's work are more ethical or moral or religious than aesthetic. People don't just say, "I like them" or "I don't like them." They say, "I *object* to them. I think they're *wrong*." Others seem to be disturbed most by their own reactions to the photographs. They are so beautiful and yet so . . . disgusting. So fascinating and yet so . . . repulsive.

In his preface to the first Twelvetrees book, Witkin says he uses an aesthetic language "which engages profound emotional dichotomies within the viewer." Witkin's photographs *do* engage profound emotional dichotomies. Many viewers are not at all pleased to be put in this position. Their reactions have become more and more vociferous as Witkin's notoriety has increased, and as his images are more widely seen.

These images are mostly portraits, as Witkin says in the same Twelvetrees volume, "not of people, but conditions of being," and tableaux of mythic scenes and figures, either classical or biblical—*Venus, Pan & Time, Expulsion from Paradise of Adam and Eve, The Wife of Cain*—or of the artist's own invention. There are numerous images in direct homage to particular well-known paintings, prints, and photographs, by Botticelli, Canova, Baron von Gloeden, Picasso, and others, as well as dozens of other visual allusions to the art of the past. In Witkin's rambling commentary on the images in the San Francisco show, which appeared as part of Van Deren Coke's catalog Introduction, he sounds at times like one unstuck in time, a contemporary of Bosch or of Sade. Like Bosch, Witkin's imagination is stimulated by abnormality and deformity, by the bestial and depraved. The photographs have a visceral impact far in advance of any extra-aesthetic effect.

From Van Deren Coke's Introduction we learn that Witkin has a twin brother (the painter Jerome Witkin); that his father, an orthodox Jew, and his mother, a Catholic, were divorced due to religious differences; that his first photographic effort, at the freak show at Coney Island, coincided with his first sexual experience (with a hermaphrodite); that he was a sculpture major at Cooper Union; and that he was drafted during the Vietnam War, enlisted for three years

54

to be trained as a combat photographer, and spent those years recording army deaths resulting from accidents on manoeuvres and suicides. In 1975, at the age of thirty-six, Witkin began graduate studies in photography at the University of New Mexico in Albuquerque.

The picture that emerges from these bits and pieces of biography is that of one who has been pursuing his vision for some time. A dedicated student of those twin instructors, excess and extremity, he is drawn to and draws his literal subjects from the lost and despised. Out of an extreme sensitivity to the essential properties of the medium of photography, he has gradually fashioned a method of materializing his visions into photographic prints in which all surface manipulations add to the emotional and visual impact of the image. At its best, Witkin's work bears witness to the mysterious and difficult process of creative transformation. He says:

> *I have consecrated my life to changing matter into spirit with the hope of one day seeing it all. Seeing its total form, while wearing the mask, from the distance of death. And there, in the eternal destiny, to seek the face I had before the world was made.*

1986

NOTE

1 Christian Metz, "Photography and Fetish," *October* vol. 34, Fall 1985.

BROKEN WINGS:
THE LEGACY OF LANDMINES

In 1995, my friend the photographer Bobby Neel Adams invited me to come to Cambodia with him, and to write about the landmines problem for a book he wanted to do. He had already been working in Cambodia and Vietnam for five years, with Bobby Muller at the Vietnam Veterans of America Foundation's Kien Khleang clinic, Patty Curran at Maryknoll's clinic at Wat Than, and with various mine-clearing groups, especially the Mines Advisory Group. Adams had also been to Mozambique with Physicians for Human Rights, to document the problem there. We wanted to reveal the faces and stories of the "personnel" affected by mines, in the hope that this would hasten the adoption of an international ban on the manufacture and sale of antipersonnel mines.

Cambodia now has the highest percentage of disabled inhabitants of any country in the world. Walking through the streets of the capital city Phnom Penh, it is unusual to go for more than a few minutes without seeing someone missing an arm or a leg. In the refugee villages on the Thai border, that time span is considerably shorter. It used to be that when a war ended, the enduring wounds were mostly internal. But Cambodia's dismemberment is visible and continuous. The reason for this is that the primary weapon in Cambodian conflicts has been the antipersonnel landmine.

The Cambodian conflict may be the first in history to have more people killed and injured by landmines than by any other weapon. Mines have been the weapon of choice for all parties involved in the war since the Vietnamese invaded in 1979, but mines were

Bobby Neel Adams, Mozambique; from *Broken Wings*, 1992

also in use in Cambodia more than a decade earlier. Today, the Cambodian earth is seeded with some thirty years' worth of mines, and most of these have yet to claim their victims.

After the conflicts of the 1970s and 1980s subsided, it was thought that the killing and wounding would at least slow down. But mines recognize no cease-fire, no treaty, no change of governments. They send no representative to the peace talks. In military parlance, they are "blind weapons in relation to time."

There are now more than forty thousand amputees in Cambodia (one out of every 234 Cambodians), and their ranks are growing at the rate of about six thousand per year. These, of course, are just the survivors. At least that many more die each year after stepping on mines. Some die quickly, from the blast, but most die slowly, from the combined effects of blood loss and exposure. Transportation is difficult, and it is often a long way to the nearest hospital. Most of these mine victims are rural civilians. About half are women and children. They are blown up while working in their fields, herding their livestock, fishing, gathering firewood, or playing on the ground. An American prosthetist recently observed that "Cambodia is being de-mined an arm and a leg at a time."

One doesn't speak of "minefields" in Cambodia, since that term has an air of formality that does not exist there. There are minefields *upon* minefields, a patchwork palimpsest of death and destruction. Under the once rich earth lies a material history of hostilities. In the same area one might find: an OZM-3 mine made in the USSR from the early years of the Vietnam War, put there by North Vietnamese soldiers to protect their base camps along the eastern border; a grouping of Chinese-made mines around a tree, placed there by the Khmer Rouge to trap Lon Nol troops in the early 1970s; and M16A1 mines made in the United States, put out more recently by one of the resistance groups retreating from the Phnom Penh government army. When the *New York Times* reported in June 1997 that Pol Pot was on the run, hunted by his own men, they noted with irony that the Khmer Rouge dictator,

who had once forced the entire population of Phnom Penh out of their homes and into the countryside where more than a million were killed, "finds himself now in a harsh and dangerous region of dense jungle that is one of the most heavily mined areas in the world."

For the past twenty-five years—from the massive aerial bombardment by the United States in the early 1970s, to the murderous rule of the Khmer Rouge from 1975 to 1979, to the devastation and civil war that followed—the Cambodian people have been tortured by war. Even when peace seemed a possibility, one had to ask what that peace would mean if the 480,000 refugees and displaced persons on the northern border returned, not to a homeland, but to one vast minefield? As one independent Cambodian mine-clearer said: "There is nowhere without mines. There are mines from here to the hills. The land has become narrow."

Landmine injuries are particularly gruesome, and are among the most difficult war wounds to treat. In addition to severing limbs, the blast up from the ground forces bits of dirt, rock, metal, shoes, and clothing deep into the wound. Infection spreads quickly. The shock wave from the blast causes blood to coagulate far from where the wound appears, so doctors often have to amputate higher than the site of the wound.

If they are not killed by the blast itself, and if they do not bleed to death before help arrives, mine victims are typically made to endure six to eight separate operations before their wounds are sufficiently clean to allow healing. If they were unlucky enough to have stepped on a mine with a plastic casing, they are in for even more extensive exploratory surgery, because plastic shrapnel does not show up in X-rays. If pieces of these more recently produced mines are missed, later they often cause serious infections, including osteomyelitis.

It is not always clear that survivors of mine blasts are the lucky ones. In a rural society that runs on physical labor, amputees who cannot work as productively as others are seen as a burden on their

families. Disabled children are often abandoned. Female amputees are less desirable as wives because they cannot work. Many employers will not hire amputees, no matter how skilled they are. In some cases, male amputees have not been allowed to become Buddhist monks because they are no longer "whole."

A number of the men I interviewed at Kien Khleang clinic outside of Phnom Penh in 1995 told me they had tried to kill themselves immediately after being blown up by a mine. Without exception, it was the first thing they thought of after realizing what had happened to them: how to kill themselves or get someone else to do it.

Far from the embarrassed awkwardness of the "differently abled" and "mobility impaired" euphemisms, these people are known in Cambodia as *cripples*, pure and simple. Rather than continue to burden their families, many Khmer mine victims drift to Phnom Penh where they become beggars and petty thieves, drunks or suicides. Only one in eight amputees receives an artificial limb, and most of these are soldiers. Civilians often fashion limbs out of wood or scrap metal, or just become accustomed to crutches.

All mine victims have one thing in common: their identities were utterly transformed in the moment it took for a landmine to register their presence and explode. Their new identity is traceable to no decision on their part. They are randomly selected.

Yavany is thirty-seven years old and blind. He picked up an AK49 mine on the ground to clear a path in 1988. When he tried to remove its fuse it exploded, blinding him. He still has dreams of the explosion, but they are slowly being replaced by dreams of his parents and grandparents. His three children are also in his dreams, but he never sees their faces; he cannot see their faces because all of his children were born after he was blinded.

After one spends some time with Bobby Neel Adams's photographs of these individuals, and then looks away, what tends to remain is the *eyes*. In most of the photographs, the people look directly back into ours. The look is sometimes confrontational, sometimes kindly, always straightforward. There is very little posing. Even the sightless

eyes of Yavany, the blind AK47-toting guard at the Kien Khleang clinic, seem unflinching in Adams's portrayal of him. One can see in these eyes the trauma of landmines, the incomprehensibility of this kind of wounding: Why was my leg blown off? What did I do to deserve this? Who is responsible for my injury, for my life being shattered in this way? Who will receive my anger?

The particular cruelty of landmines stems from their indiscriminate nature. A mine makes no distinction between an enemy soldier and a child looking for firewood; it will apply the same deadly force to each body that happens upon it, be it man, woman, or child, friendly or unfriendly, combatant or civilian. In addition to the immediate injuries, the more lasting trauma of anonymous, meaningless, random violence can be observed in the countries most affected by landmines. In these places one observes a range of emotions surrounding landmines—fear, sadness, panic, guilt, revulsion, anger, resignation, fascination. The last of these makes children especially vulnerable to mines. The devices themselves do not look evil or cruel. They look like toys.

Victims are not statistics. They are human beings, no more innocent or guilty than we are. Yet they have been singled out for dismemberment. Why is that? Cruelty, the shadow of force, can often be more effective than force itself. One can see force coming and perhaps counter it. But cruelty introduces an uncertainty to the application. A military question: Why blow off the feet and legs of innocent children? Answer: Because the *cruelty* of this has a dramatic effect on the populace. It makes them think. It is unsettling in a way that direct force is not. An advertisement for Pakistani mines put it in practical, marketing terms: "Research has shown that it is better to disable the enemy than kill him."

MOZAMBIQUE: "DUMBA NENGUE"
("YOU HAVE TO TRUST YOUR FEET")

In Bobby Adams's photograph of a family in Tica, Mozambique, Isabella sits in a wheelchair with her daughter on her lap, the child's legs occupying the space where her mother's legs used to be. Isabella

lifts her own chin, proud of her children, but her eyes show the pain. Her daughter sits straight up and looks into the camera's lens with a look so direct, so self-possessed, that one is helpless before it. To the right stands the woman's young son, arms crossed over his chest. His anger is as big as a continent.

In Mozambique, Renamo, "the Contras of southern Africa," liked to come in and scatter small landmines around on paths in the villages at night. The first person on that path in the morning—usually a child—would lose a foot or a leg or a hand or an eye. Then the rest of the villagers would know that they were not safe, and that Frelimo, Renamo's opponents, could not protect them. In addition, people badly injured by mines add another burden to the government's limited medical resources. These tactics were apparently copied from Angola, where UNITA (Jonas Savimbi's group, supported by the apartheid regime in South Africa and by the United States in the 1980s) used landmines as a destabilizing weapon very effectively. As one UNITA official said, "Control over the means of destruction . . . was more decisive in a situation of technical underdevelopment than was the control over the means of production."

The Mozambican government has laid mines all along the South African border, both to deter incursions from South Africa and to discourage runaways. The borders are thick with Russian-made "jumping jacks" that can cut a person in two at the waist. Bleached skeletons that line the border like macabre sentries are a testament to their effectiveness.

Mines are a brilliantly cost-effective weapon. A mine that can be purchased for as little as three dollars (or received in military aid from the United States, Russia, or China) will cause many times that sum in damages on the other end. This is called "the multiplier effect." Even if the mine doesn't claim a victim, it will cost the enemy up to one thousand dollars to find and clear it. In many ways, the mine is the ideal weapon of terror. It is cruel and effective, "deniable" (untraceable), indiscriminate, timeless, and inexpensive.

With all of the propaganda about "smart bombs" and "surgical strikes" in Desert Storm, the prominent place of antipersonnel landmines in the Persian Gulf War of 1991 was obscured. Hundreds of thousands of ADAM-type mines (Area-Denial Artillery Munitions) were fired from howitzers into Iraq and Kuwait. The Kuwaiti government budgeted $700 million to hire private mine-clearing contractors to undo the damage. Large portions of the Falkland Islands still conceal mines that were laid a decade ago in a war that lasted only two months. It was determined that the cost of removing the mines is prohibitive, so they were left in place *for all time*, in areas now regarded as permanent no-go areas.

The word "mine" derives from the practice in ancient warfare of tunneling under the walls of a besieged city. It was an invasive tactic to "undermine" the enemy's defenses. In addition to sowing salt around Carthage to ensure its long-term subjugation, the Romans also sowed metal balls with protruding spikes to hinder enemy cavalry. The use of modern mines began in World War II, when first antitank and later antipersonnel mines were used to deny access to military and other targets.

There are many military leaders who still defend the use of antipersonnel landmines. They contend that if landmines are used "responsibly" according to the rules of war, they are not a humanitarian problem. Some of these leaders were involved in drawing up the existing "International Landmine Protocol," signed by the United States and fifty-two other countries in 1982, prohibiting the direct use of mines against civilians and their "indiscriminate use," the remote delivery of mines, and with a commitment to map minefields.

But the fact is that mines are not used "responsibly" anywhere. And if mines continue to be produced, stockpiled, and distributed, their use inevitably will not be limited to barrier defense. The use of mines has changed in the last two decades from a primarily defen-

sive weapon to an offensive and strategic weapon, used primarily as a terrorist device.

The defining fact about landmines is that they act independently of military tactics and political movements. If a mine victim in Cambodia or Mozambique is asked the question "Who did this to you? Who laid that mine?," they will invariably say they don't know. The original message that the mine was supposed to carry—from Renamo or Frelimo, the Khmer Rouge, or the Khmer People's National Liberation Front, or the Phnom Penh government—has worn off like a manufacturer's label by the time the mine is activated. The new message is only this: you are no longer safe, anywhere, anytime.

Just as landmines carry no signature, neither do they carry a time limit. People are being killed and maimed in Libya, Poland, and France to this day from mines laid during World War II. Many of the mine victims you see in Bobby Adams's photographs were not even born when the mines that crippled them were planted. Mines truly are weapons of mass destruction in slow motion.

Landmines are an indiscriminate but private form of violence. They kill or cripple one person at a time. There are currently 110 million active mines in the ground in more than sixty-eight countries, and two million new ones are laid each year. More than two thousand people are killed or maimed by these infernal machines every month. Behind these numbers are individual human beings, with faces, families, stories, hopes, and fears.

1997

A THRENODY FOR
STREET KIDS

In 1990, Jim Goldberg produced an installation dealing with street kids and memories of home for the Seventh Annual Art in the Anchorage show, sponsored by Creative Time, in New York, and he asked me to write something to accompany the installation. I wrote "A Threnody" and we had it printed up as a four-page handout. Also included were a political-action message ("What Can Be Done?") listing congressional records, contacts, and information on the Children's Defense Fund and the Child Welfare League, and a complete annotated list of services then available for runaways and homeless kids in New York, put together by the Empire State Coalition of Youth and Family Services. In the course of the exhibition, thousands of copies of the essay were distributed, and it was later printed in the Nation.

To seek for a threnos *we need not go to a hero's tomb.*
— Jane Ellen Harrison

One of my earliest childhood memories is of standing on the porch late at night, beating my forehead bloody against the white wooden siding of the house, cursing my drunken father within and repeating the words: "I *will* not be like him. I *will* not be like him." The mantra is as memorable as it was futile. Will aside, no child ever escapes his patrimony, though the desire to do so is fundamental and formative, countered always by the equally desperate desire to please one's parents and be worthy of their (withheld) love. Adolescence is the time when this conflict between differentiation and emulation erupts into schizophrenia and civil war. The need to belong and the need to establish an individual identity seem irreconcilable. Self-

Jim Goldberg, from *Raised by Wolves*, 1995

consciousness becomes a battleground. Society is a bad joke. No place like home.

Like the angel of forgetfulness who touches us at birth to make us forget so that we can be born (becoming is a secret process), there is another angel, I suspect, who touches us when we become adults, causing us to forget the abyss of adolescence. It is hard not to forget how difficult it was—much easier to idealize the state as a "simpler, less complicated" time, when we were "free of responsibilities." Home movies to replace nightmares.

In some strange way, our "adult" identity depends on this misremembering, so that when our own children remind us of the struggle, we react defensively, even violently. We do not want to be reminded of that pain. Haven't we spent all our subsequent lives trying to overcome it? If we open ourselves up to the lives of our children, won't we also be opening our own old wounds?

In stark contrast to the image of "home" as inviolate sanctuary still projected by American integration propaganda (advertising), *home* itself has increasingly become a site of violent conflict and abuse. Half of all homes in this country are "broken" by divorce; many more are broken by spousal abuse. Child abuse in the home is a national epidemic. Poverty kills twenty-seven children every day in America.

Every year in the United States, 1.5 million kids run away from home. Many of them end up on city streets. Contrary to popular belief, most of them run away not because they want to but because they *have* to; even the streets are safer than where they're running from, where many of them have been physically and sexually abused by their families. Even so, they are not running *to* anything but a likely death. Each year, more than five thousand children are buried in unmarked graves nationwide.

It's not the running away that is the problem. The truth is, kids can't run away. They can only run from one kind of abuse or neglect at home to another kind of abuse or exploitation by adults

67

on the street. For most kids, it's a closed system. The only way out is death or oblivion. The cycle is nauseatingly consistent and far-reaching. Nine out of ten prison inmates were abused as children. Our current response to this in the United States is to build more prisons and call for the death penalty. Is it any wonder that the only thing runaway kids have left to aspire to is the orchestration of their own oblivion through "self-medication" and suicide?

When one reads the statistics, when one listens to the case histories, it is difficult not to conclude that these thousands of kids are refugees from a war going on inside the American home and inside the American psyche. It begins to look like a kind of *progenicide*. Why are we at war with our own children? How did we get here? We seem to be as shell-shocked as they are, blinded by statistics and deafened by the enormity of the problem.

One of the secrets that adults keep is that wars are always fought by children. Lied to all their lives by adults, kids lie to themselves and one another about the "freedom" and glamour of life on the streets. Friendly pimps offer sanctuary, security, even "love"—in exchange for the hard currency of the streets. The street economy is reflective of the larger economy: it runs on greed from above and dreams from below. Kids run toward the ruined centers of the American Dream: Hollywood, Times Square. Even while sleeping in Salvation Army storage boxes and squalid squats, they talk about someday making it big on stage or screen. They lie about how they prostitute themselves and they lie about their addictions. They pretend to revel in the pursuit of sex, drugs, and rock 'n' roll—only the sex consists of endless encounters with lonely old men panting to pay a little extra crystal to "ride bareback" (no condom), the drugs are crack or unreliable street speed with dirty rigs and shared needles, and the rock 'n' roll is Guns N' Roses on a tinny blaster in a dead-end alley.

Treated like pariahs by adults, these kids cling to each other for comfort and acceptance. Abused by their fathers at home, they find new sugar daddies on the streets who'll *pay* to fuck them and tell them pretty lies about how much they're going to do for them. They

try desperately to act like predators so maybe they won't look quite so much like prey. Look in their eyes. These are *children*.

As if the usual perils of living on the street—pimp violence, trick violence, gang violence, overdose, hunger—were not enough, there is also AIDS. A kid cannot last more than a month on the street without hustling. Among those hustling every night, boys and girls, the rate of exposure to AIDS is estimated at 50 percent. Adolescents are one of the fastest-growing categories of people with new HIV infection.

So far, AIDS education hasn't worked on street kids. They have too little to lose and too tenuous a grasp of their own mortality. They are dying of AIDS for the same reason that they make such good soldiers in our wars. Already blamed for their appearance, their attitude, their sexuality or sexual preference, their very existence, street kids are now also being blamed for the spread of AIDS.

When street kids are acknowledged at all (they are often dropped out of the equation of homelessness, even by social-service advocates), they are acknowledged as an irony, a festering sore on the backside of the American Dream. They are a living, breathing affront to the image of childhood that America likes to project. Images of bright, happy, uncomplicated children are at the center of much product advertising. The music and movie industries depend on the success of their sales of and to children.

At least since James Dean, the image of the sexy, alienated, autistic teenager has dominated the American psyche, and has come to represent American culture around the world. Like the ancient Greeks, we are a *puer* culture that worships youth as an ideal. But, as is often the case in Western culture, what we value and cherish as an ideal, we disregard or denigrate as reality. Just as teenagers have come to represent the desired complementary attributes of toughness and vulnerability, individuality and fierce loyalty, hipness and innocence in America's image of itself, real teenagers going through the real world-shattering transitions of puberty and adolescence are feared and despised.

Adults fear and hate kids because of the kids' relation to boundaries—the boundaries between childhood and adulthood, between innocence and experience, between "good" and "bad." When kids "go bad," they transgress the all too tenuous boundary separating "civilized behavior" from barbarism. Roving gangs of wilding youths make good news copy because this reifies our fears and justifies our enmity. Fear is one of the two main obstacles to dealing with the real problems of street kids. The other is empathic overload.

For those of us who are not insulated from the streets by wealth or privilege, the human misery we see out there every day can add up to an almost unbearable weight. To go on with our lives, it often seems necessary to let some of it slip. The phenomenon is not new. Melville described it in the New York of 140 years ago, in his "story of Wall Street," *Bartleby the Scrivener.*

> *So true it is, and so terrible, too, that up to a certain point the thought or sight of misery enlists our best affections; but, in certain special cases, beyond that point it does not. They err who would assert that invariably this is owing to the inherent selfishness of the human heart. It rather proceeds from a certain hopelessness of remedying excessive and organic ill. To a sensitive being, pity is not seldom pain. And when at last it is perceived that such pity cannot lead to effectual succour, common sense bids the soul be rid of it.*

Surely we have not gotten to that point of hopelessness with our own children? These are not someone else's kids. Like it or not, we are related, and they are becoming more like us every day—frightened, wounded, numbed. If we continue to shut them out and then ignore the nightly beating on the walls, who are the barbarians?

1992

PHOTOGRAPHY
AND BELIEF

They say that pictures don't lie, but that's not really true anymore.
—Advance promotion line for an interview with Fred
Ritchin on National Public Radio, February 7, 1991

*If material conditions need to be redescribed, more painstakingly
and in novel forms, in order to be reinvested with "believability,"
then we can surely develop the form—and the means of dissemi-
nation—to do so.*
—Martha Rosler, "Image Simulations, Computer
Manipulations: Some Ethical Considerations"

"Seeing is believing." It's been that way from the beginning, long
before Messrs. Niépce and Daguerre changed the technology of see-
ing by inventing photography. But photography materialized seeing
in a new way, and significantly changed the relation between seeing
and believing. Photography as mechanical reproduction almost imme-
diately altered the aura of the work of art, and over the next 150
years photography acquired its own aura—the aura of believability.

Now the technology of seeing is changing again, with rapid
advances in electronic imaging technologies that allow one to alter
or "make up" photographs at will, and some say these new tech-
nologies are causing a tremendous crisis of believability in photog-
raphy. In his book *In Our Own Image: The Coming Revolution in
Photography/How Computer Technology is Changing Our View of the
World*, Fred Ritchin raises a cry of alarm. In the Preface to his book,
he states that it was written "in appreciation of the important his-
torical juncture at which we stand, just before the widespread adop-

Found photograph of unknown boy, believed to be the
author's brother

tion of electronic technology, out of a sense that we must try to take some responsibility for the future of the immensely popular *and still believable* medium of photography." (Emphasis added.) The questions raised by the new imaging technologies were discussed in *Newsweek* (July 30, 1990) under the title "When Photographs Lie: Advances in 'electronic imaging' are assaulting the meaning of the picture"; five years before that (July 1985), *Whole Earth Review* had declared with dogmatic finality that "the photograph as evidence of anything is dead." Commentators of all kinds say we are moving into a period in which the boundaries between fact and fiction, real and artificial, actual and virtual reality are going to become much more operationally porous and movable than they have been in the past.

Most of these speculations about the impact of new imaging technologies on photography have tended to be strictly materialist (unlike the more heterodox, reality-hacking, *Mondo 2000* hyper-speculations of the burgeoning cyberpunk subculture), and many are based on a series of severely restricted assumptions about how photographs are actually received and used. If we are to understand the coming changes, we must try harder to understand the present and evolving complexity of the way we look at, use, and "believe" photographs now.

IS THAT A REAL PHOTOGRAPH OR DID YOU JUST MAKE IT UP?

The word *belief* derives from the Anglo-Saxon word *geliefan*, meaning "to hold dear." The Sanskrit root for this word, *Lubh*, means "to desire, love." Belief involves the "assent of the mind to a statement, or to the truth of a fact beyond observation, on the testimony of another, or to a fact or truth on the evidence of consciousness" (*Oxford English Dictionary*). In relation to photography, this assent is influenced, but not exhausted, by the photograph's relation to "objective reality." It is also influenced and determined by its place in the complex web of subjectivities that determines how we negotiate the world.

REPUTED IDENTITIES

The relation between photography and belief is especially complicated in images having to do with identity, where the effect of a photograph can be decisive. When Burl Ives shows James Dean a photograph he's been holding for years of Dean's father and mother on their wedding day in the film *East of Eden,* Dean looks at it and says, "I *knew* it was true. I knew it." Sometimes, the photograph doesn't need to prove anything on its own; it corroborates and confirms what we already know.

Many of us possess certain photographs that accrete believability over time. These may be photographs of family members or loved ones, autobiographical images, or other photographs that come to act as amulets or talismans, triggering certain emotions or states and warding off others. The relation of these photographs to belief is often not bound by their objective veracity. Rupert Jenkins (Assistant Director at San Francisco Camerawork) told me that when he was a child he picked up a photograph lying in the street and carried it around, telling everyone that this was a picture of his mother. After a while, he came to believe it *was* his mother. I had a similar experience in adolescence with a picture I found somewhere of a boy resembling pictures I had seen of my father as a child. I began to think of this found photograph as a picture of my brother who had died before I was born. In some real way, that photograph did come to represent my brother.

People use photographs to construct identities, investing them with "believability." Of course, advertisers and news-picture editors do the same thing, mimicking the private use of photographs in order to manufacture desire for products and to manufacture public consent. This has caused a great deal of confusion. The first question must always be: Who is using this photograph, and to what end?

FRIENDLY FIRE

Increasingly, those who control technology control information, and those who control information manage consent. The Gulf War ush-

ered in a new era of information control and consensus reality in the United States, and this change can be read in the way images were used during the war. Following the successful press blackouts of their invasions of Grenada and Panama, the U.S. military was able to drop a seamless screen around the entire theater of operations in the Gulf from day one. The only images released to the U.S. public were the ones projected onto that screen by military authorities. Since photojournalists were effectively shut out of the area or relegated to tightly controlled Department of Defense pools, few of the images projected onto that screen were conventional documentary photographs. Instead, the images came from electronically manipulated and enhanced tapes; video arcade images of crosshairs floating over targets, ending in delicate puffs of smoke.

As the war progressed, most of the "photographs" printed in newspapers were actually video stills from CNN footage. These strangely attractive images of fireworks against liquid green skies, tightly composed explosions, and handsome talking heads before cold blue mosques were, literally, not to be believed. What was to believe? *This is a direct hit on a munitions dump. This is the air war over Baghdad.* The actual war information in these images was so restricted that questions of believability never really came up. What did come up, over and over, was *deniability*.

In an unusually frank piece titled "The Propaganda War" (subtitled "Amid the bombs, words and pictures carry a payload on the battlefield of public opinion"), the February 25, 1991 issue of *Newsweek* stated:

> *Propaganda is a broad approach to persuasion that encompasses several disciplines. So-called "public diplomacy"—a variation on standard public relations—involves presenting one's position in the best possible light, often on TV. Formal military psychological operations ("psyops") include broadcasting and dropping leaflets over enemy lines. Each of these mind games relies at times on "disinformation"—planting false information so as to confuse and manip-*

ART CENTER COLLEGE OF DESIGN LIBRARY

ulate. Still, the most persuasive propaganda is that which is both graphic and demonstrably true.

In theory, reporters in democratic societies work independent of propaganda. In practice they are treated during war as simply more pieces of military hardware to be deployed. While the allies play it straighter than Iraq, much of the information they release has propaganda value, too. No video displays of missed targets, for instance, are ever shown. The problem for the American press is that the American people seem to like it that way. (Emphasis added.)

The American public had been well prepared for this type of propaganda war over the last decade. Watching it play across their screens now, they believed it because they wanted to believe it. This was war with a happy face—a "no body count" war in which the public quite clearly communicated to the press: "Don't tell us—we don't want to know. We know what we believe."

When former CBS anchor Walter Cronkite, whom the polls once named "the most trusted public figure in America," spoke out against Gulf War censorship, he was quickly given the bum's rush by *CBS News*. In a chilling piece published in that same February 25, 1991 issue of *Newsweek*, Cronkite brought up the analogy of post–World War II Germany, when most Germans claimed ignorance of the Holocaust. "But this claim of ignorance did not absolve them from blame," wrote Cronkite. "They had complacently permitted Hitler to do his dirty business in the dark. They raised little objection, most even applauded when he closed their newspapers and clamped down on free speech. Certainly our leaders are not to be compared with Hitler, but today, because of onerous, unnecessary rules, Americans are not being permitted to see and hear the full story of what their military forces are doing in an action that will reverberate long into the nation's future."

Saddam Hussein's bumbling attempts at electronic propaganda afforded no such shelter of deniability, and were about as effective as were his army and air force. Hussein's propaganda was of the old,

premodern type: transparently manipulative, often verifiably untrue, and easily turned to the enemy's advantage. When the videotaped confessions of downed U.S. and British pilots hit the airwaves, they backfired famously. The tortured faces of the pilots, reproduced thousands of times all over the world, along with those of Israeli citizens huddled in sealed rooms in gas masks, immediately became emblematic of Hussein's brutality and recklessness, and made almost any action against him possible.

Even so, the Vietnam-era generals in charge of Desert Storm recognized from the beginning that modern communications technologies make it impossible to wage war in the open. Today, war must be hidden behind an impenetrable propaganda curtain—no images of death and destruction, no fields bloody with carnage, no dismembered corpses; no orphans, or gangrene, or naked napalmed little girls; and no body count. The surprise was how readily, and how completely, the American public acquiesced.

BLINDSIDED BY THE NEW WORLD ORDER

The way that images were manipulated and controlled during the Gulf War makes Ritchin's warnings about the dangers of digital retouching seem almost quaint. That type of manipulation is a very small part of postmodern propaganda, and focusing on it may cause the big picture to become blurred. Take an image that appeared early in the conflict, before war was declared, in a supposedly "liberal" magazine. The cover of the September 3, 1990 issue of the *New Republic* featured a closely cropped, full-face photograph of Saddam Hussein. The image was slightly altered, not by means of advanced electronic imaging techniques, but in the old-fashioned way. The edges of Hussein's broad mustache were simply airbrushed away to create the universally recognizable sign for Adolph Hitler. Just to make sure the effect wasn't too subtle, the word *Furor* (in the headline "Furor in the Gulf") was emblazoned in red across Hussein's forehead, invoking "Der Führer in the Gulf."

Although an article inside by Edward N. Luttwak interrogates the Hitler/Hussein analogy (Iraq in 1990 was *not* Germany in 1935,

and George Bush Sr. is *not* Churchill), and suggests that the cover is intended satirically, the effect of the image is unambiguous. Like Bush Sr.'s oft-repeated refrain about "Hitler revisited," the image doesn't need to be accurate to be effective, and arguing its accuracy has little relevance to this effect. Its effectiveness—the only applicable measurement of propaganda—derives from the historical amnesia of most Americans and the perennial desire to reduce the scale and significance of atrocities by attributing them to lone, monstrously evil madmen. The *New Republic*'s image contains everything one needs to know about the analogy for it to be effective, and reflects the subtle manipulations of that analogy visually. *Saddam Hussein is Hitler.* What's not to believe?

> *All information should be considered false until proven true.*
> —Prussian military strategist Karl von Clausewitz

> *The more crap you believe in, the better off you are.*
> —Faye Dunaway's character to Mickey Rourke's
> Bukowski, in the film *Barfly*

The aura of believability surrounding photographs is not all that vulnerable to new electronic imaging technologies *in themselves*. But belief itself is vulnerable to the kind of massive propaganda assault and general degradation of information that accompanied (and will certainly follow) the Gulf War. The crisis of belief we are experiencing is much larger than a simple mistrust of photographs. It involves the wholesale, active relinquishing of our public right to know. When the manipulation and control of all forms of public imaging have become this pervasive, this *complete*, it is more than ever necessary to resist, to reassert individual initiative in the production, reception, and use of images, and to find new ways to reinvest images with "believability"—before belief itself becomes part of the collateral damage.

1991

A SEA OF GRIEFS
IS NOT A PROSCENIUM

The Rwanda Projects of Alfredo Jaar

They fired at the hospital from outside and threw grenades over the walls into the courtyard. The patients did not understand what was happening. They started to wander around, singing, with their hands in the air.

—A worker at Rwanda's main psychiatric hospital, describing the beginning of a massacre carried out by Hutu militiamen in April 1994, one of the first in the Rwandan genocide

We are forever pursued by our actions. Their ordering, their circumstances, and their motivation may perfectly well come to be profoundly modified a posteriori. This is merely one of the snares that history and its various influences sets for us. But can we escape becoming dizzy? And who can affirm that vertigo does not haunt the whole of existence?

—Frantz Fanon, *The Wretched of the Earth*

Most of all beware, even in thought, of assuming the sterile attitude of the spectator, for life is not a spectacle, a sea of griefs is not a proscenium, a man who wails is not a dancing bear.

—Aimé Césaire, *Return to My Native Land*

Rwanda. Rwanda. Rwanda: the name now calls forth a flood of images—corpses clogging the Kagera River, bloated and bleached white, collected like driftwood at the base of a falls; dismembered bodies scattered in a churchyard, under a glowing white statue of Christ the Savior, lifting his arms in benediction; and the gray squalor of the refugee camps, with emaciated children turning their huge

Alfredo Jaar, *The Eyes of Gutete Emerita*, 1996

eyes to the cameras. These were the images that appeared in newspapers around the world in 1994 as the genocide occurred in Rwanda.

The images were put there to illustrate news stories, but in the end they acted independently. The truth is, no one read the news stories. If they had read them, they would have demanded that something be done to stop the killing. They did, however, look at the images. Why didn't people respond to these images with outrage, and demand political action?

It is partly because the politics of images, the way they are organized, has changed, and this has acted to erode their effectiveness, and their power to elicit action. Filmmakers have been pointing to this erosion for years. So have the best photographers. But there has always been something about "real pictures" of real violence that undercuts their political effect, and separates them from experience.

In his short essay "Shock-Photos," Roland Barthes addressed this lack of effect. "It is not enough for the photographer to *signify* the horrible for us to experience it," he wrote. These images, intended to convey horror, fail to do so "because, as we look at them, we are in each case dispossessed of our judgement: someone has shuddered for us, reflected for us, judged for us; the photographer has left us nothing—except a simple right of intellectual acquiescence. . . ." Such images do not compel us to action, but to acceptance. The action has already been taken, and we are not implicated. Our complicity is concealed, intact. "The perfect legibility of the scene, its formulation, dispenses us from receiving the image in all its scandal; reduced to the state of pure language, the photograph does not disorganize us."[1] We are not disorganized because news images operate within a perfectly organized rhetoric of consumption, the pure language of the spectatorship under which we now live. Images of suffering and misery elsewhere in the world are used as reminders of what we are free from. They operate in the greater image environment of consumption to offset images of contentment, to provide the necessary contrast. Their use value, and their effect, is

palliative. This effect is far-reaching, and one of the histories thus buried was that of Rwanda.

The story of what happened in Rwanda in 1994 is one of massive criminality and complicity. It is the story of a state-sponsored genocide that took years to plan and direct, but only a hundred days to carry out, as the rest of the world looked on. It constitutes the third genocide of this century, following that of the Armenians by the Turks of the Ottoman Empire in 1915 and 1916, and that of the Jews by the Nazis during World War II.

Faced with growing opposition within Rwanda, and increasing pressures from without to share power, the single-party government of President Juvénal Habyarimana was showing signs of increasing instability in 1990. "Hutu Power" extremists within the Habyarimana government began to incite the Hutu majority population of Rwanda to attack the minority Tutsis, saying that they were the source of all the troubles. Radio Mille Collines ("A thousand hills") constantly spewed propaganda calling on the Hutus to "finish the work begun in 1959" (when the Hutus massacred a hundred thousand Tutsis and drove thousands of others into exile), and leaving nothing to the imagination concerning the nature of this "work." "The grave is only half full," they said. "Who will help us fill it?" In order for the genocide to be successful this time, they instructed, "The children must also be killed." The children they failed to eliminate in 1959 had now grown into the rebel Rwandan Patriotic Front (RPF) in Uganda. Commandment number eight of the "Hutu Ten Commandments" printed in the government newspaper read: "The Hutus should stop having mercy on the Tutsis."

A Hutu Power politician named Dr. Léon Mugesera gave a speech in December 1992 in which he appealed to his fellow Hutus: "We the people are obliged to take responsibility ourselves and wipe out this scum. No matter what you do, do not let them get away." To the Tutsis, he said (echoing old racial myths about the ethnic origins of the Tutsis): "I am telling you that your home is in Ethiopia and we will send you back through the Nyabarongo River as a short-

cut."[2] In the slaughter to come, the Nyabarongo and other rivers were choked with the corpses of slain Tutsis.

The authors of the Rwanda genocide are well known, and most of them are still at large in Congo, Kenya, or in the West. Dr. Mugesera took refuge in Canada, and as of the fall of 1997 could be found advising his graduate students at Laval University in Quebec City. Habyarimana's brother-in-law, Protais Zigiranyirazo, a founding member of the death squad Zero Network and an original shareholder in Radio Mille Collines, was given sanctuary in France.[3]

Since it is often difficult to tell Hutu from Tutsi by sight, death lists had been prepared using identity cards that were first issued during the colonialist period, listing the ethnicity of each bearer. Hutu youths were formed into militias, called the Interahamwe ("Those who fight together"), and were armed. When Habyarimana's plane was shot down on April 6, 1994, the Hutu leadership blamed the Tutsi-led RPF for his death (it has since been alleged that the president's plane was actually shot down by the Hutu extremists themselves, perhaps with the assistance of French soldiers[4]), and unleashed the Interahamwe to begin slaughtering Tutsis. Using the identity lists, the militiamen began to pull Tutsis from their homes and stop them at roadblocks, and government officials in the provinces lured Tutsis into churches and community centers, where they were stabbed, clubbed, and hacked to death. One survivor of the Ntarama slaughter, a child of twelve named Mutaganzwa, said: "They told us we were *inyenzi* (cockroaches), and then they began to kill us."[5] Tutsi women were raped, tortured, and mutilated before being killed. Many Hutus who refused to participate in the carnage were executed along with the Tutsis. Within three months, a million people were dead, out of a total population of eight million. An equivalent death toll per capita in the United States would be twenty-five million. The scale and speed of this genocide was unprecedented.

It was important to kill everyone. If someone survived, they could tell the story of what had happened, and name names. It was especially important to kill all the children. If any of them were spared, they could go on telling the story for a long time, and they

would never forget. And it was important to make it look as if all of the Hutus left alive participated in the killing, so that none of them could later point the finger at someone else.

The genocide in Rwanda required extensive planning, organization, and single-minded execution. It also required the complicity of the world outside of Rwanda. Given the speed with which the genocide was conducted—one million people in a hundred days, or ten thousand murders per day—any response from outside would have saved thousands of lives. Two weeks into the slaughter, the Canadian commander of the U.N. forces in Rwanda said he could end the genocide with five to eight thousand troops. Most military leaders now agree that the genocide could have been stopped in two or three days with a few thousand properly armed troops (since the Hutu militias did not have heavy artillery, and were cowards[6]). But when the United Nations began to mobilize an interdictory force to stop the killing, the United States and Belgium pressured the U.N. instead to *reduce* the number of their troops in Rwanda, from 2,500 to 270 men, who were then left in Kigali with no recourse but to stand around and watch it happen. And in May 1994, a U.N. plan to send five thousand African troops into Rwanda also collapsed because the United States opposed it. When it was finally authorized, the mobilization was held up for months while the U.S. dickered with the U.N. over the rental fee on U.S. armored personnel-carriers needed for the intervention to proceed.[7]

The French government, which had supported and armed the Rwandan government troops, finally sent their troops in only after the genocide was over, and the invading RPF troops were driving the Hutu government army and militias out of Rwanda. The million massacred Tutsis were replaced nearly one-to-one by returning refugees. But the French ended up protecting and providing official sanctuary for the fleeing Hutus.

When the killers fled, they led two million of their fellow Hutus out in a mass exodus. Fifty thousand of them died of disease, hunger, and lack of water. At that time, the international community, moved by pictures of refugees on the run, swung into action, providing mas-

sive humanitarian aid to the Hutus who had fled to Zaire. The refugee camps in Zaire were controlled by the political and military leaders of the genocide. Under international "humanitarian" protection, and with the support of Mobutu Sese Seko of Zaire, the Interahamwe began to regroup.

THE SCANDAL OF SILENCE

Some will object that the world did not know what was happening until it was too late. The record refutes that. Reading through the *New York Times* coverage of the genocide in Rwanda, it is clear that all of the above facts were known before and as the genocide happened. It's all there, in dated black and white. The world's inaction was not due to ignorance of the facts, but to a prejudice against them. On April 15, 1994, Elaine Sciolino reported in the *Times* that "Although it has not been exactly articulated this way, no member of the United Nations with an army strong enough to make a difference is willing to risk the lives of its troops for a failed central African nation-state with a centuries-old history of tribal warfare."[8]

This characterization of the genocide as "centuries-old . . . tribal warfare," or "an atavistic replaying of ancient hatreds,"[9] would be repeated throughout the killing. But what happened in Rwanda in 1994 was not war, but state-sponsored genocide against civilians. To call it "tribal warfare" defames the dead and exempts the guilty. American historian Alison Des Forges has written that, far from being "part of the 'failed state' syndrome that appears to plague some parts of Africa, Rwanda was too successful as a state."[10] It was a state that, with the help of foreign powers, eliminated nearly all potential opposition within the country. Only the returning Tutsi refugees and the RPF prevented it from fully profiting from the genocide.

Also on April 14, 1994, Bob Dole, then Republican leader in the U.S. Senate, replied to a question about Rwanda on television's *Face the Nation* in this way: "I don't think we have any national interest here. I hope we don't get involved there. I don't think we will. The Americans are out. As far as I'm concerned in Rwanda, that ought to be the end of it."[11] But that wasn't the end of it. The next day, hun-

dreds of unarmed men, women, and children were slaughtered at the Catholic church in Nyamata. Two days later, the massacre at Nyarabuye began. Philip Gourevitch later wrote: "The killers killed all day at Nyarabuye, and at night they cut the Achilles tendons of survivors and went off to eat behind the church, roasting whole stolen cows in big fires, and then in the morning, still drunk on banana beer after a night of sleep beneath the cries of their victims, they went back and killed again, for three days or four days or five days. They worked like that."[12] When government officials organized the massacres of Tutsis in 1990, they told Hutus that it was part of their communal work obligation (*umuganda*) to kill their neighbors.

Bob Dole is a war hero, who fought against Hitler's genocide of the Jews. How could he turn his back on the genocide in Rwanda?

One month later, on May 17, the Executive Director of Human Rights Watch, Kenneth Roth, was reported as saying: "The delay and lack of leadership shown by the United States Government in confronting genocide in Rwanda is appalling."[13] And U.N. Secretary General Boutros Boutros-Ghali called the United States' lack of response to genocide "a scandal."

In London, *Guardian* columnist Simon Hoggart offered this chilling explanation for Britain's lack of response: "Rwandans are thousands of miles away. Nobody you know has ever been on holiday to Rwanda. And Rwandans don't look like us."[14]

In June, when the hundred-day pogrom in Rwanda was nearly complete, President Bill Clinton instructed U.S. government spokesmen to avoid using the word "genocide" to describe what had happened there, so as to avoid U.S. implication and responsibilities under the 1948 Convention on the Prevention and Punishment of the Crime of Genocide. Under this agreement, the United States and all other signatories pledged to respond to genocide wherever it occurred, so that "never again" would the horror perpetrated by the Nazis be allowed to happen. What happened in Rwanda was precisely what the United Nations was formed to prevent.

When the French government suddenly decided to support armed intervention in Rwanda, French Foreign Minister Alain Juppé

pontificated: "It is no longer time to deplore the massacres with our arms folded, but to take action. The urgent need for international intervention should lead us to show both imagination and courage."[15]

The RPF leaders in Rwanda discouraged the French intervention, pointing out that "they would be intervening to protect the torturers." In the years leading up to the genocide, the French government had backed the Rwandan government against the RPF, and had armed the men who organized the militia gangs. Under the French, the Rwandan army grew from five thousand men to thirty thousand. "Whatever happens, we will do it," vowed French President François Mitterand in June 1994; "every hour counts."[16] In his 1996 essay on "Understanding the Rwandan Massacre," Ugandan writer Mahmood Mamdani noted that "so public was France's role in the training of armed militias that would become the stormtroopers of the genocide—particularly the Interahamwe—that when I got to Kigali it was common to hear the French President called *Mitterahamwe*."[17]

What the French political leaders knew full well came as a surprise to their soldiers on the ground. On July 1, 1994, one of them said: "This is not what we were led to believe. We were told that Tutsi were killing Hutu, and now this."[18] And on July 2, another said: "We were manipulated. We thought the Hutu were the good guys and the victims."[19]

As the new government of Rwanda under the RPF was trying to rebuild, the world was feeding and protecting the killers, who were regrouping in Zaire, and strengthening themselves for war.

THE CULTURE OF IMPUNITY

On July 24 in Hot Springs, Arkansas, President Clinton was pressed by reporters to explain his lack of response to Rwanda. "We're doing the best we can," the president said, "but we're going to do more. If you look at the record, I think it would very difficult to point the finger at anyone."[20]

But it is not difficult. The truth is that the United States, through the United Nations, could have intervened in April 1994 and saved

hundreds of thousands of Rwandan lives, with limited risk to U.S. troops. There was a right and a wrong in Rwanda, just as surely as there was in Nazi Germany. To conceal this fact behind loose talk of "tribal warfare" and "an uncontrollable spasm of lawlessness and terror" was obscene.

As late as December 21, 1997, James C. McKinley, Jr. wrote this in an opinion piece in the *New York Times* under the title "Searching in Vain for Rwanda's Moral High Ground" and a huge image of the Associated Press photograph of bodies at the falls on the Kagera River:

> *For Westerners, whose concept of genocide has been shaped by the moral clarity of the Nazi Holocaust in Europe, the situation in Central Africa is baffling and frustrating. Today's killers often appear to be tomorrow's victims, and vice versa.*
>
> *"It's not a story of good guys and bad guys," said Filip Reyntjens, a history professor in Antwerp, Belgium, whose specialty is Rwanda. "It's a story of bad guys. Period."*[21]

Bad-guy Africans, specifically. Just bad, crazy Africans doing what crazy Africans do. The media representation of Africans in the West has often supported this logic, as Fergal Keane wrote in his book *Season of Blood*:

> *In our world of instant televised horror it can become easy to see a black body in almost abstract terms, as part of the huge smudge of eternally miserable blackness that has loomed in and out of the public mind through the decades: Biafra in the sixties; Uganda in the seventies; Ethiopia in the eighties; and now Rwanda in the nineties.*[22]

This image of black Africa made the Western powers reluctant to see what happened in Rwanda for what it was: genocide, a crime against humanity. As Hannah Arendt wrote: "If genocide is an actual possibility of the future, then no people on earth . . . can feel reasonably sure of its continued existence without the help and the protection of international law."[23] And David J. Sheffer, the current

U.S. Ambassador at Large for War Crimes Issues, has said: "The most challenging test for the rule of law in our generation is the genocide of 1994 that consumed Rwanda."[24] The message from 1994 was that the rule of law does not apply to Rwandans.

The conspiracy of silence, subterfuge, and complicity that surrounded that genocide was the conspiracy of *us*. It is not only the people of Rwanda who were complicit in this crime against humanity, but we who, in our freedom, comfort, and security, sat by our screens and watched it happen.

ALFREDO JAAR'S RWANDA PROJECTS

All art is meaningless to those for whom life itself is merely a spectacle.

—John Berger, *A Painter of Our Time*

You cannot penetrate events with reportage.

—Michelangelo Antonioni, *The Architecture of Vision*

In August 1994, Alfredo Jaar went to Rwanda to see with his own eyes what had happened there. Accompanied by his friend and assistant Carlos Vásquez, he flew from Paris to Kampala and, after spending two days in Uganda, proceeded overland to Kigali, Rwanda.

The capital city of Kigali, the epicenter of the genocide, was completely devastated. There was no power, no water, and little food. The Hutu militias had fled to the Zairean border. The RPF, formed mostly of Tutsi refugees returning from Uganda, was now in control. The Tutsi dead far outnumbered the living in Kigali, and the few survivors all bore the mark of the miraculous.

With assistance from the United Nations, Jaar and Vásquez began to meet people and to hear their stories. One day, Jaar came upon an inoperative post office and bought up the last of their postcards. The cards, which had been produced at some point by the Rwandan Office of Tourism (and sponsored by the Belgian airline Sabena), all had the same slogan emblazoned across the top: "Rwanda—Découvrez 1,000 merveilles, au pays de 1,000 collines" (Rwanda—Discover 1,000 marvels in the land of 1,000 hills). On

the verso they carried tourist pictures of the wildlife in Akagera National Park—impalas, zebras, eagles, and lions—and beautiful mountain vistas of Kibuye and Gisenyi or the serene skies over Lake Kivu. One postcard showed dancers in full regalia, with long white headdresses and beads.

Jaar began to collect the names of the survivors he met in Kigali and write them on the postcards in this way;

JYAMIYA MUHAWENIMAWA
IS STILL ALIVE!

EMMANUEL RUCOGOZA
IS STILL ALIVE!

CARITAS NAMAZURU
IS STILL ALIVE!

Then he addressed the postcards to his friends and colleagues in other parts of the world. Twenty-five to thirty people received more than two hundred postcards altogether. Since there was no postal service left in Rwanda, he mailed the cards from Uganda on his way out of the country.

This action, which came to be called *Signs of Life*, was Jaar's first from Rwanda. It was simple and direct and at the same time layered with meaning. Rwanda's tourist slogan recalls the more virulent propaganda of Radio Mille Collines, the lush landscapes recall Simon Hoggart's assurance that "Nobody you know has ever been on holiday to Rwanda," and the wildlife shots point to the fact that many in the West know more about the plight of Rwanda's fauna (especially Dian Fossey's gorillas in the mist) than about the slaughter of its human inhabitants. The simple statement that a named person "is still alive" recalls the time when the appearance of one's name on the *genocidaire*'s lists meant instant death. It reverses the effect of naming.

As is often the case in Jaar's work, there is also an art historical reference, in this instance to On Kawara's early conceptualist post-

card series from 1969 and 1970. Kawara's *Confirmation* consists of a telegram mailed to Sol LeWitt in February 1970, which read: "I AM STILL ALIVE." A previous series of telegrams carried the messages: "I am not going to commit suicide—Don't worry," "I am not going to commit suicide—Worry," and "I am going to sleep—Forget it."[25]

In *Signs of Life*, Jaar appropriates a landmark in conceptual art and reinvigorates it, bringing it back to life out of the dead-letter file almost thirty years later. He also pointedly moves the originally self-involved work out into the world, in an act of *engaged* conceptualism.

Jaar and Vásquez joined up with a Swiss journalist and a Japanese reporter and traveled around Rwanda, continuing to document what they found. They went to refugee camps outside of Kigali and on the Zaire-Rwanda border, and on August 29, 1994, they went to Ntarama Church, forty kilometers south of Kigali, where four hundred Tutsi men, women, and children who had sought refuge in the church had been systematically slaughtered during Sunday Mass four months earlier. Outside the church, they met a woman named Gutete Emerita, whose husband and two sons had been hacked to death with machetes before her eyes.

Jaar took photographs wherever he went in Rwanda, and they numbered more than three thousand by the end of the trip. There were times, Jaar said, when the camera acted as a welcome buffer, an intermediary between himself and the all too unmediated things he was looking at. At other times, it seemed superfluous and altogether inadequate, reminding him only of "the futility of a gaze that arrives too late." In a later interview, Jaar reflected back on this time:

> For me, what was important was to record everything I saw around me, and to do this as methodically as possible. In these circumstances a "good photograph" is a picture that comes as close as possible to reality. But the camera never manages to record what your eyes see, or what you feel at the moment. The camera always creates a new

reality. I have always been concerned with the disjunction between experience and what can be recorded photographically. In the case of Rwanda, the disjunction was enormous and the tragedy unrepresentable. This is why it was so important for me to speak with people, to record their words, their ideas, their feelings. I discovered that the truth of the tragedy was in the feelings, words, and ideas of those people, and not in the pictures.[26]

When Jaar returned to New York, he found that he could not look at the photographs he had taken in Rwanda. It would be almost two years before he found a way to actually show the images.

In November of 1994 Jaar was invited to participate in a public art project in Malmö, Sweden. He was given the use of forty light-boxes all around the city in which to display any image he wished. But he did not wish to display an image, yet. The truth is, he *could* not. Instead, he filled the light-boxes with *Rwanda*; that is, with the name Rwanda, repeated over and over, filling up the frame. These posters, scattered around the streets and squares of Malmö, reduced the rhetoric of advertising to a cry of grief. But they also served notice to a complacent public: "You—in your tidy parks, on your bicycles, walking your dogs—look at this name, listen to this name, at least hear it, now: *Rwanda, Rwanda, Rwanda. . . .*"

The posters were a raw gesture, produced out of frustration and anger. If all of the images of slaughter and piled corpses, and all of the reportage did so little, perhaps a simple sign, in the form of an insistent cry, would get their attention.

Real Pictures was first exhibited at the Museum of Contemporary Photography in Chicago in January 1995. Out of the thousands of photographs he had made in Rwanda, Jaar carefully selected sixty images, to show the different aspects of the genocide: the massacres, the refugee camps, the destruction of cities. He then "buried" each of these images in a black linen box. On the top of each box, he had silk-screened in white a written description of the image inside. These boxes were stacked and arranged into "monuments" of var-

ious sizes and shapes. The completed work consists of 550 direct positive color photographs in 550 black linen boxes.

The sixty images were all taken in late August 1994, in Nyagazambu Camp and Ntarama Church in Rwanda, and the Kashusha and Katale refugee camps and Ruzizi 2 bridge in Zaire. The text that replaces them (written in collaboration with the artist and writer Susan Otto) both describes and inscribes them:

> *Caritas Namazur, 88 years old, fled her home in Kibilira, Rwanda and walked 306 kilometers to reach this camp. Her white hair disappears against the pale sky. Because of the early morning temperatures, she is covered in a blue shawl with a geometric print. Her white blouse cuts across her neck, adorned with a string of amber beads. Her gaze is resigned, weary, and carries the weight of her survival.*

> *Caritas is a Hutu caught between the actions of her own people and the fear of retribution from those who have been victimized. In her life, she has witnessed how many Tutsis had to seek exile in other countries. At this late age, in a dramatic reversal, she too has become a refugee.*

Jaar has described *Real Pictures* as a "cemetery of images," and the effect is certainly funereal. The silence of the gallery is deafening. One wanders among these dark monuments as if through a graveyard, reading epitaphs. But in this case, the inscriptions are in memory of *images*, and of the power that images once had in us. Reading them, we imagine images as if in memory: "real pictures."

The epigraph to *Real Pictures* comes from the Catalan poet Vincenç Altaió: "Images have an advanced religion; they bury history."[27] In *Real Pictures*, the tables are turned—images are buried in order that history might again be made visible and legible. It is heretical in its refusal of visual representation, in saying no to the image. Sylvère Lotringer has commented that "In Kantian terms, Alfredo Jaar's installation is a 'non-presentation.' It is meant to bear witness to the impossibility of presenting the unpresentable.... This is what

Jaar's black boxes are about: they are the negative of the pictures; a tomb for the media. . . . simultaneously blocking out the media, presenting a mental image and putting the victims to rest."[28] And there is a way in which the images become more horrific, and more effective, in their absence. Holland Cotter noted in his review in the *New York Times* that the method of *Real Pictures* "is in the spirit of classical tragedy, where violence takes place out of sight, and is reported only in words."[29]

In addition to resembling a graveyard, *Real Pictures* also looks like an archive. Stored in this way, archivally, these images accumulate a charge, so that the monuments begin to operate like batteries: image batteries.

One referent of *Real Pictures* is certainly Maya Lin's Vietnam War memorial, in its elegant simplicity and strength (and its visual restraint), but the monuments of *Real Pictures* also allude to Minimalist sculptures such as those by Donald Judd and Tony Smith. Jaar's repositioning of the formal and the contextual in this work is related to Hans Haacke's, in his *U.S. Isolation Box, Grenada, 1983*. If *Real Pictures* accuses Minimalism, or formalist purism in general, of anything, it is (as Leo Steinberg wrote of *Isolation Box*) "of being hermetic—the blind deaf-mute icons of a reductive aestheticism." Again, as in *Signs of Life*, the alienation of art for art's sake, and the separation between aesthetics and ethics, is denied.

It had been almost two years since Alfredo Jaar had returned from Rwanda, and he had not yet *shown* any of the images he made there. *Let There Be Light*, first presented at the Printemps de Cahors in France in June 1995, let out the first image. The installation in a converted cloister consisted of a row of ten standard light-boxes and a separate, specially made light-box. Each of the ten smaller light-boxes displayed a different place name: Kigali, Cyangugu, Amahoro, Rukara, Shangi, Mibirizi, Cyahinda, Kibungo, Butare, and Gikongoro. To most viewers, these names meant nothing, even though a total of one million people had been killed in these places in three months' time in 1994.

The names were made of light. When viewers stood before them to read, their faces were illuminated by the names and then reflected back to them in the shiny black surfaces of the boxes. In this way the names were inscribed on the faces of those who read them.

Reading these names today, one recalls another such list: Chelmo, Sobibor, Treblinka, Auschwitz.... In Claude Lanzmann's extraordinary film *Shoah*, he evokes the horrors that occurred in those places through words and images, often by showing the faces of the survivors and of the perpetrators and collaborators. The epigraph to that film (like the title *Let There Be Light*) comes from the Bible, from the book of Isaiah. It is from a passage stating that the privileges of the people of God are open to all, even to those who think themselves excluded by race or disability: "I will give them an everlasting name."

The second part of *Let There Be Light* is a light-box fitted with a mechanism that allows four different images to appear on the same surface in sequence, one after another at selected intervals. We see two boys standing with their backs to us. They are looking across an open area to where a crowd has gathered. The boy on the right has his left arm around his friend. In the next shot we have moved closer and a bit to the left, so we can now glimpse the boys' eyelashes. In the third shot, closer still, the boy on the right has intensified his embrace. His fingers are laced together around his friend's shoulder, and his head is now pressed against that of his friend. In the final frame, the boy on the left turns and rests his forehead on his friend's cheek.

The sequence is timed to draw us into the action of this tender embrace. We cannot see what the boys are looking at, but given the context we imagine it is something terrible. We are not shown this, but only their reaction to it. And their reaction is to draw closer together, for comfort and in solidarity.

As we watch the sequence repeated again and again, and are drawn into the boys' embrace over and over, we begin to feel ashamed by our distance from the boys. Their response to what they are seeing is to reach out to one another, in human sympathy. Our response

to what we saw happening on our screens and on our front pages in Rwanda was to turn away.

The second image from Rwanda to appear in Jaar's constructions was *The Eyes of Gutete Emerita*, first shown at the City Gallery of Contemporary Art in Raleigh, North Carolina in June 1996. Two of the "quadvision" light-boxes were placed side by side, almost touching. As in the composition with the two boys, the sequencing and timing of the changing words and images in this piece are what determines its effect. The method is cinematic even if the form is not.

At the beginning of the sequence, a block of text appears, white on black, in each of the two light-boxes. There are ten lines of text in each box, and they remain there for forty-five seconds:

> *Gutete Emerita, 30 years old, is standing in front of a church where 400 Tutsi men, women and children were systematically slaughtered by a Hutu death squad during Sunday mass. She was attending mass with her family when the massacre began. Killed with machetes in front of her eyes were her husband Tito Kahinamura, 40, and her two sons, Muhoza, 10, and Matirigari, 7. Somehow, Gutete managed to escape with her daughter Marie Louise Unumararunga, 12. They hid in a swamp for three weeks, coming out only at night for food.*

This text dissolves and more text appears, five lines on each panel, this time for the duration of thirty seconds:

> *Her eyes look lost and incredulous. Her face is the face of someone who has witnessed an unbelievable tragedy and now wears it. She has returned to this place in the woods because she has nowhere else to go. When she speaks about her lost family, she gestures to corpses on the ground, rotting in the African sun.*

This text, too, disappears, and is replaced by two more lines:

> *I remember her eyes.* *The eyes of Gutete Emerita.*

These last two lines reverberate for fifteen seconds. Then, suddenly, an image flashes into view. It is Gutete's eyes, very close up, filling the two frames, one in each frame. Before one has time to think, they are gone, leaving a potent afterimage.

The first time I saw this piece, I became physically ill at the sight of Gutete Emerita's eyes. I felt dizzy and almost retched. I don't know why this happened, but it did. Perhaps the flash of the image caused a flash of recognition that resulted in vertigo: a surplus of information in too small a period of time. Or maybe it had to do with the way the time of reading slows down over the course of the three movements, and then the visual shock of the eyes blasts in. The truth is that I feel ill now, remembering it.

The Eyes of Gutete Emerita is nothing less than a concentrated attempt to recover the power of the image. By carefully balancing the information carried in the text with the visual information in the image, Jaar propels the relation into crisis. The precision of the altered relation in *The Eyes of Gutete Emerita* goes to the heart of the "the social function of subjectivity" that John Berger describes in *Another Way of Telling*:

> *The way photography is used today both derives from and confirms the suppression of the social function of subjectivity. Photographs, it is said, tell the truth. From this simplification, which reduces the truth to the instantaneous, it follows that what a photograph tells about a door or a volcano belongs to the same order of truth as what it tells about a man weeping or a woman's body.*
>
> *If no theoretical distinction has been made between the photograph as scientific evidence and the photograph as a means of communication,* this has been not so much an oversight as a proposal.[30]

This proposal, which underlies every use of images in the regime of spectatorship, has as its goal the erasure of such distinctions. By insisting on the distinctions, and recalibrating the balance between "evidence" and "communication," Jaar short-circuits the exchange, to get to "the point where an image can make *sense* again." He has said

of this piece: "In that fraction of a second, I want the spectator to see the massacre through the eyes of Gutete Emerita. I think that this is the only way to see the massacre now, since we failed to see it in the actual images of the Rwandan genocide."[31]

At about the same time in 1996 *The Eyes of Gutete Emerita* took another form, this one more architectural than cinematic. It was first presented at the National Gallery of Australia in Canberra in February 1996.

The first thing we see as we approach the work is a black wall with a thin line of text embedded in it at about eye level. It is the same text that appeared in the light-boxes: "Gutete Emerita, 30 years old, is standing in front of a church. . . ." We read the illuminated text as we move along the wall. "I remember her eyes. The eyes of Gutete Emerita." When we come to the end of the wall, we turn the corner and are confronted by a fantastic sight: a huge (16-by-16-foot) light-table, on which is piled a mountain of 35mm slides. One million of them, in fact. A million slides for a million deaths. As we approach this apparition, we see that there are loupes arranged around the edges of the table. We pick one up, take a slide from the mountain, and hold it up to our eye. It is the eyes of Gutete Emerita. We pick up another slide—more Gutete eyes. Another and another, all eyes.

The artist has said that it is this moment, when our eye comes that close to the eyes of Gutete, which is the moment he has been waiting for. In that moment, the distance imposed by media representations of Rwanda is collapsed. Eschewing the so-called "objectivity" of the news media, Jaar here breaks through to another objectivity, both in the optical sense of the lens that is *closest to the object*, and in the root sense of "something thrown before the mind." As in the light-box version, the effect is almost neurological. Eye-to-eye, we are involved. If the world turned a blind eye to the killings in Rwanda, Gutete Emerita did not. Her eyes saw it clearly. Looking into her eyes, perhaps we too will see it. It is a risky, some will say foolhardy attempt, but it works.

The light-table version of *The Eyes of Gutete Emerita* was reconstructed in April of 1997 at the Galeria Oliva Arauna in Madrid, and in May 1997 at the Franck + Schulte Gallery in Berlin, with a different text on the wall, telling the story of a different survivor:

Over a five-month period in 1994, more than one million Rwandans, mostly members of the Tutsi minority, were systematically slaughtered while the international community closed its eyes to genocide. The killings were largely carried out by Hutu militias who had been armed and trained by the Rwandan military. As a consequence of this genocide, millions of Hutus and Tutsis fled to Zaire, Burundi, Tanzania and Uganda. Many still remain in refugee camps, fearing renewed violence upon their return home.

Like adults, children were systematically targeted and killed. The militias wanted to make sure they did not repeat the mistake of 1959 when they had not killed the children. Those children went into exile and formed a resistance.

It is impossible to estimate the number of children killed during the massacres. Some children were slaughtered with their parents. Others witnessed their parents and brothers and sisters being murdered. Many who survived the killings lost their will to live and died.

On Thursday morning, August 25, 1994, I entered the Rubavu Refugee Camp near Gysenyi in Rwanda as school was about to begin. As I approached the make-shift school, children gathered around me. I smiled at them and some smiled back. Three children, Nduwayezu, Dusabe and Umotoni, were seated on the steps in front of the school door. Nduwayezu, 5, the oldest of the three, was the only one that looked directly at my camera. Like the other 36 children in the camp, he lost both parents. When Nduwayezu arrived at Rubavu, he remained silent for four weeks. Four weeks of silence.

I remember his eyes. And I will never forget his silence. The silence of Nduwayezu.

Rwanda is now filled with orphans like Nduwayezu, and many of them (UNICEF estimates some eighty-five thousand) are now the heads of their families, taking care of younger children without the aid of parents or other adults. Fergal Keane spoke with a woman named Rose Kayitesi, who fought with the RPF and is now caring for these orphans. "We are trying to teach them to trust the world again," she said. "But it is very, very difficult."[32]

The *eyes* of Gutete Emerita and the *silence* of Nduwayezu are offered as signs of the genocide, in the hope that they might make its significance perceptible to us.

The exhibition of *The Silence of Nduwayezu* at the Franck + Schulte Gallery in Berlin also included a piece called *Field, Road, Cloud*. It consists of three large framed photographs, each paired with a small reproduction of a sketch indicating the location shown.

The first large photograph pictures a lush green field of tea, stretching out to the horizon. In the far distance to the left stands a white building with a broad brown roof. The sketch next to the photograph indicates that it was taken on the main road from Kigali on August 29, 1994. We recall that the main export crops of Rwanda are tea and coffee, and that the farmland is rich and productive.

The next photograph is especially gorgeous. A rough dirt road is bathed in late afternoon or early morning golden sunlight. The trees lining the road cast striated shadows across it. In the top center of the image appears a torso-shaped patch of sky. Glancing at the sketch next to the image, we read that this is the road to Ntarama Church.

In the last photograph in the series, one cottony white cloud is framed by a deep blue sky. The cloud has begun to break up, letting off a few fine wisps. In the last sketch, the lonely cloud appears directly above the pointed steeple and cross of Ntarama Church. In front of the church are drawn some squiggly lines and under them the legend "BODIES, 500?"

This is the church where Gutete Emerita saw her family killed.

Three images on the way to a killing site: fecundity, felicitous light, and freedom of movement. I remember once traveling on a

train from East to West Germany before the Berlin Wall came down, and looking out the window at a row of trees, and wondering whether this was an East German or a West German row of trees.

The Rwandans have insisted on leaving some of the killing sites, like Ntarama Church, as they are, with the remains of bodies all around, so that people can see with their own eyes what happened. But the truth is, human bodies do not make good monuments. They decompose quickly and disappear. There will have to be other ways to show the world what happened.

IMAGES HAVE AN ADVANCED RELIGION

The question of evil, like the question of ugliness, refers primarily to the anaesthetized heart, the heart that has no reaction to what it faces.
　　　　　　　　　　　—James Hillman, *The Thought of the Heart*

The most political decision you make is where you direct people's eyes. In other words, what you show people, day in and day out, is political. . . . And the most politically indoctrinating thing you can do to a human being is to show him, every day, that there can be no change.
　　　　　　　　　　　—Wim Wenders, *The Act of Seeing*

We know that under the revealed image there is another one which is more faithful to reality, and under this one there is yet another, and again another under this last one, down to the true image of that absolute, mysterious reality that nobody will ever see. Or perhaps, not until the decomposition of every image, of every reality.
　　　　　　　　　　　—Michelangelo Antonioni, *The Architecture of Vision*

Jaar's Rwanda works constitute an attempt to throw light on an occluded history and to act as an indictment of the world's silence and inaction in the face of the genocide in Rwanda. Are these things that art can or should try to do? The world's great history paintings have been doing this for at least the last three and a half centuries. In a recent essay on On Kawara's work, artist Jeff Wall points out

that the great history paintings, from Velázquez's *Surrender at Breda* (1634–35) to Manet's *The Execution of the Emperor Maximilian* (ca. 1867), to Picasso's *Guernica* (1937), are "rhetorical, ideological, conforming, or dissenting poetic expressions, subjective 'readings' of the same sources other people were reading at the time. This kind of painting was thrown into crisis by photography—or, more specifically, by photojournalism." Jaar works back into this crisis, transforming photojournalism through aesthetic means, by reworking the mise-en-scène. Like the history paintings of the past, these works operate in time—one must know their historical context in order to fully appreciate them. But they work aesthetically, not as propaganda. Jaar refuses to make a choice between politics or ethics and aesthetics, believing, with Godard, that "whichever one you choose, you will always find the other one at the end of the road."

The Rwanda works also address a crisis in the image, and in our relation to images, that Paul Virilio has called "a sort of pathology of immediate perception that owes everything, or very nearly everything, to the recent proliferation of photo-cinematographic and video-infographic seeing machines; machines that by mediatizing ordinary everyday representations end up destroying their credibility." As we become increasingly subject to images, the subject of any image becomes less and less available to us. Must we turn away from images entirely in order to begin again?

It was Stalin who said: "A single death is a tragedy; a million deaths is a statistic," recognizing that tragedy and statistics are two entirely different classes of information. Statistics (the science of the state) is designed to suppress or preclude action, to encourage passivity and stasis. We live in a time when information, in the form of words and images, is being transmitted in vast quantities and at increasingly high speeds, and this mass and velocity determine its effects. Human beings cannot act on information transmitted in this way, but only attempt to retrieve, sort, and process it.

In order to counter statistical thinking, one must focus on individuals. Not a million deaths, but one death. Not thousands of refugees

in camps, but one survivor at a time, with a name and an image. Jaar severely limits the number and speed of his images, in order to have a different effect. A single image, of one woman's eyes, is given the time required to do another kind of work.

It is not possible to make an image of genocide. But it is possible to make images of individuals, and to put words and images and sounds together to say something in relation to genocide. Without turning a sea of griefs into a proscenium, one can still effect the mise-en-scène.

There are of course those who say that such events as genocide should not be represented at all, that any representation is bound to falsify and trivialize it. Even art should keep its distance. But these are people for whom art itself has become false and trivial.

One terrible truth about photographs is that they can only ever show us *what happened*, never what is happening or will happen. They are always about something that is *gone*, and so are in league with death.

In Jaar's Rwanda works, we see the artist's tremendous frustration with this, with "the futility of a gaze that arrives too late." In the first of these works, he turns away from the image in disgust. The image is only used to carry the message on its back: CARITAS NAMAZURU IS STILL ALIVE! Then he abandons the image entirely, and pares the message down even further, to only the name, *Rwanda*, repeated again and again. Then he *buries* the images, in sepulchral cubes that stand like a rebuke to representation itself.

It is only in the later works that Jaar finds a way to begin again, to recover the image from the obscurity into which it has been cast. The first resuscitated image is of a simple human gesture, an embrace between children. In a way, it is the same image that W. Eugene Smith made of two children holding hands and walking away. It was the first image Smith made after having abandoned photography to the war, and he made it "to refute two years of negation." In focusing on the eyes of Gutete Emerita, Jaar returns to the most basic human encounter, eye to eye, and begins again.

The Rwanda works finally return to the one thing that photographs can do well; they can fix an image in memory, so that it is not forgotten. Though it is not enough in relation to the one million dead in Rwanda, it is something.

1998

NOTES

1 Roland Barthes, "Shock-Photos," in *The Eiffel Tower and Other Mythologies*, trans. by Richard Howard (New York: Hill and Wang, 1979), pp. 71–72.

2 Andrew Jay Cohen, "On the Trail of Genocide," *The New York Times*, September 7, 1994.

3 Fergal Keane, *Season of Blood: A Rwandan Journey* (New York: Viking, 1995), p. 119.

4 Raymond Bonner, "Behind Rwanda's Disaster: A Plot by Extremist Hutu?" *The International Herald Tribune*, November 14, 1994.

5 Donatella Lorch, "Children's Drawings Tell Horror of Rwanda in Colors of Crayons," *The New York Times*, September 16, 1994.

6 The commander of a French marine unit, Lieutenant Colonel Erik de Stabenrath, said of the militias: "They were very courageous when they were killing people who could not defend themselves." Raymond Bonner, "With French Exit Near, Rwandans Fear the Day," *The New York Times*, August 9, 1994.

7 Michael R. Gordon, "U.S. to Supply 60 Vehicles for U.N. Troops in Rwanda," *The New York Times*, June 16, 1994.

8 Elaine Sciolino, "For West, Rwanda Is Not Worth the Political Candle," *The New York Times*, April 15, 1994.

9 John Darnton, "Africa Tries Democracy, Finding Hope and Peril," *The New York Times*, June 21, 1994.

10 Philip Gourevitch, "Letter from Rwanda: After the Genocide," *The New Yorker*, December 18, 1995, p. 87.

11 Sciolino, "For West, Rwanda Is Not Worth the Political Candle."

12 Philip Gourevitch, "Among the Dead," *Doubletake*, Winter 1998, p. 85.

13 Paul Lewis, "U.N. Backs Troops for Rwanda But Terms Bar Any Action Soon," *The New York Times*, May 17, 1994.

14 Hoggart, quoted in Stephen Kinzer, "European Leaders Reluctant to Send Troops to Rwanda," *The New York Times*, May 25, 1994.

15 Alan Riding, "France Seeks Partners for Rwandan Venture," *The New York Times*, June 17, 1994.

16 "Who Will Save Rwanda?," *The Economist*, June 25, 1994.

17 Mahmood Mamdani, "Understanding the Rwandan Massacre," *New Left Review*, no. 216, 1996, p. 28.

18 Raymond Bonner, "Grisly Discovery in Rwanda Leads French to Widen Role," *The New York Times*, July 1, 1994.

19 Raymond Bonner, "As French Aid the Tutsi, Backlash Grows," *The New York Times*, July 2, 1994.

20 Richard D. Lyons, "Airlift Shifts Into High Gear To Supply Refugee Camps," *The New York Times*, July 24, 1994.

21 James C. McKinley, Jr., "Searching in Vain for Rwanda's Moral High Ground," *The New York Times*, December 21, 1997.

22 Keane, *Season of Blood*, pp. 29–30.

23 Hannah Arendt, *Eichman in Jerusalem: A Report on the Banality of Evil* (New York: The Viking Press, 1963), p. 250.

24 Steven Lee Myers, "Making Sure War Crimes Aren't Forgotten," *The New York Times*, September 22, 1997.

25 Lucy Lippard, *Six Years* (New York: Praeger Publishers, 1973), p. 180.

26 Rubén Gallo, "Representations of Violence: The Limits of Representation," in *Trans* 3/4, 1997, p. 57.

27 Vincenç Altaió, "Europe or the Difficulty of History," essay in *Europa* exhibition catalog, Institut für Auslandsbeziehungen, Stuttgart, 1994.

28 Gallo, "Representations of Violence," p. 66.

29 Holland Cotter, "Alfredo Jaar," *The New York Times*, May 12, 1995.

30 John Berger with Jean Mohr, *Another Way of Telling* (New York: Pantheon Books, 1982), p. 100.

31 Gallo, "Representations of Violence," p. 61.

32 Keane, *Season of Blood*, pp. 68–69.

BEAUTY AND THE BEAST, RIGHT BETWEEN THE EYES

Reflections on a Book of Images by Miguel Rio Branco

Darwin suspected that there was always "something left over" after sexual attractiveness has done its work, and that this something was what we call beauty, and that it may have given rise to art.
> —Guy Davenport, *A Balthus Notebook*

I am your mirror, Beauty. You reflect me. I shall reflect you.
> —The Beast, in Jean Cocteau's *Beauty and the Beast*

There is no ecstasy of Beauty in which I will not remember Man's misery.
> —Robert Duncan, "In Blood's Domaine"

Beauty has no other origin than the singular wound, different in every case, hidden or visible, which each man bears within himself, which he preserves, and into which he withdraws when he would quit the world for a temporary but authentic solitude.
> —Jean Genet, "The Studio of Alberto Giacometti"

The seed of the whole drama is there, right between the eyes. In the beginning, between the man's eyes, appears a woman's face—flushed in blue, eyes closed, lips pursed—the face he sees in ecstasy and can recall at any moment. And at the end, between the woman's eyes—one open, one closed—runs a river split and serpentine, cutting canyons into the desert. The rest happens inside—between union and disintegration, memory and oblivion, cool blue spring (the mermaid's mirror) and heat-blasted desert. Projections on a screen, behind that glowing golden damask curtain—the mise-en-scène is set.

Miguel Rio Branco, *Neck & Hand*, New York, 1970

Inside, we find an image of Jean Marais as the Beast, gazing into the face of Josette Day's Beauty for the first time, already in love, next to a ruined mirror drenched in gold, under a hanging bouquet of forbidden roses. (Cocteau: "It is very probable that this rose is one of the jaws of a trap which will now ensnare Beauty through all eternity.") And a little further on comes a deadly coup d'oeil, that glimpse of perdition in the flayed bull's eye, like the eye of a raging storm, still, as the woman in a red dress flees.

The grand gender drama is both symptomatic and symbolic—the visible wounds of invisible contests—and so is unconstrained by biology or other circumstantial evidence. In the frontispiece, we see a couple from behind, framed from knee to neck. The man wears a green sport coat and checked slacks; the woman black stretch pants, turquoise sash, and brown velvet vest. The bloodstains in the middle of her back and on his left sleeve mark and implicate them in a common crime of violence.

In fact, this image shows two young male *novilleros* (matadors-in-training) at a bullfighting school in Madrid. The appearance is the same, and the symbolic extensions work either way. In a bull-fight, the matador actually represents the feminine principle, pitted against the masculine bull. Over and over, the matador's heart-shaped scarlet cape yields to the bull, turning the bull's own charges against himself. The matador relies on intelligence, skill, and cunning to defeat the bull's brute force. When the bull lowers his head just before impact to maximize the force of his charge, he takes his eyes off the matador for a split second, and so becomes vulnerable to a perfectly aimed thrust of the previously veiled sword.

Portuguese bullfights are bloodless in that the bull is not killed in the ring. The Spanish don't consider these real bullfights—they call them *simulacros*. When I lived in San Francisco, we used to drive out into the San Joaquin Valley on weekends and go to the fights in Escalon and Gustine, where Portuguese ranchers originally from the Azores raise fighting bulls. California state law permits bullfights only when they are connected to a religious festival, but there were always more than enough of those to allow a full schedule of fights.

The bulls were fought from the horse by the Portuguese and from the ground by matadors from all over, but the best thing about the San Joaquin fights were the *forcados*—teams of local, mostly high-school-age guys who came in at the end to finish the show. At the appointed time, eight of them would leap over the wall into the ring with the bull, and quickly line up single file behind the leader or catcher. With their hands on their hips, dressed in their finery, they strutted around the ring until the catcher caught the attention of the bull and approached him, shadowed by his seven teammates. Looking directly into the bull's eyes, the catcher drew the charge. As the bull pounded toward him, he took three, four, five steps back. When the bull lowered his head just before impact, the catcher lifted his arms and went up over the horns of the bull, wrapping his arms back under them. The other *forcados*, lined up behind, took the charge in turn, one after the other, like a human shock-absorber. When the bull's charge was spent, one of the *forcados* grabbed the bull's tail and pulled it around toward his head, turning the bull against itself and bringing it to a standstill. Then, at a signal from the catcher, the *forcados* broke as one away from the bull and ran for cover.

Of course, this method hardly ever worked. More often than not, the bull charged out of direct line, or raised its head too soon, or otherwise failed to cooperate, and the *forcados* were mowed down like grass, or gored and thrown off to the sides like roadkill. But when it worked, it was a thing of great beauty and grace. Time stopped, the sun increased in brightness, and ugliness disappeared, just for a moment.

The *forcados* were visibly changed by their experience with the bulls. They were calmer, less destructive, less tortured by doubt than other adolescent males. Many of them became quite introspective. They might not have known anything about the labyrinth or the double-ax or the bull-leapers in a thirty-five-hundred-year-old fresco on a wall in Crete. But if you asked them about it, they would tell you that something happened to them when they went between the horns of the bull, that they saw things differently there and from then on.

What goes between the eyes is often concealed beforehand—veiled or masked in order to better slip between worlds. According to the ancients, the pineal gland, located right between the eyes, is the seat of the soul, acting as a link between the visible and invisible worlds. But the eyes must rely on the evidence of appearances, that which is revealed by light. The great Cuban poet José Lezama Lima wrote that "Light is the first visible animal of the invisible." He meant that it is a double agent. And it is an animal that is born and dies many times in the course of a day.

Photography is light-writing, the language of images. Less abstract than written or spoken language, it selects images from the existing world of appearances and arranges them in patterns. The camera-eye doesn't think, it *recognizes*. It shows us what we already know, but don't know that we know. Its syntax is less constrained than its grammar, so the way images are put together is important. In the hands of Rio Branco, the montage becomes poetry—specifically tragic poetry. Like all tragedy, it focuses on two essentials: courage and the inevitability of defeat. These are enacted through the images, rather than illustrated by them. At the beginning of his book *Dulce Sudor Amargo* (Sweet sour sweat, published in Mexico by Colección Río de Luz, 1985), Rio Branco placed an epigraph from Goethe: "Color is the expression and suffering of light." In his best images, color pushes up into an intensity that occurs only when light is dying or being born—at dusk or dawn or any other time these extremities are induced. His colors vibrate between mourning and exaltation. A little boy, standing naked in a sink at dawn being washed by his mother, looks into the camera with a perfect mixture of wonder and terror, and glows incarnadine.

Borges said: "There is no chance; what we call chance is our ignorance of the complex machinery of causality." A glimpse, a glance—an image—may contain a wealth of information about the relations between things: among three green coconuts and a machete on a stone slab and a conversation in the street, or between the blood-red tape that wraps the ropes around a boxing ring and the

sinews that hold the heart in place. Things may appear unexpectedly, but inevitably, in place—like a mirror in a rainforest, or a mermaid on the ceiling. And the discrete gestures of a deaf and dumb boy, or the movements of the *capoeiristas*, become hieroglyphs in a language of images.

In Rio Branco's images colors become characters, with their own histories, attributes, and roles to play. They move around one another like the *capoeiristas*, in that kind of fighting that is also a dance. The red in a doorway waits, around the corner from a white silk wedding dress. Blue trousers straddle a ladder to raise a veil over spread red legs, across from a rosy striptease, just before a lioness, bathed blood-red, leaps through yellow flames.

Long before Brazil was a country, it was a color. Medieval European painters used the rich red dye made from brazilwood (*Caesalpina*) to obtain transparent reds in dark passages, and the rose to purplish-pink inks used in Italian Renaissance drawings were mostly made from brazil. Rio Branco's Brazil is constituted primarily of color, from the golden curtain in Bahia to the starry firmament of a blue veil swirling around a dancer in Rio's Carnaval, to the red coming out through Saint Sebastian's pores. The colors in Rio Branco's images often work like dyes, saturating and staining what is around them. A gutted turtle stains the hands that grasp it, the banana leaves below, and even the four feet of the onlookers, crimson. The fruit of a *jambon* (rose-apple) tree explodes and sprays the darkness with red-violet. And a canary-colored wall at the Santa Rosa boxing academy sweats red, staining the woman who moves away from it.

These colors are carnal, in a way that makes everything seem alive, or once alive. A TV breathes, biomorphic in the dark, before the gaze of the body-painted Kayapo (what, exactly, are any of us native *to*?). Many of the images are like Canopic urns: containers to hold the remains of the dead. Again and again we get the mortal remains, the carcass that is no longer activated by life but now by *light*. In an image from after a bullfight, a bloody horn curls into a

ART CENTER COLLEGE OF DESIGN LIBRARY

black tip in the foreground, while the bull's flayed corpse glows transcendent behind, like liquid fire. And in another image, made after a cockfight, we get that magnificent feathered back, like the back of a fallen angel, with wounds where the wings used to be. Even the tattered bluejeans seem to sheath a shade, defeated yet resplendent, before a smoky Lethe.

At the entrance to the House of the Tragic Poet in Pompeii, archaeologists uncovered a mosaic from 79 A.D. depicting a dog baring its teeth and straining against a leash, over the inscription *Cave Canem*, "Beware of dog." Dogs appear in Rio Branco's images as slothful scavengers, devoted attendants, or disinterested witnesses, but most often they are juxtaposed with human tragedy. An early image from New York showing a sleeping drunk leaking saliva on a Bowery bench is paralleled by one of a dead dog in the foreground, pressed close to the lens, with a dark building looming up behind. And in one of Rio Branco's signature pairings a man dead or sleeping on the pavement is juxtaposed with a dog in the same position and condition, forming an abjection equation. What is the difference between a man lying in the street with his ass hanging out and a dog in the same state? Diogenes, the Cynic, would have said that we have been led to expect more from the dog. If Rio Branco (who was born in the Canary Islands—those "Isles of Dogs") is a cynic, he is one in the line of Diogenes of Sinope, who, when he ran into Alexander the Great in the street, had this exchange:

A: *I am Alexander the Great.*
B: *I am Diogenes, the dog.*
A: *The dog?*
B: *I nuzzle the kind, bark at the greedy, and bite louts.*
A: *What can I do for you?*
B: *Stand out of my light.*

(Guy Davenport's translation)

Rio Branco's eyes love light, following it wherever it leads: from a painted red door in a Maciel bar to a young girl's arm bent impossibly back behind her at the entrance to an emerald mine; and from

a man's tattooed torso behind bars to a woman in a pink dress leaning over an iron railing in Havana with an agony column of names behind her: Claudio, Cosimo, Ibis . . . Omara, Lapera, Blanca.

These images have an especially intimate relation with Darwin's "something left over." They find it wherever it is hidden—in garbage heaps and slaughterhouses, at pissoirs and cockfights, and of course in the brothels of Brasilia, Luziania, and the Maciel *zona* of Salvador, where what is left over "after sexual attractiveness has done its work" is not often beautiful. Still, Rio Branco finds it again and again: in a woman turning away from a red wall, framed first in a green doorway and again between a white shirt on a line above and white platform shoes below, while just beyond her gaze and grasp a bouquet wilts in deference, or sympathy. Or in the woman sitting naked in a window, bringing her right hand to her crucifixed heart to mimic the gesture of Christ on the wall behind her, while her left hand touches an ivory Venus and flowers grow up between her legs. Or in the black odalisque who lets in the light to illumine a wall of white-bread images of surrogate desire over her crimson bed. Even the most degraded of spaces—those airless duplexes of love and commerce—are transformed. Before façades glowing red and blue, and a jukebox sadder than a coffin, a disabled vehicle flames out like a star, and a dark horse out of nowhere passes, riderless. ("Go where I am going. Go, go.")

On the back of Leonardo's portrait of Ginevra de' Benci is painted the inscription *Virtutem forma decorat*, "Beauty adorns virtue." This is true as far as it goes (and surely it was true of Ginevra), but as an axiom it falls short. The truth is, beauty adorns everything. Rio Branco's images revel in the ministrations of beauty—adornment, ornamentation, decoration—recognizing that beauty can be "made up," insisting that it *must* be made up. When they take everything else away from you, beauty is what you have left. The most beautiful face I've ever seen was my mother's as she died.

The relation between physical beauty and virtue is neither accidental nor direct. The rouged cheeks and blue-shadowed eyes of Rio Branco's "Mona Lisa" *are* "the lineaments of gratified desire."

The red flower behind the laughing woman's ear, the bejeweled arms and painted nails of the one who eats, the body painting and elaborate ornamentation of the Gorotire and Kayapo, the transvestite being made up, the one-armed boxer, all of these are not separate from the contest (*agon*) whose reflection is brutality. Beauty always reflects, and is reflected by, that other. All contests (literally, "coming together to bear witness") are *simulacros* of the one between life and death, the one we all eventually lose. It is Beauty's grief for the suffering Beast that breaks the spell and causes him to be transformed.

Rio Branco's book is a vision of Brazil, certainly (and New York, Paris, Seville, Bilbao, Havana), but it is also an imagination of a world beyond appearances, where Beauty is finally able to make the Beast forget his ugliness, so that they may both roam free as the lions in Rilke's fourth elegy, "all unaware, in being magnificent, of any weakness."

<div align="right">1998</div>

A SECOND
GAZE

The real Hotel Polen was a relic from the 1930s that burned to the ground in Amsterdam in 1977. Wandering through a junkshop in that city, Polish-born artist Ania Bien happened upon a silver menu stand that had survived the inferno, and began to put images into it.

Bien's *Hotel Polen* became a series of eighteen wall panels measuring 47 by 76 inches, on which are printed enlargements of as many small images, all held by the Hotel Polen sign. The show was designed for the Humphrey Gallery at the San Francisco Museum of Modern Art, but has been recreated for other locations in Amsterdam, Munich, Copenhagen, and New York, and is now permanently installed in the Israel Museum in Jerusalem.[1]

Bien managed to take advantage of the spatial limitations of the Humphrey Gallery by closing off both ends of its long narrow corridor; thus when a spectator entered the corridor, he or she was *inside* the show, and had to make a decision to leave. The size and arrangement of the wall panels made it impossible to scan the images. Instead, visitors had to view each panel separately, one after another—like turning the pages of a book, while standing inside the book.

The single images on the wall panels are mostly "simple" and straightforward: a view of a hotel balcony with guests on benches and mountains beyond, a luggage tag with the name "Józef Bién" printed on it, a typical family group portrait, a section of a map. . . . The simplicity of means is disarming, and rapidly leads to an extraordinary sense of intimacy. The antique Hotel Polen menu stand acts to pull the initially disparate images together and up to human scale, and also to foreground the guileless presentation.

Hotel Polen is a work of fragments and silence, using the simplest of means to overcome resistance to technique and reach a soli-

Ania Bien, from the installation *Hotel Polen*, 1986

tary viewer. The images, and the silences between images, begin to take on the quality of remembrances. The hotel could be anywhere, on a certain kind of day. The people in the group portrait hold themselves erect and gaze out of the frame, like any family. The bluebird on the card (why is it clearly a bluebird? The images are all in black and white) is familiar—the kind of talismanic image each of us acquires by accident, over time, and keeps in a drawer with other bits and pieces of our lives. There is a photograph of a woman lying in a field, posing not quite seductively, an oval photograph of a German shepherd dog, with the name "Lux" written over it in pencil, and a rectangle of delicately patterned material, embroidered with flowers in a regular design. It happens slowly—only as we move back and forth among the images for a while—that we begin to recognize that we have entered into an elegy, and this recognition is as slow and as painful as the recovery of an amnesiac.

The time of *Hotel Polen* is intentionally nonspecific, but the images gradually regain their memories, and will not remain silent. The sixth panel in the series is a small square cut from a larger map of Poland ("Polen" is the Dutch name for Poland). In the center of the square is Kraków, with lines radiating out in all directions. One of these lines passes through a small town named Oswiecim, whose parenthetical German name is Auschwitz. The eighth panel contains a small grainy photograph of a man whose eyes have disappeared in shadow. He is dressed in the vertically striped shirt and tag of a concentration-camp detainee. On the opposite wall, in the fifteenth position, is a similar photograph of a woman in a white scarf and the same striped prisoner garb. This "twentieth-century Adam and Eve"[2] emerge "under the date of no human day in September," as Paul Celan, perhaps the greatest of the postwar European poets, named it: the first day of September in 1939, when the Germans invaded Poland and inaugurated the extermination of European Jews.

All who attempt to speak of or to transform the material of that dark (present) time face the threat of muteness. Katherine Washburn, a translator of Celan's *Last Poems*, characterized the Celan of

legend as "the musician of the Holocaust struck dumb by terror and anxiety, who ends by making a burnt offering of language itself."[3] Celan himself described the progress of his own poetic career as "*still geworden,*" "becoming silent." After surviving a Nazi labor camp and the murder of his Romanian Jewish parents by the S.S., Celan finally committed suicide in Paris in 1970, throwing himself into the Seine. His poems are filled with images of severed tongues, crippled hands, and mouths stuffed with earth.

When Theodor Adorno claimed that, after Auschwitz, "to write a poem is barbaric," French poet Edmond Jabès replied that it was not only not barbaric, it was necessary, and proceeded to make a "writing-in-the-Holocaust," questioning the nature of representation itself for a generation of French writing.[4]

When the social fabric was forever rent, we were left with *fragments*—never again a complete and seamless narrative. In antithesis to the *Gesamtkunstwerk* (total, unified work of art), *Hotel Polen* is a polysemous work of surviving fragments and silence. It is a work of absence, in which what happens *between* the images is most important.

Trained as a painter and in cultural anthropology, Ania Bien has spent the past fourteen years exploring the nature of the photographic medium and manipulating its particular properties in order to reveal essences. All of this time, she was building a grammar and syntax and a vocabulary with which to speak.

In 1980, Bien's piece *Transient Matter* called attention to the fragility of photography by exhibiting a framed photograph high on a wall over a wastepaper basket overflowing with crumpled prints of the same image. In 1981 she produced a piece titled *One Unknown German Soldier—Two Unknown German Soldiers—Three Unknown German Soldiers (Mathematics of the Absurd)*, which depicted three white crosses marking the graves of six German soldiers killed in the war. In 1982, a show called "Transmigrations" was presented at Bertha Urdang Gallery in New York; it consisted of ten more or less conceptual pieces using the photo-series and/or the integration/juxtaposition of objects and drawings with photographs to further explore

the materiality and referentiality of photographs. One of these works, *Checkpoint Charlie* (now in the collection of the Israel Museum), consists of three square close-up photographs of the old East-West borderline in Berlin. On the left is the East Berlin pavement, on the right is the West Berlin pavement, and in the center is the white line that separated them.

All along, Bien has painstakingly pared her representations down, to uncover the central operational paradox of photography—its simultaneous enactment of iconic and symbolic modes of signification. In being "literally an emanation of the referent,"[5] a photograph asserts its uniquely iconic representational relation to the referent, while at the same time operating as an immaterial "emanation" away from (or outside of) the referent.

In reply to a series of questions from curator Van Deren Coke about her work, and *Hotel Polen* in particular, Ania Bien wrote: "In a way there is something very *immaterial* about photography. It is ideal in that sense. It is an ideal medium for working with ideas because it is so flexible, so immaterial."

Standing before the first panel in *Hotel Polen*, the viewer is reflected into the black frame, taking his own place on the presentation stand: the first image to be considered. Next comes a postcard showing several people sitting quietly on benches arranged in rows on the open-air terrace of a hotel. Beyond the white balustrade is a shadowed mountain vista, but none of the hotel guests seems to be looking in that direction. This is the signature self-reflexive image that begins and ends the *Hotel Polen* sequence. From the imprimatur in the lower-left corner we see that the image is reversed in the first position. So the tale begins backwards, as an unraveling. It is a retelling, a recovery, a remembering.

Following the aforementioned map of Central Poland in order is another sort of "map"—a crude crayon drawing. Chaos following the (artificial) topographical order? The first scribblings of a child? Or the first *representation*, in defiance of the oppressive order of political boundaries, of political renamings?

The same image follows both death-camp I.D. photographs. It pictures a different kind of landscape, a landscape reduced to a boundary—a wintry horizon, cutting foreground and background, from black to white, through shades of gray, bisecting the frame. The mourning of the image. This is a landscape familiar to Celan. As Washburn puts it: "The thing made is open to entry, but must remain forever open to the unsaid, the drift of snow. It is the tenancy of silence, erected to lie open to what cannot be given human utterance."[6]

Following the Adam image and the wintry horizon is an image of a chessboard—black-and-white squares occupied by a rook, a knight, and two pawns. The perspective puts us above the playing board, but nothing we do will allow us to move the pieces. They are frozen there forever.

Following the Eve image and the wintry horizon is the rectangle of fabric, embroidered with tiny flowers—a pattern of human recurrence.

The papyrus-shape of the Hotel Polen stand, repeated around the room, makes one think of flowers—flowers spreading "pollen," dust to dust, following the Diaspora, not to forget. This kind of proliferation of meaning, through rhyming and extended correspondences, is a prevalent feature of *Hotel Polen*, and actually increases its coherence over time.

Some readings are bound to be symbolic—the hotel is the place of untroubled life in peace; the German shepherd is control by force (the conjunction of the wild and the domestic); the bluebird is the lyric spirit, surviving adversity—but the real fascination of *Hotel Polen* is that its constitutive images are less symbolic than actual, cathectic, being an arrangement of referent-emanations in *cathexis*, reaching the reader with the force of their own haecceity (*thisness*).

As Allan Sekula has so effectively demonstrated, photographic meaning is at present essentially conditional: "The photograph is an 'incomplete' utterance, a message that depends on some external matrix of conditions and presuppositions for its readability."[7] Twenty years ago, perhaps even ten years ago, *Hotel Polen* would

have been virtually unreadable. Its present legibility is due to the fact that these images occur along existing lines of socially determined meaning. We have now seen enough of such images (through private picture-taking and public consumption) for them to trigger already active considerations. We *recognize* these images. We name them, and in so doing participate in the elegy: "To be named . . . perhaps always brings with it a presentiment of mourning."[8] This naming, intimately connected to the process of photography, is essentially elegiac: "And the person or thing photographed is the target, the referent, a kind of little simulacrum, any *eidolon* emitted by the object, which I should like to call the *Spectrum* of the Photograph, because this word retains, through its root, a relation to 'spectacle' and adds to it that rather terrible thing which is there in every photograph: the return of the dead."[9]

Writing to Van Deren Coke, Ania Bien likened the experience of *Hotel Polen* to that of a certain film: "It is as if I myself had once been in Hotel Polen. In the sense like Marienbad"—as in the Resnais/Robbe-Grillet film *L'Année Dernière à Marienbad*, where images from the past are used to reconstruct a previous time, which is always in doubt, always deferred. "X" hands the woman called "A" a photograph and asks: "Do you remember this?" But she does not remember anything about last year at Marienbad. She is shown "evidence"—photographs—but they are only representations. How can one remember a representation? Still, the elements should all add up, to something. Something did happen. "There is no last year, and Marienbad is no longer to be found on any map." The town is renamed Oswiecim, and Nazi propagandist Fritz Hippler retires to Bavaria. "Nazi anti-Semitism is not simply an historical phenomenon for which we can determine the causes and sociological structures. . . . If it is that, it is also something else: the manifestation of pure violence addressed without motivation to the other, simply because he incarnates the scandal of *another existence*."[10]

The images in *Hotel Polen* emerge from the darkness of that past. In the linkages between these images, we read the story of a partic-

ular time and place because we cannot help doing this. But the implications extend, in us. As Jabès wrote:

> *If the Jew is "the other," it is because by trying to be, at any price, himself, he is each time* more, *a being from nowhere. That is where his difference, and the distance at which he maintains himself, is inscribed.*
>
> *I would even go so far as saying that this* more—*which is, in fact, a less as it is an emptiness that always has to be filled—is his only difference. That lack is the source of his questioning.*
>
> *That is also why his gaze cannot stop at the level of simple appearances. To his eyes these are never more than a stage. It is as if he had a second gaze widening the visual field excessively and giving credit to the idea that behind every reality there lies an even more tangible reality.*[11]

If a photograph is "literally an emanation of the referent," then photography can conceivably be used to let things speak for themselves. If this luggage tag, this family portrait, this scrap of fabric could speak, what would they say? If one could make a context in which these things could speak, turning it over to the referents and their emanations, what would they tell us? In *Hotel Polen*, they tell of "an even more tangible reality," before and behind the image, beyond appearances.

1989

NOTES

1 A catalog of the exhibition, including Forewords by gallery owner Bertha Urdang and curator Van Deren Coke and an Afterword by Dutch critic Cor Blok, was printed in Amsterdam.

2 Ania Bien, in a letter to Van Deren Coke, February 1987.

3 Katherine Washburn, in her Introduction to *Last Poems: Paul Celan*, trans. by Washburn and Margaret Guillemin (Berkeley, CA: North Point Press, 1986).

4 "In the last ten years, nothing of interest has been written in France that does not have its precedent somewhere in the work of Jabès."—Jacques Derrida

5 Roland Barthes, *Camera Lucida: Reflections on Photography*, trans. by Richard Howard (New York: Hill and Wang, 1981), p. 80.

6 Washburn, *Last Poems: Paul Celan*, p. xiii.

7 Allan Sekula, "On the Invention of Photographic Meaning," in *Thinking Photography*, ed. by Victor Burgin (London: Macmillan, 1982), p. 85.

8 Walter Benjamin, *The Origin of German Tragic Drama*, trans. by John Osborne (London: NLB, 1977), pp. 224–225.

9 Barthes, *Camera Lucida*, p. 9.

10 Robert Misrahi, *La Condition réflexive de l'homme juif*, quoted by Maurice Blanchot in "Interruptions," trans. by Paul Auster and Rosmarie Waldrop in *The Sin of the Book: Edmond Jabès*, ed. by Eric Gould (Lincoln, NE.: University of Nebraska Press, 1985), p. 54.

11 Edmond Jabès, *From the Desert to the Book: Dialogues with Marcel Cohen*, trans. by Pierre Joris (Barrytown, NY: Station Hill Press, 1990). First published in *ACTS: A Journal of New Writing*, 1986.

AFTER YOU, DEAREST PHOTOGRAPHY

Reflections on the Work of Francesca Woodman[1]

*Everything comes down, in the final analysis, to taking account of
the relations of light which, from the point of view of knowl-
edge, should perhaps be considered in its very simplest details.*
— André Breton, *L'Amour fou*

Because time is out there, eaten by light.
— Norma Cole, "Spinoza in Her Youth"

The first photograph we have, in time, is a self-portrait of the artist
at age thirteen. It already reveals the gestural clarity and emotional
depth that will drive the work to come. Francesca Woodman sits
sideways on a sort of pew, her head turned toward the camera and
tilted forward, bowing, so that (like the fair-tressed Ariadne) her hair
hangs down over her face, which is further obscured by shadow. She
is dressed in a heavy cable-knit sweater and jeans. Her right elbow
rests on the pew's arm so that her right hand hangs suspended in
light, relaxed and expressive, while her left hand is tensed and extended
to grasp the cable release, stretched taut to the camera. The cable (or
rod?) widens as it nears the lens, forming a black dagger shape that
cuts diagonally back toward the sitter. That enhanced line represents
both release and bondage, bridge and tether: Ariadne's thread.

The constitutive facts of Francesca Woodman's life are by now
well known. We know that she was born in 1958, the daughter of
artists George and Betty Woodman, that she began taking photo-
graphs seriously at age thirteen or fourteen and continued this
involvement into her twenty-second year, building up, in this brief
time, a remarkably coherent and affecting body of work. And we
know that on January 19, 1981, not long before her twenty-third

Francesca Woodman, *i could no longer play . . .* ,
Providence, Rhode Island, ca. 1977

birthday, she took her own life, leaping from a window on the Lower East Side in Manhattan to her death.

This latter fateful knowledge cannot help influencing the way we view her art. Because these are photographs, "evidence of a novel kind," our projections are inevitable. As Roland Barthes and others have pointed out, paintings and drawings are iconic, while photographs are indexical; that is, they always point to something else. Woodman's images are haunted, as all photographs are, by death, but these harbor additional ghosts.[2] Because they are self-portraits of a particular kind, we scrutinize them for clues to their untimely cessation. But we would be missing a great deal of substance if we confined our viewing of these images to an overly forensic search for a corpus delicti.

From the beginning, Woodman's relation to the camera was intense, never casual. She did not take the transformations it wrought lightly (becoming an image is a secret process, a mystery). Recognizing right away that this "mirror with a memory" could be the stage for an inquiry, she organized her work into etudes, exercises, and experiments—what Rosalind Krauss termed in her essay on the work "problem sets."[3] Often responses to specific assignments in school, these sets in time became a working method. The artist remarked on the origin of this method in a notebook entry: "What happened is I played the piano for a long time. The pieces I played most were themes on variations, Scarlatti, etc. This occurs in my imagery." In a series produced in Providence in 1976 and 1977 when Woodman was a student at the Rhode Island School of Design, the musical model is made explicit.

An image of her nude figure crouched and bowing before a scarred wall, with a torn sheet of wallpaper covering her back like a shell, and her hands caressing the wall like a keyboard, is captioned: *Then at one point I did not need to translate the notes; they went directly into my hands.* Another remarkable self-portrait shows her dressed in a black brocade gown, opened to reveal one breast. The upper edge of the frame cuts off her head at the chin; a compensatory piece of

white lace hanging down into the frame on the right. Under the image is scrawled: "When i started again" (this line appears under erasure, obscured by a brushstroke) "i could no longer play. i could not play by instinct." From her right hand dangles a small knife with a curved blade, in motion, and from a cut under the line of her breast emerges a strip of photo-booth self-portraits, spattered with real or simulated blood. No longer playing by instinct, her body has become an automatic producer of images that issue from a self-induced wound. All she needed to do, for the images to come, was open the wound.

In a photograph from the same time, the artist/model sits on the edge of a white chair, wearing only a pair of black shoes. She is seen from the waist down, and before her on the floor is a shadow-graph, the negative impression her prone body has made in white powder, mimicking the impression light makes on silver salts. In another, she kneels on a heavily framed mirror placed flat on the floor. Her head and upper body are in motion, so that her face is distorted, and only her legs and one hand are in focus. And in the series titled "A Woman/A Mirror/A Woman Is a Mirror for a Man," that same heavy mirror, now stood upright in a corner of the studio and tilted in its frame, is again the ground for her actions. She turns away from it, embraces it, gazes into it, and, in the final image, places herself awkwardly between it and a sheet of glass—between transparency and reflection—in an attempt to flatten herself into a complete image. Or perhaps she is attempting to go back through the looking-glass, into a world before the fall into representation and self-consciousness, before the gendered mirror-stage, before the wounds of image-making and being made into an image have been inflicted.

In a single image related to her "House" series of 1975–76, the artist appears as Alice, in a Victorian-style dress. She looks directly into the camera and gestures oddly with her hands and arms toward a door ajar, drawing it open to the darkness beyond, the seductive camera obscura.

Now we come to the passage. You can just see a little peep of the passage in Looking-glass House, if you leave the door of our draw-ing-room wide open: and it's very like our passage as far as you can see, only you know it may be quite different on beyond.[4]

Because of Woodman's age when these works were made (thir-teen to twenty-two), it would be retroactively premature to try to place them definitively in the context of other work being done in photography at the time. In her feminist reading of Woodman's work, Abigail Solomon-Godeau calls it the work of a prodigy, noting that "prodigies in photography are singularly rare; women prodigies vir-tually unheard of."[5] Growing up with artist parents and friends, Woodman knew a great many things about how art happens that young artists often spend half a lifetime discovering (or rediscover-ing): that seeing and making are not the same thing, that making has a logic of its own that must be attended to, that ideas are cheap and embodiment dear, that art is the *labor* in the process of creation, that life is short but art is long. Consequently, her youthful work is not a series of false starts and forays, but rather the substantially realized fragments of a whole that was defeated by time. This was a real inquiry, however incomplete.

That said, it remains the work of youth and inexperience. And as such, as both Solomon-Godeau and Krauss asserted in their intro-duction of Woodman's photographs to the public in 1986, it is dif-ficult to place this work in the chronology of the institution of art photography (Krauss uses the term "Straight Photography"). But I believe Solomon-Godeau too quickly dismisses the connection to the one tradition with which it can usefully be compared: surreal-ist photography.[6] It is not, after all, so great a distance from the book-store called Humanité in Paris to the one called Maldoror in Rome.

The relation of Woodman's work to surrealist photography is not primarily one of style, although its focus on transformations and deformations of the female nude, its attraction to romantic ruins and dilapidated interiors, and its use of fetish and found objects ("those object-talismans surrealism still cares so much about"[7])—gloves,

swans, umbrellas, costume jewelry, and mirrors—are surrealist tropes, and a number of single works (such as the "*explosante-fixe*" before the wall in Rome) and sets (such as the "veiled-erotic" of "Horizontale/Verticale") could almost have been made by Man Ray or Lee Miller. But by the time Woodman stopped making photographs, surrealist style had been thoroughly absorbed into the "corporate surrealism" of product advertising and fashion photography, where desire is downsized into consumer choice. Surrealist style had already become a cliché.

But Woodman's work participates not so much in the surrealist *style* as in its *substance*, its original revolutionary desire to crack the code of appearances and see through the looking-glass. As Krauss has shown, photography and surrealism were made for each other. In her essay "Photography in the Service of Surrealism," Krauss writes that surrealist photography "exploits the very special connection to reality with which all photography is endowed. Photography is an imprint or transfer of the real; it is a photochemically processed trace causally connected to that thing in the world to which it refers in a way parallel to that of fingerprints or footprints or the rings of water that cold glasses leave on tables."[8] Surrealists recognized photography's subversive potential in their assault on bourgeois values and reality, and on Straight Photography's narrow sense of realism. "Contrivance," writes Krauss, "is what ensures that a photograph will seem surrealist." In not admitting of "the natural, as opposed to the cultural or made," surrealist photography insisted on the utter *constructedness* of the real, including the categories of identity: "Within surrealist photographic practice, too, *woman* was in construction, for she is the obsessional subject there as well. And since the vehicle through which she is figured is itself manifestly constructed, *woman* and *photograph* become figures for each other's condition: ambivalent, blurred, indistinct, and lacking in, to use Edward Weston's word, 'authority.'"[9]

In Woodman's work, we see a young woman making it up from the beginning, recognizing no authority outside of her intimate relationship to the camera, and claiming no authority outside the frame

of her photographs. This is a scandal in the house of Straight Photography. Whereas photographs most often trace the relation between the one photographing and the one photographed, in Woodman's images that relation is collapsed. The result is not the closed circuit of narcissism (which all women photographing themselves are accused of inhabiting), since it always imagines an other, a viewer outside (space and time). The playful eroticism of Woodman's odalisques is neither narcissism nor deconstruction of the male gaze, since these images are clearly directed outward, to an other. This other—whether an individual or the camera—is actually the Narcissus to Woodman's Echo. When Woodman looks in the mirror, she is looking in the mirror *for the camera*, which is us, since the camera is our temporal representative. Given that cameras have most often been in the hands of men who want to look at women, a beautiful young woman handling her own camera is always a subversion.

Krauss locates the concept of "convulsive beauty" at the very core of the surrealist aesthetic, a concept that she says "reduces to an experience of reality transformed into representation." And in his *L'Amour fou*, Breton asks "that we look for a new beauty, a beauty 'envisaged exclusively to produce passion,'" and describes the operations of convulsive beauty in characteristically uncompromising terms: "There can be no beauty at all, as far as I am concerned—convulsive beauty—except at the cost of affirming the reciprocal relations linking the object seen in its motion and in its repose."[10]

Again and again in Francesca Woodman's photographs, the body—her own body—is caught at that precise point where motion becomes repose, where a fleeting gesture settles onto paper. Often the body is in motion while another object of focus (a mirror, a wall, a bolt of fabric, or a basin coiled with eels) is seen at rest. Or one body is in motion while another rests (in the vitrines of *Space²* or the studio of "Charlie the Model").

Woodman's "Charlie the Model" series is a moving meditation on the exigencies of representation. In the beginning, an affable-looking middle-aged man stands in for the artist, giving her a chance

to reflect on the condition of being turned into a photograph from the other side of the camera (later, she cannot resist joining Charlie on stage, leaving her friend Sloan Rankin to release the shutter). In the first image, Charlie the model, dressed in a white T-shirt and slacks, holds a sheet of glass in front of him and looks into the mirror, on which is written his name. Under this print the artist has written "Charlie has been a model at RISD for 19 years. i guess he knows a lot about being flattened to fit paper." In this image appear three different modulators representing three elements of transformation: a sheet of glass (transparency), a mirror (reflectivity), and a window (illumination). Charlie stands in the corner formed by the wall with the window and the wall with the mirror. He holds the sheet of glass before him like a frame and leans into the mirror, forming a body bridge between window and mirror. Camera, mirror, corner, and window delineate a square that is rotated ninety degrees from the focal plane. In the last image in the series, Charlie sits on the floor nude, with his legs spread, holding the sheet of glass pressed awkwardly against his body. It flattens him. He closes his eyes and leans back against the mirror, in defeat. The caption reads "Sometimes things seem very dark. Charlie had a heart attack. I hope things get better for him." Becoming an image (being "flattened to fit paper") points toward death: we are all becoming images.

The manipulation of photographic space that Woodman explores in this series and elsewhere is sophisticated and clear, but I find her attempts to manipulate time even more compelling. These attempts reached an apogee in Woodman's last images, for the "Temple Project" in New York, in the spring of 1980. In one of these studies we see two female nudes, stripped to the waist and holding shallow fabric-covered boxes over their heads. The slight movement of the boxes causes a blur from the bottom of the frame to the top, so that our eye moves up the image and across to the left, in a way that implies a whole row of caryatids. Somehow, this contrived and otherwise banal image manages to move outside of time, evoking those archaic column-shafts in the shape of draped women of the Athenian

Erechtheum, or the earlier (late sixth-century B.C.) Siphnian Treasury at Delphi. These figures represent priestesses of Artemis Caryatis, who presided over female rites of passage, especially the transition from *parthenos* (virgin) to *gyne* (fully acculturated woman).[11] Woodman saw something in these figures that allowed her to simulate them photographically. Just as the ancient caryatids were a way to bring the female figure into space as an architectural element, Woodman's photograph casts these figures into time, into a participation in the archaic.

Another study for the "Temple Project" shows a wall in a bathroom: peeling paint over an ornate tile border, a sliver of a mirror, a round metal armature of some kind on a glass shelf, and a glass towel rod on which a white silk garment is wound in regular spirals. This bathroom could be in Pompeii. This image, too, is *out of time* in its archaic resonance.

Perhaps Francesca Woodman was herself out of time, exiled in the present. In her photographs, she materialized her condition and transformed it, manipulating appearances in order to move around in time. In her last images, for the "Temple Project," she accomplished this to an extraordinary degree. Perhaps it was not enough. Or perhaps the transformation continues undiminished, for she is here now, in her images.

1998

NOTES

1 The title refers to a line by André Breton that Walter Benjamin quotes in his 1929 essay on surrealism: "Quietly. I want to pass where no one yet has passed, quietly!—After you, dearest language."

2 "All those young photographers who are at work in the world, determined upon the capture of actuality, do not know that they are agents of Death. . . . Contemporary with the withdrawal of rites, Photography may correspond to the intrusion, in our modern society, of an asymbolic Death, outside of religion, outside of ritual, a kind of abrupt dive into literal Death. *Life/Death*: the paradigm is reduced to a simple click, the one separating the initial pose from the final print." Roland Barthes, *Camera Lucida: Reflections on Photography*, trans. by Richard Howard (New York: Hill and Wang, 1981), p. 92.

3 Rosalind Krauss, "Problem Sets," in *Francesca Woodman: Photographic Work*, catalog for the first showing of Woodman's work at the Wellesley College Museum and Hunter College Art Gallery in 1986.

4 Lewis Carroll, *Through the Looking-Glass, and What Alice Found There* (London: Macmillan and Co., 1872), p. 10.

5 Abigail Solomon-Godeau, "Just Like a Woman," in *Francesca Woodman*, 1986, p. 14.

6 Ibid., p. 36: "Certain correspondences or similarities that one might note between Surrealist photographs and Woodman's work are most likely fortuitous."

7 André Breton, *Mad Love*, English trans. of *L'Amour fou* by Mary Ann Caws (Lincoln, NE and London: University of Nebraska Press, 1987), p. 101.

8 Rosalind Krauss, "Photography in the Service of Surrealism," in Krauss and Jane Livingston, *L'Amour fou: Photography & Surrealism* (Washington, DC and New York: The Corcoran Gallery of Art and Abbeville Press, 1985), p. 31.

9 Krauss, "Corpus Delicti," in *L'Amour fou*, p. 95.

10 Breton, *Mad Love (L'Amour fou)*, p. 10. In her note on this passage, translator Mary Ann Caws sets out a serviceable genealogy of the surrealist aesthetic: "As cubism can be thought to be the picturing of an object many times from many angles of repose, and futurism to be the picturing of it in action, surrealism combines the two tendencies."

11 In Homer, Artemis is also a death-bringing deity, who brings sudden death to women, as Apollo does to men. When Odysseus addressed the shade of his mother in the Underworld, he asked her, "What fate of grievous death overcame thee? Was it long disease, or did the archer, Artemis, assail thee with her gentle shafts, and slay thee?" (*Odyssey*, XI: 171–173)

"I MYSELF WILL BE THE CHISEL"

Hannah Villiger's Sculptural Photography

My skin is itching and burning; my thoughts are restless and want something to eat; the eyes want to see, to think. They demand and bother me . . . my entire body is much too present . . . I need . . . to extinguish this feeling, to calm myself.
 —Hannah Villiger, "On My Book *Envy*"

That shadowless light. Simply to be gone. . . . A single leg appears. Seen from above. You separate the segments and lay them side by side. It is as you half surmised. . . . You leave the pieces lying there and open your eyes to find her sitting before you. All dead still.
 —Samuel Beckett, "Heard in the Dark 2"

For each of us space begins and slants off from our own eye, and from there enlarges itself progressively toward infinity. Space, in the present, strikes us with greater or lesser intensity and then leaves us, visually, to be closed in our memory and to modify itself there. Of all the means of expression, photography is the only one that fixes forever the precise and transitory instant. We photographers deal in things that are continually vanishing, and when they have vanished, there is no contrivance on earth than can make them come back again.
 —Henri Cartier-Bresson, *The Decisive Moment*

Is not this rather the place where one finishes vanishing?
 —Samuel Beckett, *The Unnamable*

The progress of Hannah Villiger's art, over the twenty-five years she was given to work (she was born in Cham in 1951 and died in Auw in 1997), was to pare down and simplify her means while building

Hannah Villiger, *Skulptural*, 1984–85

up and complicating what she could do and say with them: complete freedom within strict limits. In the end, it all came down to her alone in a room with a camera, photographing the inside (her own rapidly dwindling body) and the outside (the cityscapes of Paris from her open window), to form a complete, if condensed, picture of the world. The catalog for the first posthumous exhibition of Villiger's work, at the Kunstmuseum Lucerne in 1998, opens with a photograph captioned *Atelier Paris*, showing a small, spare room with white walls containing only an adjustable floor lamp on a long cord and a T-square hanging from a nail. All that is missing is the artist and her camera, her ideal companion in confinement.

From her beginnings as a sculptor, Villiger always sought the most economical means to materialize her sculptural ideas, and photographs increasingly came to fill this need. She used photography to document her three-dimensional sculptures and actions and also (along with drawings) to work things out and to think visually about sculptural problems. Her two earliest artist's books, produced in Rome, show that these two uses of photography were both operative in her work from the beginning. *Objekts 1975–76* consists of black-and-white photographs of small, freestanding sculptures, while *Sky 1975–77* is a purely photographic book, containing images of palm branches, balls, blimps, helicopters, airplanes, and birds suspended against a blank sky. A photograph of a burning palm branch falling through the air, with a view of the Amalfi coast far below, is all about scale and depth of field, and a photograph of a photograph of a palm branch lying on a table next to a plant in a glass of water provides at least three levels of abstraction. The sequencing of the images in *Sky* is very deliberate and, again, photographic.

Villiger recognized in photography a particularly effective way to investigate entropic actions: vapor trails from jets, dust raised by a speeding car, water sprayed from an irrigation pipe, hay being turned in a field, and the leaping and falling of flames. Her photographs of burning palms and ricocheting *pétanque* balls are conceptual images, but they avoid the anti-aesthetic deadpan pose of earlier

conceptual photography of the late 1960s and early 1970s by such artists as Ed Ruscha ("Various Small Fires," 1964), Douglas Huebler (*Duration Piece #7*, 1969), and Alice Aycock (*Cloud Piece*, 1971). Villiger's burning palms, especially, display an exuberance that thrusts them between conceptual and expressionist modes, more like the photoworks of Robert Smithson (I'm thinking especially of his "Mirror Displacements"). Like Smithson, Villiger had no interest in the "craft" of photography—in learning to make good negatives or prints—and was drawn as a sculptor into a photographic inquiry that had nothing to do with the conventions of art photography. Also like Smithson, she retained throughout her life a certain ambivalence toward the camera that sometimes edged toward fear, or envy. "There is something abominable about cameras," wrote Smithson, "because they possess the power to invent many worlds. As an artist who has been lost in this wilderness of mechanical reproduction for many years, I do not know which world to start with. I have seen fellow artists driven to the point of frenzy by photography."[1]

Until the end of 1979, Villiger always showed both objects (sculptures) and images (photographs) together in exhibitions. Her show in December 1979 at the Galerie Jörg Stummer in Zurich was the first to contain only photographs, but even then they served a dual purpose: recording three-dimensional sculptures and freezing processes of active form-making in order to make new arrangements. At the beginning of 1980 Villiger photographed two of her sculptures—a rank of warping planks and a spiral roughly cut from Plexiglas—and realized that her photographs of these objects were more compelling (and, ironically, more *sculpturally* satisfying) than the objects themselves. This was a turning point, opening up a tremendously productive period in her work.

At precisely this moment of creative breakthrough, at age twenty-nine, Villiger learned that she had contracted tuberculosis and was hospitalized. Her hospital room immediately became her new atelier, with drawings on the walls, sculptures on the floor, and photographs everywhere. A number of Polaroid images that figure

prominently in her later grids were made in this hospital room. Consumption and confinement emerged as the operative signs of her mature work.

When she was released from the hospital, Villiger wrote on the first page of a sketchbook, "Veil Grenzenloser" ("More, without borders"). In order for her to attain the expressive freedom she craved, and to do "more, without borders" aesthetically, she would have to bring the borders in close, and then put herself into the resultant enclosure. In September 1980 she was hospitalized again. When she came out this time, she took a photograph of an open window in her apartment, and wrote in her sketchbook, "Ich werde selbst zum Meissel" ("I myself will be the chisel"). The stakes had been raised, and from this point on, her work took on a ferocious new intensity.

In November and December 1980, at the Aargauer Kunsthaus in Aarau, she exhibited for the first time images made from internegatives of SX70 Polaroid photographs enlarged onto color negative paper and mounted on aluminum sheets one meter square. The images she chose for this show were more frankly autobiographical than anything she had shown previously: a self-portrait showing her blue eyes reflected in a hospital table, a close-up of the décolletage of her lover, a face with freckles, the window in her apartment, a brilliant green plant, Villiger kissing her lover under her chin, tennis in the lights, another self-portrait showing only her chin and hand in a vest, and a close-up image of red lips. A few months later, in January and February of 1981, she participated in a group show at the Kunsthalle Basel and produced a small catalog (with an Introduction by Bice Curiger) that incorporated some of the earlier entropic images in black and white, along with more recent color Polaroids, to form a coherent and concise visual statement of her emerging concerns. Again, the sequencing of the images is pointed, providing a visual, spatial counterpart to an emotional movement.

At this same time, Villiger began to combine the one-meter square unframed aluminum sheets into grids or "blocks" containing

anywhere from two to twenty sheets, in which the individual images began to operate as signs in a syntax. The grid structure also further *cooled* the images and allowed Villiger's sculptural intentions to act on the space between the works and the viewers—to be realized in a different way. Jean-Christophe Amman has said that Villiger used photography "to give her spatial sensibility the form and context of a *physical* sensation." She intended viewers to experience these imposing blocks of body images in a direct, visceral way—to feel the shifting alignments and compression in their own bodies as they looked at them. This effect does not result merely from the representation of Villiger's body in these works, but from the physical weight and arrangement of the images.

Some people have compared Villiger's work to that of John Coplans, but the relation is a superficial one. Coplans's work references the tradition of photographic nudes in a way that Villiger's does not. Villiger is not making abstractions from the human form, but *recording* sculptural forms made with her own body. Her method requires her to focus on the body's extremities, and the harsh lighting she uses tends to flatten the forms, further de-emphasizing the integrity of the whole body and creating an index of fragments. These fragments appear in a nongravitational space that does not pay attention to the usual up-and-down orientation of the human body. Reviewing Villiger's exhibition at the Zabriskie Gallery in New York in 1990, *New York Times* critic Roberta Smith noted Villiger's pursuit of "a complex, disorienting space," and said that the artist was "playing Frank Stella to Mr. Coplans' Henry Moore."[2] In Stella's 1986 book *Working Space*, he argues that great art "is never indifferent to the creation of viable pictorial space, the vehicle of motion and containment."[3]

In the preface to her groundbreaking 1973 book *Six Years: The Dematerialization of the Art Object*, Lucy Lippard wrote that "in a broad sense, anyone taking a photograph is geometricizing life."[4] Because the organic form that is being "geometricized" in Villiger's work is her own body, the visceral effect is one-to-one: instead of observ-

ing the relation of artist to model from outside, we become active participants in Villiger's multiform investigations of all the possible configurations and arrangements of her own body within the confines of the square. If you look for it, you will find evidence of Villiger's illness in the images—the knotted swellings and red rashes, and later the chilling geometry of phthisis—but overall, the images are strikingly restrained, even impersonal. If this is narcissism, it is of a very peculiar kind. In fact, these images appear to have been made not by someone who was obsessed with her own body, but by one who was so estranged from her body that she could consistently view it as an object.

In 1985, the Kunsthalle Basel produced a book by Villiger titled *Neid* (Envy). "Working on the book," Villiger wrote, "I felt two personified forces within myself: One was envious, the other was envied. The envious one was envious of the I that took the photographs. It envied the other's concentration and will. The title also signified my envy of the life of its own that the work took on." There was the life of the person making the work; there was the life of the person depicted in the work; and there was a third element: the life of the work itself. Both of the first two envied the latter its clarity, its limitations, and its longevity.

The function of a chisel is to cut away the extraneous, and for Hannah Villiger that meant getting down to the forms she could make with her own naked body, with as little interference as possible. Eventually, even her body was cut away, leaving only the images. The first image in *Neid* is of the artist's left hand, painted white, against a white background. The hand is closed as if around a chisel. We know that the artist's right hand must have held a camera instead of a hammer, but even so it hits its mark.

2001

NOTES

1 Robert Smithson, "Art through the Camera's Eye," in Eugenie Tsai, *Robert Smithson Unearthed: Drawings, Collages, Writings* (New York: Columbia University Press, 1991), p. 88.

2 Roberta Smith, "Hannah Villiger," *The New York Times*, January 19, 1990.

3 Frank Stella, *Working Space* (Cambridge, MA: Harvard University Press, 1986), p. 99.

4 Lucy R. Lippard, *Six Years: The Dematerialization of the Art Object from 1966 to 1972* (New York: Praeger Publishers, 1973), p. 7.

WHERE THE CAMERA CANNOT GO

A Conversation with Leon Golub
on Painting and Photography

DAVID LEVI STRAUSS: You've been an image-scavenger for a long time now, and in beginning I wanted you to talk about how that got started. Was it always directly connected to paintings?

LEON GOLUB: It all began kind of "innocently!" My work in the early 1950s had been primitivist—totemic and frontal. In the late 1950s the potential of activating the images excited me. I looked to Greco-Roman sculpture to evolve anatomical gesture and action. That's how it began, with books on Greek and Roman sculpture. Around 1960, I went to wrestling photographs for the "Burnt Men" images. I became increasingly an image junkie! I have huge files of images and image fragments. I virtually sense myself as made up of photos and imagistic fragments jittering in my head and onto the canvas.

DLS: You've always said that sketching is boring. You were never attracted to drawing from the figure for a painting.

LG: Not since art school. No.

DLS: Because it didn't give you what you needed. The unmediated body in front of you wouldn't have been of any use to you in this process.

LG: Not much. I increasingly searched out photo sources. I can't trace all the sources of the "Gigantomachies" or "Vietnam" paintings, as I didn't always copy closely, and often used several photos for one image. Photo reliance really comes in with respect to my developing notions of reality, or realism. What's "Real"!—and how, under Modernism, is the Real hit upon, how do you reach it? You

Images from Leon Golub's source materials

see? And so on. This is an age of abstraction and huge information surplus, and in the early part of the twentieth century you have this enormous expansion into abstraction: Futurism, Cubism, Surrealism, and so on. Realism becomes devalued, blindsided, can no longer tell it the way it's supposed to be told—at least according to Modernist theory. In abstract theory the Real has nothing to do with the appearance of things. You get the Suprematists, Frantisek Kupka, Jackson Pollock, Barnett Newman, all manner of abstraction, and this purports to be the look of our time.

At the same time, the issue for me was: in seeking the transcendental (big *T* or small *t*), have we transcended the event-world and entered into an eventless world, thus missing a big chunk of reality? It's not that I deny the value of, for example, Cubism. Cubism has been an amazing tool by which to open things up, and express alternate realities. But Realism in any normative sense was traduced as being corny. Now we're given Norman Rockwell as a "centered" artist!

In my early work, I was looking for images to somehow show the coruscating nature of what the world was about—in a way, *survival*, you see? And the savagery of war, and the savagery of human relations in general.

DLS: One reason why this was so much outside of any discourse going on in other painting at the time was that photography was then seen as having preempted painting's purchase on the Real.

LG: I wasn't satisfied with that argument. My dilemma was in the world of events, the event-world. How to make *contact*. My responses took various forms. But what you point out is one of the elements of my dilemma, that came out especially, for example, between my imagery and the Vietnam War. That's where it came to crisis, the crux of what it was about. I was active in Artists and Writers Protest Against the War, and we met, we planned, we marched, we did this, we did that. We were busy all the time. And my studio became a location where a lot of this was being organized. Meanwhile, there are these figures on the wall, and I am seeing stuff on TV, and in

news photographs, and I realize that the American G.I. doesn't look like what I'm painting. The scenes don't click. There is a *disconnection*. I can justify my paintings by saying that I am doing something which synthesizes all of these aspects in a both simpler and more complex notion of what war is like. But at the same time, there is a big doubt growing in my mind.

DLS: A doubt that your work is relevant, or entirely truthful—that you are being real enough.

LG: Yeah, whether I am doing what I could be doing. How do I get the life-art parts together? Now, a totally abstract artist who is against the war in Vietnam (of which there were many), and who participated in the exhibitions and actions we put on, didn't have to self-doubt. That artist could say: "I'm against the war: I do this. This is my art: I do this." You can't fault an artist on that. You see? But I could fault myself, because I was making figurative images dealing with violence and tension and stress, and there was violence and tension and stress right in front of my eyes and the two didn't connect.

DLS: It was too close. It was in your realm.

LG: Exactly. So I had a huge problem. I became aware of the problem around 1966 or so, right in the middle of the "Gigantomachies" series. And I couldn't resolve it. Didn't resolve it until '69 (and then only partially with the "Napalms"). It took years to resolve, and it became increasingly an anxiety as time went on.

So in 1972, I made the first of the Vietnam paintings, and because I was angry I called them "Assassins." I changed the titles some years later, because you can't blame the G.I.s for the guys who were initiating all this. The soldiers weren't assassins. So I became ashamed of the title. Anyway, the painting was already a problem. Because I was so unsure of what I was doing, the three soldiers in *"Vietnam" I* don't look like G.I.s. One of them has black pants rather than olive drab, and the other two are shown bare-chested and cut off at the waist. So I was evading the issue. Okay? But at the same time, they

have guns. And the painting is crude, too. It's the crudest of the Vietnam paintings. It's crude because of my mixed feelings. It has a peculiar power due to its crudeness and awkwardness. "*Vietnam*" *II* and "*Vietnam*" *III* are photo-derived and realistic in description of uniforms, guns, racial appearance, etc. I can show you source photographs.

DLS: What were they, and where were they from?

LG: Some were from G.I. manuals, books, and other publications on Vietnam—images straightforwardly transcribed, adapting the photographs in a literal way, referencing them for physiognomy, gesture, etc.

DLS: In some cases you were projecting the images onto the canvas and in some cases taping the images right up there on the canvas.

LG: Yeah, depending on what I needed, and working between the two. I used an opaque projector, but I also drew directly on the canvas from pinned-up images.

DLS: You've talked about your attraction to the fragmentary in Classical art and elsewhere, and it occurs to me that all these photographic images you've collected are themselves fragments.

LG: That's true.

DLS: They can't be whole. You can't have a "whole" photograph. It's always a fragment, a quotation from the Real.

LG: Which makes them true to our current situation, since our world is so fragmentary and mediated. I mean, what the hell are the big unifying theories by which we are holding it all together? You know? Things are moving faster and becoming more fragmentary all the time. We're riding the waves. We're very good surfers!

DLS: When the use of photographic images like this really came in, you started to keep files.

LG: Well, I'd been keeping files all along.

DLS: But this obsessive typology, archiving hundreds of different types of images, did this start. . . .

LG: It started with the photographs of Greek sculptures.

DLS: You were already collecting images, cutting them out and keeping them in files at that point?

LG: At first I didn't cut them out, but would reference from books. Over the years a photo-mania developed! At times, photographic images have signaled a way forward and gotten me out of a bind. In 1974–75, I got into a crisis. I couldn't make the paintings work. Somehow I'd lost the visual tension that I experienced making the "Vietnam" paintings. It just wasn't coming out right. So I destroyed several huge paintings and considered giving up painting altogether. I was depressed about it. But what else could I do? Write? Teach? I'm not qualified to do too many things. You know?

DLS: This was a real crisis.

LG: Yeah. But in *"Vietnam" III*, there is a blond soldier smoking a cigarette. And I thought that he looked like President Gerald Ford. On a hunch I rented ten photos of Gerald Ford.

DLS: You rented them from what? A photo agency?

LG: Yeah, a photo agency that sold images to the news media. I rented ten photographs for thirty dollars.

DLS: Why did you think to do that?

LG: Because it was either give up painting or lower my expectations, to see if I could shift what I was doing to a more limited or more deliberate way of working. Just to work, and see what I would do. And I thought, well, it could be interesting to do heads of state. This soldier looked like Ford; why not do some political heads? So I followed the impulse and I did heads of Ford. I got into it. I did a

whole series of the guys who run the show! More than a hundred political portraits in the next three years: Justices Rehnquist and Douglas, a lot of Kissingers, a lot of Francos, Brezhnevs . . . and so on.

Over the years I've tried to puzzle out just what I was doing, to get as close to the face as possible, the face of power. These are ordinary-looking faces that had all this power. Sometimes arrogant, but often bland and "faceless." I also think of them like rubber masks that you can put your hand in and sort of make the skin stretch. I tried to do them realistically and to look accurate. For the most part, I succeeded.

DLS: What did you think about the transition from the original photographs to these painted portraits? Obviously, something very different happens in these paintings than happens in the photographic images, even in terms of identity. I don't know who it was that said, apropos of this shift in Realism, that you don't carry a painting of yourself around in your passport; you carry a photograph, for identification purposes. And at a certain point, we extended this to say that a photograph is more *real* than a painting.

LG: Well, we're still puzzling out the peculiar relationship between photographs and other forms of realism. I studied these photographic portraits, looking for clues. Take Nelson Rockefeller. Rockefeller is often grimacing, his face contorted. He was histrionic and self-conscious, unlike his impassive brother, David.

In the summer of 1979, confidence sufficiently restored or maybe just because I was bored with the heads, I hung a ten-foot-high canvas. Time for scale again. In the "Vietnam" paintings, I had rendered the faces like the faces in the photographs; they don't show more or less emotion. Whatever their interior responses, their external expression in the photograph is reflected in the paintings. The "Mercenaries" are different. I got interested in the psychology of mercenaries. You know? Covert activities. Who are the guys that are pulling the strings? And who are the guys who are carrying these actions out? What kind of guys are they? What's their experience with violence?

148

To show these guys up front, watchful, intent, aware, not stock figures in some comic book. To give the men a kind of recognition, smiling, or impassive, or even—in the "Horsing Around" series—playing around. You see?

DLS: Jon Bird has written that the kind of gaze that is represented in these paintings of yours couldn't happen in photography because nobody could be in that position. A photographer couldn't be in that position to take the photograph, even though in many of these paintings, the figures look like they're being photographed.

LG: Oh, yeah. Perhaps they are posing for a snapshot by one of their pals.

DLS: But it's completely different than a photograph would be. Bird also says that your paintings "establish a dialectic of gaze and power that points to an ethics of seeing, of the link between the viewing subject—the one who sees—and the field of vision." And he notes that this form of looking is generally associated with photography and the cinema, but it is completely transformed in these paintings. The closest thing to it in photography might be those photographs from Tuol Sleng in Cambodia that the Khmer Rouge took of people right before they murdered them [*The Killing Fields*, edited by Chris Riley and Douglas Niven, Twin Palms, 1996].

LG: Yeah, I've seen it.

DLS: Those photographs were taken from the position of the subject's torturer and executioner. I know you've also gone to sado-masochistic sources.

LG: Yes.

DLS: A sadist's gaze is never disinterested.

LG: Well, the way I think about it, it's not so different from the looks you get in popular movies. You know? In other words, when somebody casts an eye on something, and there's a thing going on between two people, you sense that in a movie. I am trying to get

something similar. You see? You and I are in a film. We're reacting to each other. Looks have passed between us. We recognize that in the audience.

DLS: Yes.

LG: The way I put it is, I want these guys to be able to walk into our space. They are in our space, and we are in their space. It's the same space. It's as if I am present at the scene. They recognize me. You see? *"White Squad" IV* is a good example of that. There is a body in the trunk of the car. In the actual source photo, the police agent's head is not seen. But I have him looking back, a look that is tentative, cautious—he doesn't want to be interrupted, and he's on the verge of anger. It's a look that you could see in a movie. It's an *interrupted* look.

DLS: It's interrupted, but it has duration—or at least it's a compression of time. There's no way you could photograph it. In a photograph there would be maybe one thing happening, or there would be one look. It can only be *one* look because it's frozen—crystalline. The paintings are not. They're more liquid, and they flicker. They include many looks, all at the same time. So it's an aggregation. A photograph is never an aggregation; it's a crystalline slice.

I'm trying to get at this real difference between the two ways of seeing, because people think that they know what that is, but I don't think we do, really. I mean, you've talked about the place of the paintings as "the place where the camera cannot go." To see "the Finks of the Bosses" at work, up close—a "Violence Report."

LG: Your distinction is crucial. And I do think of it as a reportage—in the wider sense of the word. I am trying to make some kind of connection to what is going on in the world. To make some sort of *contact*. And I use the instruments that our modern world offers, these extraordinary instruments of photography and film and computers. People say: "But photographs are all lies." That's not the point. The lie is a truth, too. How the hell are we going to know what Kissinger looks like? Well, the photograph tells us one version; I'm trying to

tell it also, but differently. And Realism, the way I think of it, is not outmoded. It's a powerful laser into our world. Not just a surface thing. It's going to pierce right into it. You see?

DLS: Some people have asked, Why should a painting now be realistic if photography and film can do that much better? In his great first novel, *A Painter of Our Time*, John Berger wrote: "There is so much that painting cannot do now. This is not the result of any poverty of intention. It is the result of the abundance of the means of expression at our disposal. I believe that if Giotto were alive today he would rightly make films; so would Goya. But not Raphael, Piero, Titian, Poussin, Cézanne."

LG: I think you require a different temperament to be a filmmaker. I could never be a filmmaker. I don't know quite what it is, but I recognize that it's different. Maybe a different kind of *mobility*. I don't know.

DLS: Have you taken photographs?

LG: You can count the photographs I've taken on one hand, practically. Nancy [artist Nancy Spero] has taken a lot of photographs, mostly of our children! [LAUGHS] And sometimes people have asked: "Why don't you use models?" When our kids were growing up, I'd say: "I need an arm; would you mind standing there?" And they'd reluctantly hold their arm out, and I would draw. Or maybe not reluctantly. But those times were very rare. Because photographs give me so much more information.

DLS: So it's all found images. You collect them. Which is very different from you making them.

LG: Yes. When I started to do dogs, even if we'd had dogs, I still wouldn't know enough about what a dog is like. How dogs move and jump and show their teeth. See? I now have a huge collection of dog photos.

DLS: Because they're not dogs. They're *images* of dogs.

LG: Yes. And they reflect all these different thoughts about dogs, what a dog has meant and does.

DLS: Culturally, visually. . . .

LG: Yes, to get variant aspects. Look, the paradox we're working with is that the world is both more knowable and less knowable than it's ever been, all at the same time. Like, let's say in the Medieval period, it was knowable. There was God in Heaven, there was Hell below, there were distinctions and hierarchies. Sometimes peasants might revolt, but the elites knew how to handle them. And so on and so forth. Now the world is more and more unknowable because of the information impasses that we're continually enmeshed in.

We know more than has ever been known. So we mark time in the middle of all this. Yet one has to keep moving. Now I've shifted. I'm more sardonic and trying to slip around more. I'm trying! You know? Even the "Mercenaries" have become too realistic a point of reference.

DLS: Because Realism now has to deal with *Distraction*.

LG: Exactly. That's a good way to put it.

DLS: It would be inaccurate to have any kind of definitive representation.

LG: That's right. I can't use the "Mercenaries" as so direct a symbol any more—as a symbol of the systemic uses of power and domination in our society. It's not that this has changed, but there are other inferences I'm interested in now and that I would like to poke at.

DLS: And how has the way that you draw on photographic images or media images in the world changed?

LG: More aleatory, to use an elegant word. I like that notion, you see, of having something appear, and then something else happens. There may be a connection, or maybe a connection happens because they are aligned near each other. Once you put them together, there is a connection.

DLS: A number of times in the past you've talked about the difference between looking at paintings and viewing the cinema. You say that you go to a cinema and sit down and you watch, but painting operates completely differently than that. At one point you said that painting has "glancing power," which I like a lot. Painting doesn't move; it stays in the same place, so the spectator has to move.

LG: You've got to get off your ass.

DLS: Yes. But I shouldn't say the spectator has to move. As soon as you move, you're no longer a spectator. I think that we still live in the society of the spectacle. . . .

LG: Oh, I think so, too.

DLS: . . . and that we are trained, now almost from birth, to be spectators. And whenever we look at photographs or cinema, we are always in danger of becoming spectators. But when we look at paintings we're not spectators. What's the difference?

LG: Of course, one can look at paintings in many different ways. Often it's meditative. Suddenly you realize, that hand is beautifully done, and suddenly it becomes like a friend, filled with significance for the moment. I have another notion about painting lately. You walk into a museum, and there's a Malevich. Okay? I'm using that rather than Chardin! [LAUGHS] It's a Malevich. And you admire it. You respect it. You look at it for thirty seconds, whatever it takes, and you walk on. The next time you go by it you hardly notice. You're aware it's there but you couldn't care less. Then one day you're walking by, and suddenly the Malevich traps you, grabs you! For some goddamn reason you're looking at it like you've never seen it before!

I mean, we often have these things happen with paintings. Maybe you don't have that with photography.

DLS: It's different. At one point James Elkins, I think, was going to write a book about people crying in front of paintings, which I thought was a grand subject. When that happens, it's like the paint-

ing comes out and grabs you. It's very palpably physical. Now you might weep looking at a photograph, but it is less likely to be physical in the same way.

LG: Suddenly, the damn thing is even eerie. I don't know, it floats in front of you, challenges or is evasive, or it does something to you. So painting has a capacity to send out signals, and you may be attuned to that signal at that particular moment.

DLS: It's always made sense to me to talk about photographs and even film as language, in terms of language. But it doesn't make sense to talk about paintings in terms of language.

LG: Yeah, that's true. Painting is resistant, obdurate. You see? I don't think it's going to lose it. In fact, it may become even more critical due to the very transience of virtually everything else. You know? As everything goes speeding by and we're running for our lives, so to speak, painting may have staying power, for those who are susceptible to it!

DLS: Your use of photographic images, the way you collect, sort, combine, and use them, is very particular. Painters who do not work from photographs often disdain the practice. Lucian Freud said recently that photographs are "useless as sources of information." You use them as sources of information but also something else.

LG: I couldn't disagree more with Lucian Freud. I use photographic images ideologically! Because at different times I've had different notions of who I was, how I was functioning, and what was going on. . . . For example, going to Greek art, I wanted the awesomeness and beauty and ideality and even the corruption [LAUGHS] of Greek and Roman art! How this extraordinary sculpture marches across the time/space of our world—the Greco-Roman World and all that it signified. I even conceived of it as Man into Space, space adventuring, and so on. The articulation of the body gradually becomes a machine of motion, a machine of possibility, a machine of adventure, and therefore, *out into the world*. That's the way I thought of

Greek art. I still think of it that way. Simultaneously, I view Greco-Roman art as a world of stress. In the "Gigantomachies," there are huge amounts of stress and force, anticipatory but in a totally different dimensional aspect to the violence of the Vietnam era and the world of U.S. power. "Mercenaries," "White Squads," and "Riots" all mark those stress points in our society.

And now I'm into what can be called "Late Art." I'm older. It's late style. And late art is paradoxical. Theodor Adorno has this beautiful piece on "Late Style" where he talks about what happens in late art, which is both retrospective and unraveling. The look from which you introspect society—skepticism or irrationality or a wish to believe, or simply wearing down. What comes in as you achieve the curious clarity of age. Yes. It just comes in, because that's the stage of life I'm in. This is now. I'm seventy-eight and I'm still on the hunt for photo images! You see? And so on.

2001

CAN YOU HEAR ME?

Re-Imagining Audience
Under the Pandaemonium

In a little more than a century we have progressed from photography and telephony to cacophony. Under the twin deities of speed and interconnectivity, the technologies of communication have proliferated and accelerated beyond all previously perceived boundaries. This second industrial revolution has been driven not by the transportation of physical goods or people, but by the transportation of messages. As the resultant all-consuming Pandaemonium of sound and image sweeps across the globe, and the signal-to-noise ratio plummets, it has become more and more difficult for any one voice to be heard above the collective din. Even as art schools promise to develop "the individual voice and vision" of each and every prospective artist, the possibility of exercising such a voice in any meaningful way is rapidly disappearing. The main channels of communication are corporate, and are not accessible to individual artists. The channels that are accessible (the narrow-band ones) are increasingly isolated and enfeebled. Energy is spread so thin, over so many channels, that there is not enough current left in any one of them to amount to anything extraordinary. In our rush to abandon the local exigencies of time and place, we have embraced "global" forms that are mostly banal or empty of content. The principle requirements of the audience have become passivity and obedience. We're all becoming global village idiots.

Even so, one of the most prominent features of the current communications explosion is its attendant Panglossian optimism. Everything is for the best, and is getting better every day. More and faster means better. Pay no attention to those languishing in the shadows. They are poor and hungry because they are not thinking positively enough. They are unwired because they are unworthy. And if you're

Daniel Joseph Martinez, *A Flood Can Happen Anywhere*, 2002

Art Center College of Design
Library
1700 Lida Street
Pasadena, Calif. 91103

not altogether pleased with the social conditions resulting from these changes, perhaps *your* thinking is not entirely correct either. Critical thinking is a drag. Don't worry, be wired. The Free Market will solve everything. Remember: "For the Market, Everything; Against the Market, Nothing." Like Candide, we only wish to ask: "If this is the best of all possible worlds, what are the others?"

YOUR CALL IS IMPORTANT TO US

Anyone who is still interested in freedom must become a student of the new systems of Control. When Norbert Wiener coined the word *cybernetics* (from the Greek for "steersman" or "governor") in the 1940s, he defined it as "the study of messages as a means of controlling machinery and society." Cybernetics places communication and control in the same category, both locked in the struggle against entropy.

> *The commands through which we exercise our control over our environment are a kind of information which we impart to it. Like any form of information, these commands are subject to disorganization in transit. They generally come through in less coherent fashion and certainly not more coherently than they were sent. In control and communication we are always fighting nature's tendency to degrade the organized and to destroy the meaningful; the tendency . . . for entropy to increase.*[1]

Wiener's book *The Human Use of Human Beings*, first published in 1950, is an almost flawless work of prophesy. In it he predicted everything that has happened in communications technologies over the last half-century, and provides a cogent analysis of the social stakes involved. Wiener also held the now curious view that "computing machines" should free human beings from drudgery into lives of increased creativity and spiritual development. The competing "sinister possibilities" he points to are all social and political rather than technological. Unfortunately, almost all of the things Wiener warned against have come to pass.

The great weakness of the machine—the weakness that saves us so far from being dominated by it—is that it cannot yet take into account the vast range of probability that characterizes the human situation. The dominance of the machine presupposes a society in the last stages of increasing entropy, where probability is negligible and where the statistical differences among individuals are nil. Fortunately we have not yet reached this state.[2]

Much of *The Human Use of Human Beings* concerns "the limits of communication within and among individuals." But Wiener also says that as the likelihood of an individual voice being heard diminishes, the need for it increases. Information is necessary for life, and information is carried in messages, the larger theory of which is a probabilistic theory. "The more probable the message, the less information it gives," wrote Wiener. "Clichés, for example, are less illuminating than great poems." One of the great problems with the vast proliferation of messages in the current environment is that the less "probable" messages (such as those that come from art and literature) have little chance of being heard. Wiener is not sanguine about the ultimate outcome, even if those messages were heard. "Beauty, like order, occurs in many places in this world," he writes, "but only as a local and temporary fight against the Niagara of increasing entropy." But he places the kind of information that comes from art in the category of necessary information, and warns of dire consequences if this kind of information is lost.

The truth is that the Information Age is actually the Age of Forgetting. We are receiving less and less real information (information on which we can act), and losing or forgetting vast quantities of information at an ever-increasing rate. So why are we pursuing this information-poor direction so enthusiastically? Setting aside the motivation of greed, it appears that we are involved in a kind of cultural discharge. Can it be that we are letting off steam, releasing energy, and emptying our cultural memory banks in preparation for some future epochal shift?

SIGNAL TO NOISE

In the early 1980s in San Francisco, I lived around the corner from a punk and noise club called The Deaf Club, at 16th and Valencia. Ascending the stairs from the street, one encountered the noise rolling down from above like a tidal wave. It made us instantly drunk, intoxicated by sound. Everyone who worked in the place was deaf—literally. If you wanted a drink (or anything else), you wrote your request down on a piece of paper and handed it to one of them. It was easy to pick the club employees out, since they all wore beatific looks of almost obscene pleasure as they were both calmed and stimulated by the sound waves pulsing through their bodies. The deaf people were the only ones above the fray, sensually and synaesthetically superior to the rest of us, locked in our auditory habits, with something to lose. Those of us who were not deaf went to The Deaf Club in search of overstimulation and intoxication, and a place where we couldn't hear ourselves think. The noise-induced nausea was already familiar to us. We could see it rising on our screens.

CAN YOU SEE ME?

The question of audience is connected to the question of social subjectivity, and photography has a special role in this due to its historical melding of subjective vision with objective record. Clement Greenberg long ago remarked on the transparency of the medium to the "extra-artistic, real-life meaning of things." No matter that any photograph can now be digitized and manipulated at will in imperceptible ways; people still believe photographic images and recognize their special relation to the real.

Under the Pandaemonium, a single message from an individual artist has a better chance of being heard if it is *slowed down* enough so that it drops out of the mainstream, underneath the standard frequencies. It used to be that photographic images were relatively fast, but now they're slow relative to electronic speed, and this is their paradoxical new strength. No matter how many images rush by in the image stream every day, single photographs still appear to slow things down. It has to do with photography's relation to light and

light's "limit speed" that, as Paul Virilio has said, "conditions the perception of duration and of the world's expanse as phenomena."[3] Photographs take time to develop after being exposed and time to see, and can be used to manipulate time.

PHOTOGRAPHING THE FUTURE

All I had to do was find out what words music picture odor brought out in the subject the face I wanted. Then I took my picture just before I played the music or whatever the cue was and the subject never knew when the picture was taken since I still used the false click gimmick. Reaction time? Yes, I went into that. You see, I couldn't just pick up the money and forget it. Better if I had. I was warned. But I couldn't get it out of my mind. And I found the answer: allowing for reaction time there was still an interval of a few seconds unaccounted for . . . I was taking a picture not of the face as it is "now" but as it would be in a few seconds: I was photographing the future.

If you can take pictures of someone's face a few seconds from now, you can take pictures of someone's face a few years from now . . . same gimmick. Pick a cue, any cue. Always need a peg to hang it on. Remember it's all a matter of timing.

—William Burroughs, "Old Photographer"

What the technology of photosensitivity introduced . . . is that the definition of photographic time was no longer the same as time passing, but essentially a kind of time that gets exposed, that "breaks the surface"—surfaces; and this exposure time then succeeds the classic time of succession.

—Paul Virilio, *Open Sky*

The age of photography and the photographic image—and hence of cinema—is approaching its end. At the end of this era, as it enters the new era of digital electronic images, perhaps the cinema will be able to summon up all its strength, and do what it was intended for: to show twentieth-century people their image, in reality and in dream.

—Wim Wenders, *The Act of Seeing*

In *Lisbon Story*, Wim Wenders has his protagonist spend most of the film searching all over Lisbon for an image-maker friend of his who has sent him a postcard, an urgent cry for help, and then disappeared. When the protagonist, a sound-recordist, finally locates the missing image-maker, the latter takes his friend to a ruined cinematheque and launches into a sort of eulogy for images:

> *Images are no longer what they used to be. They can't be trusted any more. We all know that. You know that. When we grew up, images were telling stories and showing them. Now they're all into selling. They've changed under our very eyes.*
>
> *They don't even know how to do it anymore. They've plain* forgotten. *Images are selling out the world. And at a BIG DISCOUNT!*

And then the distraught image-maker reveals his plan, his answer to the problem of the empty image, which he believes is not a problem of the image, but of those who make and see and use images.

> *An image that is* unseen *can't sell anything. It is pure, therefore true, beautiful, in one word: innocent. As long as no eye contaminates it, it is in perfect unison with the world. If it is not seen, the image and the object it represents belong together.*

The image-maker's response is his "Library of Unseen Images"—boxes of film or tape that has been exposed "automatically," with the camera hanging on the image-maker's back, so that no one has seen or previsualized them. Uncontaminated by sight or intention, they "show the city as it is, not as someone would want it to be."

Wenders's next film, *Until the End of the World*, is about the future of seeing. Made in 1990 and set in the year 2000, it was shot in twelve countries on five continents, and is one of the first films to be made as if the world is *one place*. A son (played by William Hurt) travels around the world (which is being threatened with total destruction by a malfunctioning nuclear satellite) with a special camera invented by his scientist father (Max von Sydow), collecting images

for his blind mother (Jeanne Moreau) to see. When his mother is wired and plugged in and is able to see the images her son has collected for her, she sees that the world is "darker and uglier than she could possibly have imagined it." Just as they all discover that the world will not be destroyed by the nuclear satellite, Jeanne Moreau's character concludes that "the world is not okay," and dies, poisoned by the images that have overwhelmed her.

In despair, the father, son, and the son's lover (Solveig Dommartin) then begin to use the new technology to record their own dreams, and become hopelessly addicted to watching the resultant images. When the internal (mental) images are externalized, they become toxic to their original host.

In both of these films, images are seen to be in crisis—of incapacity, overexposure, and toxicity—which induces panic in the audience for images. A panic is an irrational terror involving noise and confused disturbance. Panic is a disease of the imagination. The word was originally used to describe the state experienced by soldiers camped at night: someone would hear an unfamiliar sound in the night, then another sound, and would become dizzy with fantastic images. The delirium was contagious and would spread through the troops like wildfire, finally causing the soldiers to pick up their weapons and turn on one another.

Although panic seems to arise from disorder and lack of control, panics and pseudopanics are often used in the service of control, such as the recurrent sex panics in the United States over "obscene art" and child pornography. The one surefire way to break a panic is to *slow things down*, and rely on social feedback to break the loop of irrational fear.

What I call the all-consuming Pandaemonium is something different, but related. The word means "the place of all howling demons." In Milton's *Paradise Lost*, it is the name given to the capital city of Hell. Nowadays we might call it the capital of the New World Order. It is the media center that makes everything else possible. The principle political effect of its amped-up, over-the-top

propaganda assault of words and images is the perversion of the significance of events, leading ultimately to what Virilio has called "the progressive derealization of the terrestrial horizon"—the loss of connection to the real.

Artists cannot compete with the Pandaemonium on its own terms; they are outgunned and vastly undercapitalized. The only way to effectively subvert it is to change the rules of engagement, to engage the audience differently. The most basic questions about audience and communication have to be asked differently now than in the past, perhaps especially when it comes to images, but they still need to be asked. The question is no longer, Should there be a global mass-market consumer culture? but, Should there be *anything else*? With all of the hype about interconnectivity, are we really more connected than before? What is the nature of that connection? Is the Internet the first and only transparent medium, or does its form determine its content? Is art a subcategory of mass-market consumer culture or something different from it? What is the difference between commercial messages and art? Does motivation affect the message essentially? Can you hear me?

1999

NOTES

1 Norbert Wiener, *The Human Use of Human Beings: Cybernetics and Society* (New York: Da Capo Press, 1954), p. 17.

2 Ibid., p. 181.

3 Paul Virilio, *Open Sky*, trans. by Julie Rose (New York and London: Verso, 1997), p. 13

A FEROCIOUS PHILOSOPHY

The Image of Democracy and the Democracy of Images

PROLOGUE

A Conversation on Democracy and Images, Out of Time, with Walt Whitman, George Eastman, and Paul Virilio

WALT WHITMAN: Curious word, "Kodak." What is a Kodak?

GEORGE EASTMAN: Well, now it's the name of a huge multinational corporation, but when I coined the word it was the name of a camera that anyone could use.

WHITMAN: Splendid! A tool for democracy! Image-making for the common man! But what does the word mean?

EASTMAN: It doesn't mean anything. I just wanted a name that couldn't be misspelled or mispronounced in any language—a brand name for the global market. But the first Kodak actually cost a lot of money, and only the rich could afford to use it. I called the *real* first camera for everyone a "Brownie."

WHITMAN: Even better! A hobgoblin or ghost! A household spirit of good or ill. "A new cloak, a new hood/Brownie will do no more good." "You've got to be a spirit, Bullworth, can't be no ghost."

EASTMAN: Yes, well . . . actually, it was a product tie-in to a popular series of children's books. I just thought it would sell cameras, especially to children. And it did, like hotcakes.

WHITMAN: But it also brought about a new democracy of images, did it not? When everyone could make their own pictures, they

Margaret Crane/Jon Winet, *Capital*, 1991

could remake themselves in their own image, and produce a history from which there would be no appeal.

PAUL VIRILIO: History has been created through stories and the memories of individuals having witnessed certain events. Today, however, the media no longer exist as narratives but rather as flashes and images. History is therefore being reduced to images.

WHITMAN: I told Mathew Brady that his photographs of the Civil War would change the way history is written. But the real war never got into the books. When I first published *Leaves of Grass* in 1855, I put a photograph of myself opposite the title page, instead of my name. It was a snapshot of me, standing—casual, sensual, direct—you know, one of the roughs. I wanted the whole book to be a daguerreotype of my inner being. I said: "What is commonest, cheapest, nearest, easiest, is Me." Like a photograph. I loved being photographed, especially by my friend Gabriel Harrison. I always thought that photography would someday become one of the great expressions of an ecstatic, erotic democracy. And you, Brother George, made that happen!

EASTMAN: Whitman, you missed your calling—you should have been in advertising. Advertising is the business of bullshit, and you have a real talent for it. All that sentimental crap about "the people" is good for only one thing: to move more product. Your "vision of democracy" is pure folderol. What the people want is to get something for nothing. If you can convince them that they're getting something for nothing, they'll line up like lambs to slaughter, and make you rich. I did it with the Brownie camera in 1900. Convinced them they were getting "memories preserved" for one dollar. "The people" en masse are greedy, vain, lazy, and selfish. All they ever meant to me was numbers in an account book. I didn't get to be one of the wealthiest men in the world by appealing to their "higher selves."

VIRILIO: But you did, inadvertently or no. You made them look at the world differently and this made the world different. You engendered the possibility that if everyone took photographs themselves, they would learn how images worked and wouldn't be tyrannized by them. You took the means of production of representation out of the hands of experts and put it into the hands of the common person.

EASTMAN: Look, I did that because the "experts," the professional photographers, wouldn't buy my products. They said they were inferior. So I thought that if ordinary people could take pictures, maybe they wouldn't be so goddamned *fussy*. And they weren't. As I said, people are lazy. Something for nothing. "You press the button, we do the rest."

VIRILIO: Things have gone far beyond that now: from the box camera to the cinema, to television, and now the Internet. You still had human beings holding the means of production in their hands and pressing the button to make images that had something to do with them. But that button soon became the one on a remote control, able only to change channels and increase the volume. Everything speeded up. All resistance was eventually overwhelmed by the speed and frequency of transmissions. The democratic impulse has been reduced to this: voting every second with your finger on the button. With the Internet, this reduction is hyped as a great democratic revolution, but it is the ruin of democracy. It replaces the *practice* of democracy with its *image*—an eidolon without a body.

WHITMAN: But such images matter a great deal! We can't have democracy without first having the imagination of democracy!

VIRILIO: Yes, if it is the people's imagination. But today everything is imagined *for* them, in images manufactured like any other consumer product and beamed into every American living room. Because

168

of how these images are made and transmitted, they displace the democratic idea rather than inspiring it. They turn it into its opposite. One of the most retroactively cynical statements in history came from your second president, who said that the trouble with democracy is that people get the government they deserve.

EASTMAN: Excuse my anachronism, but I just saw a spokesman for Eastman Kodak on TV talking about the importance of free trade to China. He said China is now the second-largest market for consumer photographic materials in the world, after the United States. So the last Commies want to take pictures, too. Democracy has no special claim to this. The age of the omnipotent image is postpolitical. Wake up and smell the Starbucks, gentlemen, this is *business*.

VIRILIO: And as the business of consumption has come to replace the social, freedom of choice is reduced to consumer preferences. As the new leader (and former KGB cop) of Russia—that old simulacrum of the social—said recently: "Voters shouldn't be asked to choose between candidates as between products, like Tampax or Snickers."

EASTMAN: What are those?

VIRILIO: Code names for Gore and Bush.

WHITMAN: *I sing to the last the equalities modern or old,*
 I sing the endless finalés of things,
 I say Nature continues, glory continues,
 I praise with electric voice,
 For I do not see one imperfection in the universe,
 And I do not see one cause or result lamentable at
 last in the universe.[1]

EASTMAN: Bill Gates is my progeny . . . and my revenge.

VIRILIO: Brownie, movie, TV, PC, out.

VIRTUAL DEMOCRACY: THE SILENCE OF THE LAMBS

Anything about which one knows that one soon will not have it around becomes an image.

—Walter Benjamin, *Charles Baudelaire*

Everything in this world reeks of crime: the newspaper, the wall, the countenance of man.

—Charles Baudelaire

On the rise of photography . . . a new reality unfolds, in the face of which no one can take responsibility for personal decisions. One appeals to the lens.

—Walter Benjamin, *The Arcades Project*

Truth is like sunshine; people used to think it was good for you.

—Bobby Hill's dad

Walt Whitman died at the threshold of the twentieth century. His most productive period was ending just as the age of consumerism was beginning. Modern product advertising didn't really take off until after the Civil War, with the hawking of patent medicines (and ever since, product advertising has remained fundamentally pharmaceutical—something is wrong with you, buy this to fix it). In "Democratic Vistas," first published in 1870, Whitman praises the incoming tide, with one important proviso:

> *I hail with joy the oceanic, variegated, intense practical energy, the demand for facts, even the business materialism of the current age, our States. But woe to the age or land in which these things, movements, stopping at themselves, do not tend to ideas. As fuel to flame, and flame to the heavens, so must wealth, science, materialism— even this democracy of which we make so much—unerringly feed the highest mind, the soul.[2]*

One can't help wondering how Whitman would respond to the new claims of democracy. He might have celebrated them. As the poet

of American Democracy ascendant, Whitman was also the poet of Manifest Destiny (the antecedent of the New Globalism):

> *Long ere the second centennial arrives, there will be some forty to fifty great States, among them Canada and Cuba[!!]. When the present century closes, our population will be sixty or seventy millions. The Pacific will be ours, and the Atlantic mainly ours. There will be daily electric communication with every part of the globe. What an age! What a land! Where, elsewhere, one so great? The individuality of one nation must then, as always, lead the world. Can there be any doubt who the leader ought to be?[3]*

Contrast this with Arthur Rimbaud's short poem "Democracy," probably written just after Whitman's "Democratic Vistas" was first published, in 1870:

> *The flag goes with the foul landscape, and our jargon muffles the drum.*
>
> *In the great centers we'll nurture the most cynical prostitution. We'll massacre logical revolts.*
>
> *In spicy and drenched lands!—at the service of the most monstrous exploitations, industrial or military.*
>
> *Farewell here, no matter where. Conscripts of good will, ours will be a ferocious philosophy; ignorant as to science, rabid for comfort; and let the rest of the world croak. This is the real advance. Marching orders, let's go![4]*

Rimbaud most likely wrote this just after personally witnessing the crushing of the Paris Commune of 1871. He knew that things can change when people rise up, but they can just as quickly change back. He railed not only against the false promises of democracy, but against those of Western, Christian civilization as a whole. Yves Bonnefoy notes that, in "Democracy," Rimbaud shows "how concerned he is with those colonial expeditions in which the West, at this bourgeois and scientific turn of the century, seemed to succeed once and for all in the Christian annihilation of instinct. For he him-

self had also been colonized."[5] That is, he had become *subject* to bourgeois ideology. Rimbaud is the poet of shattered illusions, and one of those lost ideals was democracy.

Which image of democracy is the more prescient, Whitman's dream or Rimbaud's nightmare? The definition and nature of democracy have been in dispute for a very long time, but its image has changed dramatically just in the last decade. The long battle between Capital and the Social came to an end in 1989–91, and Capital now reigns supreme and unopposed. The beneficiaries of Capital claim that democracy, too, is triumphant. But what, exactly, is democracy without the Social?

Conservative economists and neoliberal politicians alike have made Capital's market contractual relations both the model and the necessary prerequisite for democracy. These are the terms of the New Globalism. Open markets (that is, open to multinational corporations) are "democratic," so China is more democratic than Cuba. This welding of democracy to Capital obscures (and is intended to obscure) the essential characteristics of each. In Capital Democracy, whoever has the most money has the greatest voice. Value equals valuation. It does simplify things. Since only Capital (rather than labor and imagination) creates value and rights, any opposition to Capital is by definition "undemocratic." Labor is undemocratic; artists and writers are mostly undemocratic.... For the Market, everything; against the Market, nothing.

Coincident with the triumph of Capital has been the explosive growth of the new communications technologies, and the attendant acceleration has inspired breathless enthusiasm and futuristic optimism among technology's sycophants. Technopolists claim that the new technologies will usher in a new era of greater democracy, quite aside from—or more to the point, *in spite of*—the Social. All of the old divisions—rich and poor, North and South, black and white, management and labor—that exist in the actual world (the place of the Social) will supposedly be dissolved in the virtual world (the place of Capital). As Peter Lamborn Wilson recently pointed out:

"Cyberspace is not really a 'market' at all, but simply the conceptual space of Capital as a totality, together with all its representations."[6]

The totalizing effects of this ideology have made resistance difficult to organize. Nevertheless, such resistance has grown steadily in those countries feeling the bite of the actual as they are pressured into accepting the terms of the New Globalism (most significantly in Mexico, with the Zapatistas), and has even erupted in the United States recently, most visibly in the Battle for Seattle in November 1999.

One of the most consistently outspoken dissident intellectuals in this fight has been the Italian/French urbanist, architect, and philosopher Paul Virilio. In his book of interviews *Politics of the Very Worst*, Virilio makes the case for a historical analysis of the present ahistorical claims and conditions of technocracy:

> *I paint a dark picture because few are willing to do it. I am definitely not against progress, but after the ecological and ethical catastrophes that we have seen, not only Auschwitz but also Hiroshima, it would be unforgivable to allow ourselves to be deceived by the kind of utopia which insinuates that technology will ultimately bring about happiness and a greater sense of humanity. Apart from Hannah Arendt, no one has really reentered this debate. So the work I'm doing is like backfire or resistance. Serge Daney used to say: "In wartime, you don't talk about the resistance." The new technologies, as well as the media in the broadest sense, are like the German Occupation. My work is that of a "resister" because there are too many "collaborators" who are once again pulling the trick of redemptory progress, emancipation, man liberated from all repression, etc.[7]*

Virilio is explicit about the actual effects of the new communications technologies on democracy. He says "the tyranny of real time," wherein reflection is replaced by reflex (TV/Internet consumers with their fingers on the buttons), results in the subjugation of people and replaces solidarity with solitude.

Democracy is the expectation of a decision made collectively. Live democracy, or automatic democracy, eliminates the reflection and replaces it with a reflex. Ratings replace deliberation. This is extremely dangerous for democracy in terms of the decision and voting time. Ratings and polls become electoral. The poll is the election of tomorrow, virtual democracy for a virtual city.[8]

In the United States this trend has already rendered the traditional trappings of the presidential campaign superfluous. The only remaining rationale for any personal involvement by the "candidates" is for fundraising. Apparently corporation heads want to see whom they're buying. Otherwise, the advertising campaigns could proceed without any product placement at all.

It is not surprising that virtual democracy is now being embraced by opportunistic public-relations hacks like Dick Morris. In his book *Vote.com*, Morris advocates government by Internet referendum, basing his entire argument on the fraud of transparency, claiming that the Internet is the neutral instrument of public opinion. For people like Morris, "public opinion" is something that changes (and can be influenced) by the minute, and so must constantly be metered and measured, like the stock market. The only way to measure public opinion in this way is to reduce it to rigidly circumscribed choices, like "buy" or "sell."

In Virilio's terms, this is all part of the movement to replace *feedback* (the necessary corrective or brake on cybernetic control systems) with *interactivity* (the reduction of choice to "a system of questions/answers that cannot be evaded"). When the field of choices is reduced to a binary (digital) yes/no, on/off reflex, the apparatus, and the people who control it, gain tremendous power over respondents.

When people vaunt the world brain by declaring that humans are no longer human but neurons inside a world brain, and that interactivity favors this phenomenon, it is more than just a question of the society of control—it's the cybernetic society. . . . the very opposite of freedom and democracy.

The information superhighway is therefore going to set up an interactive system that is as daunting to society as is the bomb to matter. According to Einstein, interactivity is to the computer bomb what radioactivity is to the atom bomb. It is both a constitutive and dissociative phenomenon.[9]

If those truly interested in the question of technology (not industry e-collaborators and flacks) would go back and read Norbert Wiener (founder of the science of cybernetics) on the social philosophy of cybernetics,[10] a lot of the later confusion could be cleared up. Virilio is not the only public intellectual to dissent from the widespread Panglossian dream of technotopia, but he is one of the few who's been doing it long enough to have theorized a way out (that is, to put it very simply, to reestablish a connection with the terrestrial horizon). He has long argued that speed is not a neutral factor, and has studied its effects in various sectors, especially the military and in the public imaginary.[11] Recently, the kind of warnings that Virilio has been voicing for years have started to come from inside the arena of the computer industry itself.

Bill Joy's article in the April 2000 issue of *Wired* magazine, ominously titled "Why the Future Doesn't Need Us," caused considerable consternation in complacent cyburbia. Joy, cofounder and currently Chief Scientist of Sun Microsystems, apparently began having some concerns about endless technological fixes after talking with Ray (*The Age of Spiritual Machines*) Kurzweil at George (*Wealth and Poverty*) Gilder's Telecosm conference. It occurred—perhaps belatedly—to Joy that technological progress without social progress might not necessarily lead to a human utopia, but might lead to an inhuman one. His article begins with quotes from all the currently fashionable cyberutopians (Kurzweil, Hans Moravec, Danny Hillis, Jacques Attali) but gradually gives way to J. Robert Oppenheimer, Thoreau, and the Dalai Lama, who inspire Joy to confess:

My continuing professional work is on improving the reliability of software. Software is a tool, and as a toolbuilder I must struggle

with the uses to which the tools I make are put. I have always believed that making software more reliable, given its many uses, will make the world a safer and better place; if I were to come to believe the opposite, then I would be morally obligated to stop this work. I can now imagine such a day may come.[12]

And Joy makes an even more startling statement of conversion: "I believe we must find alternative outlets for our creative forces, beyond the culture of perpetual economic growth." Joyous blasphemer!

IMAGO POPULI: THE PEOPLE ARE NOT WHAT THEY USED TO BE, BUT THEN, THEY NEVER WERE

Any image of democracy must begin with an image of "the people." When a fifth-century B.C. Athenian democrat used the word *demos*, he meant "all citizens." But the root of *demos* is division, and from the beginning there have been strong disagreements about where to draw the lines. In Athens, the demos consisted of male citizens over the age of twenty. Women, slaves, and foreign-born residents (and, after 451 B.C., people whose parents were not both citizens) were not included in the demos. So, "the people" numbered about thirty thousand, out of a total population of probably three hundred thousand. This 10 percent of the total population was allowed to attend and speak in public assemblies held forty times a year on Pnyx, the hill southwest of the Agora. But these assemblies usually drew only about six thousand men (called the *idiotes*), who voted by raising their hands. So even in this pristine form of direct democracy, "government by the people" meant government by at most 2 percent of the population, who were heavily influenced by the most persuasive speakers and rhetoricians in the assemblies.

The philosophers of Athens generally regarded democracy as a sham based on a mistaken ideal that leads to a flight from the true purpose of life (love of knowledge and truth). Plato tells us that Socrates deplored oligarchy and democracy about equally. In the

Republic, Socrates describes the oligarchic man as "a squalid fellow . . . looking for a surplus of profit in everything, and a hoarder, the type the multitude approves." Such a man considers "nothing but the ways of making more money from a little," because "he has never turned his thoughts to true culture." The transition from oligarchy to democracy is not based on noble motivations, but on "the insatiate greed for that which it set before itself as the good, the attainment of the greatest possible wealth." The oligarch's object in a democracy is to encourage profligacy among the rabble and then lend money to the profligates at high interest, "to become still richer and more esteemed." Democracy cares "nothing from what practices and way of life a man turns to politics, but [honors] him if only he says that he loves the people!"

Socrates then goes on to describe how "in the same way in which democracy arises out of oligarchy . . . tyranny arises from democracy." It is his opinion that liberty's "excess and greed . . . [constitute] the fine and vigorous root from which tyranny grows," since "any excess is wont to bring about a corresponding reaction to the opposite." This will occur until democracy, "in exchange for that excessive and unseasonable liberty, has clothed itself in the garb of the most cruel and bitter servile servitude."[13]

Socrates's ideal regime was that of philosopher-kings, something like what Tibet had before the Chinese crushed it. But his ultimate conclusion in the *Republic* is that while the ideal *polis* can never exist, the ideal person might.

REVOLUTIONARY NEW PRODUCT

Technology is, . . . with its mesmerizing intelligence, the human will projected without measure of the care of relation with the world.
—Robin Blaser, "The Recovery of the Public World"

We do not lack communication. On the contrary, we have too much of it. We lack creation. We lack resistance to the present.
—Gilles Deleuze and Félix Guattari, *What Is Philosophy?*

The Athenian democrats made no distinction between art and technology (*techne*), which Aristotle defined as "the trained ability of making something under the guidance of rational thought." So there was no real conflict at that point between art and democracy, only between philosophy and democracy (a conflict for which Socrates ended up on death row). It wasn't until much later, in Hellenistic times, that artists were reconceived as inspired visionaries whose insight (*phantasia*) surpassed that of ordinary people. And this is the background for our own questions about the compatibility of art and democracy.

Democratic culture is supposedly anti-elite, which if applied across the board ultimately leads to a lowest-common-denominator level of culture. The likelihood of extraordinary work being done is lessened if all work must have broad popular appeal in order to survive. If all people are created equal, doesn't this mean that all images and works of art made by people are created equal as well? And if so, aren't the claims made by artists and writers to a different scale of value pure hokum, intended to hoodwink the populace? When this fallacy is employed by cultural conservatives to foster public animosity toward contemporary art and artists, neoliberal politicians have no real stake in countering it. If there is to be nothing outside of the Market, art's claim to some value independent of the market is heretical, and any cultural activity that does not appeal to a mass audience must ultimately cease to exist.

THE LAST CAMPAIGN

So what is to be the relation between art and Capital Democracy in the absence of the Social? What can be done in the face of this crippling reduction? One imperative is to refuse the totalizing claims of the postsocial and to continue to make distinctions. In a statement published in *Artforum* in 1994, Jonathan Crary put this in perspective:

> One of the most difficult tasks facing us today is to imagine strategies of living and acting that may well be within the terrain of the image and information marketplace but that are discerning and

mobile enough to identify and elude its ever-changing consumerist and productivist imperatives. Part of what is needed is to conceptualize technological culture in terms of the larger, turbulent geographies and flows in which it is embedded, and to realize that the actual and potential violence of global polarization will have more of an impact on the future of our material lifeworld than anything we assume to be internal to a process of technological change. It is more and more crucial to challenge fraudulent neofuturist visions of a "wired" world. *If new social ecologies (to use Félix Guattari's term) or novel convergences of the biological and the mechanic are ever to flourish independently of the market's laws of equivalence and exchange, they will emerge only through the creation of ways of listening to and learning from that majority of voices and bodies that are outside the circuits of compulsory communication and "augmented" realities.* (Emphasis added.)[14]

Some of the answers to the question, What can be done? are so simple that they are almost always overlooked. Since democracy is based on human conversation, especially face-to-face conversation, one of the most direct and effective actions individuals can take is to begin again to talk with one another about these things, in person, and to *listen* as if the answers matter. Another answer is the Bartleby one: whenever you are approached by a public opinion pollster or market researcher, just say: "I prefer not to." A recent article in the *New York Times* titled "Polling's 'Dirty Little Secret': No Response," revealed that the number of people who refuse to respond to polling inquiries has risen sharply in the last ten years. In some recent polls, response rates have fallen to 20 percent, meaning that *eight out of ten people* initially approached refused to answer.[15] As this resistance spreads, the "science" of statistical polling will lose all legitimacy (even on its own terms), and policymakers will be forced to consider more direct democracy.

Resisting the tyranny of visual public images can also be effected in some fairly simple ways. When you reduce the speed and frequency of images, you make it possible to see images differently. It is not nec-

essary to embrace the visual rhetoric and speed of product advertising in order to counter it. The processing and storage of images (by human beings) is not instantaneous. It takes time. So if you can control the speed of transmission, you can begin to make images memorable. As Wyatt Earp used to say: "Fast is good, but accurate is better. You have to learn how to take your time quickly." (This advice comes from a gunfighter who lived to be eighty years old.)

It's also important to remind yourself that you're probably not unique. That is, the public image, the totalizing image of the monoculture projected by the Internet, is not comprehensive, contrary to its claims. Helen Caldicott is fond of quoting Alex Carey in noting that the twentieth century is marked by three important developments: the growth of *democracy*; the growth of *corporate power*; and the growth of *propaganda*, to protect corporate power from democracy. If the propaganda breaks down—even intermittently—corporations lose their protection. One of the principal techniques of propaganda today is to overwhelm the viewer's ability to process or store images. When the higher transmission speeds exceed human neurological limits, images have a toxic, authoritarian effect. In this way, photographic images are certainly implicated in the failure of democracy, but they can also be a key element in its realization. As the prophet Hakim Bey has said: "The blind panopticon of Capital remains, after all, most vulnerable in the realm of 'magic'—the manipulation of images to control events, hermetic 'action at a distance.'"[16]

The phenomenal increase in the volume and speed of the transmission of words and images has certainly effected a leveling of quality, in both production and reception. But even though there is more text around now than ever before in history, if the right words are put together in the right order and relation, they can still have an effect on individuals, and the same is true of images. Of course, new techniques and approaches must be employed as the environment changes. But the actual environment for both images and words exists in the minds of individual viewers and readers. So far, at least, that's still free ground.

2000

NOTES

1 Walt Whitman, "Song at Sunset," *Leaves of Grass* (1891–92), in Whitman, *Complete Poetry and Collected Prose* (New York: The Library of America, 1982), p. 604.

2 Whitman, "Democratic Vistas," in *Complete Poetry and Collected Prose*, p. 986.

3 Ibid., p. 981.

4 Arthur Rimbaud, *Illuminations*, trans. by Louise Varèse (New York: New Directions, 1957), p. 129.

5 Yves Bonnefoy, *Rimbaud*, trans. by Paul Schmidt (New York: Harper Colophon, 1973), p. 91.

6 Peter Lamborn Wilson, *Escape from the Nineteenth Century and Other Essays* (Brooklyn, NY: Autonomedia, 1998), p. 64.

7 Paul Virilio, *Politics of the Very Worst: An Interview by Philippe Petit*, trans. by Michael Cavaliere, ed. by Sylvère Lotringer (New York: Semiotext(e), 1999), p. 79–80.

8 Ibid., p. 87.

9 Ibid., p. 80.

10 Norbert Wiener, *The Human Use of Human Beings: Cybernetics and Society* (New York: Da Capo Press, 1954).

11 See especially *Pure War*, in conversation with Sylvère Lotringer, trans. by Mark Polizzotti (New York: Semiotext(e), 1983); *Speed and Politics: An Essay on Dromology* (New York: Semiotext(e), 1986); *The Vision Machine* (Bloomington and Indianapolis: Indiana University Press and British Film Institute, 1994); and *Open Sky* (London and New York: Verso, 1997).

12 Bill Joy, "Why the Future Doesn't Need Us," *Wired*, April 2000, p. 262.

13 See Plato, *Republic*, sections 554–569, in *The Collected Dialogues of Plato*, ed. by Edith Hamilton and Huntington Cairns (New York: Pantheon, Bollingen Series LXXI, 1961).

14 Jonathan Crary, "Critical Reflections," *Artforum*, February 1994, p. 103.

15 Don Van Natta, Jr., "Polling's 'Dirty Little Secret': No Response," *The New York Times*, November 21, 1999, p. 1.

16 Hakim Bey, *Millennium* (Brooklyn, NY and Dublin: Autonomedia and Garden of Delight, 1996), p. 49.

THE HIGHEST DEGREE
OF ILLUSION

But certainly for the present age, which prefers the sign to the thing signified, the copy to the original, representation to reality, the appearance to the essence. . . illusion only is sacred, truth profane. Nay, sacredness is held to be enhanced in proportion as truth decreases and illusion increases, so that the highest degree of illusion comes to be the highest degree of sacredness.

> —Ludwig Feuerbach, Preface to the second edition of
> *The Essence of Christianity* (included as epigraph to the first
> chapter of Guy Debord's *The Society of the Spectacle*)

Everyone said the same thing after September 11: "It didn't look real." They said this whether they had seen it live from a vantage point in lower Manhattan or Brooklyn or watched it "live" on TV, standing up, hands covering their mouths. Someone took a photograph of people standing only blocks away from the event with their backs to the collapsing towers, gazing entranced into a storefront TV. When the second plane hit the second tower, pushing a fireball the size of a false sun out into the bluest sky anyone had ever seen, it was immediately frozen into a still image that could be infinitely reproduced. It was not legible as "reality," but as representation it was indelible.

The attack on New York's Twin Towers was the most photographed event in history. It was clearly planned and executed to maximize imaging. The delay between the two crashes seemed calculated to allow cameras—in what is arguably the most densely camera-rich environment in the world—to turn en masse toward the towers like a field of phototropic sunflowers. The "multiplier effect"

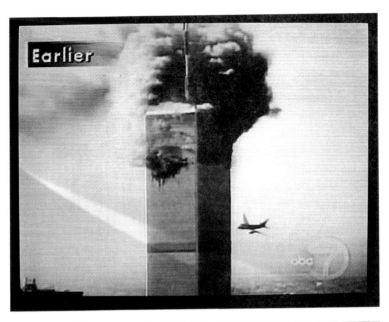

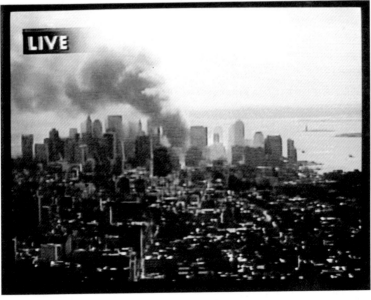

that the military craves in weapons design was here accomplished optically. The effect was further enhanced by the luck of a bright fall day with a preternaturally clear sky, and the unusually high number of professional photographers that happened to be on hand. The usually far-flung correspondents of the influential Magnum Photos agency, for instance, had gathered for their annual meeting the night before September 11. One store on Church Street stayed open through the collapse of the towers, and did a brisk business selling disposable cameras, film, and even quick processing to people fleeing the advancing debris cloud. There were so many photographs taken of the event and its aftermath that the *New York Times* changed its policies to include more images. A makeshift archive was opened in a vacant storefront in SoHo to collect photographs of the catastrophe taken by pros and amateurs alike, and huge crowds formed, waiting in lines around the block to offer up their images. On September 11, more people clicked on documentary news photographs than on pornography for the first (and only) time in the history of the Internet. Special issues of picture magazines were rushed into print, including several one-off picture collections published by tabloid media conglomerate American Media, Inc. (AMI), soon to be on the other end of the news when its corporate headquarters in Boca Raton, Florida became the target of the first anthrax letters. The first person to die of anthrax poisoning from these mailed letters was an AMI picture editor who had worked on a "Special Report" issue of the *Globe* featuring a picture of Osama bin Laden on the cover under a banner reading "WANTED! DEAD!" and "BIN LADEN— INSIDE HIS SICK, TWISTED WORLD." The anthrax letters seemed to be a rearguard counterattack against the hegemony of images by the receding word.

In the hours and days following the events, words seemed inadequate and, curiously, too *real* to signify. Only photographs had just enough unreality and distance to "make it real" to us. Seeing is believing, but photographs are more accessible. We don't necessary believe them, but we accept them. They have become our familiars, domes-

ticated versions of our once wild sight. The terrorists tried to turn our extreme attraction to images of violence and catastrophe against us, but they underestimated the extent to which these images have actually *supplanted* reality for us. They now instill less fear than fascination. Images of the exploding towers have already been used to sell magazines and TV programs. It is only a matter of time before they are used to sell soft drinks and cars.

Before the dust from the towers had settled, talismans of loss—photographs of the missing—began to appear, carried through the streets by stunned survivors who rushed to try to forestall their loss of the *originals*. Hordes of image-bearers fanned out into the city, showing them to anyone who would look: "This is my son. He's a wonderful person. He has black hair and red lips, and two young children." Within days the talismans were transformed into funerary images, but still the living clung to them like life preservers that buoyed them over despair. The *New York Times* began printing these images of the lost, hundreds and thousands of them, day after day. Still they continue.

Our response to all the images of September 11 made it clear how much we still rely on them. All the talk about a "crisis of believability" in photographs seemed far away indeed, and there were very few complaints about "aestheticization."

It's not that we *mistake* photographs for reality; we *prefer* them to reality. We cannot bear reality, but we bear images—like stigmata, like children, like fallen comrades. We suffer them. We idealize them. We believe them because we need what we are in them.

2001

Art Center College of Design
Library
1700 Lida Street
Pasadena, Calif. 91103

[faint library stamp, illegible]

THREE IMAGE-TEXTS

CAPE TOWN, SOUTH AFRICA, FEBRUARY 11, 1990

Nelson Mandela is released from prison, after twenty-eight years of brutal treatment by the apartheid regime. The images of his release, broadcast live around the world, show a man squinting into the light as if blinded.

More than half of Mandela's sentence was spent on Robben Island, a windswept rock surrounded by the treacherous seas of the Cape of Good Hope. Only seven miles off Cape Town, the island had been used as a maximum security prison for "non-white" men since 1959. Mandela's fellow inmates there included Walter Sisulu, Ahmed Kathrada, and Govan Mbeki, the father of current South African President Thabo Mbeki. Mandela later said that Robben Island was "intended to cripple us so that we should never again have the strength and courage to pursue our ideals."

In the summer of 1964, Mandela and his fellow inmates in the isolation block were chained together and taken to a limestone quarry in the center of the island, where they were put to work breaking rocks and digging lime. The lime was used to turn the island's roads white. At the end of each day, the black men themselves had turned white with lime dust. As they worked, the lime reflected the glare of the sun, blinding the prisoners. Their repeated requests for sunglasses to protect their eyes were denied.

There are no photographs that show Nelson Mandela weeping on the day he was released from prison. It is said that the blinding light from the lime had taken away his ability to cry.

PENNSYLVANIA, U.S.A., APRIL 15, 2001

It is reported that one of the largest collections of historical photographs in the world is about to be buried in an old limestone mine forever. The mine, located in a remote area of western Pennsylvania, was turned into a corporate bomb shelter in the 1950s and is now known as the Iron Mountain National Underground Storage site.

The Bettmann and United Press International archive, comprising an estimated 17 million images, was purchased in 1995 by Microsoft chairman Bill Gates. Now Gates's private company Corbis will move the images from New York City to the mine and bury them 220 feet below the surface in a subzero, low-humidity storage vault.

It is thought that the move will preserve the images, but also make them totally inaccessible. In their place, Gates plans to sell digital scans of the images. In the past six years, 225,000 images, or less than 2 percent of them, have been scanned. At that rate, it would take 453 years to digitize the entire archive.

The collection includes images of the Wright Brothers in flight, JFK, Jr. saluting his father's coffin, important images from the Vietnam War, and Nelson Mandela in prison.

Gates also owns two other photo agencies and has secured the digital reproduction rights to works in many of the world's art museums. At present, Gates owns the rights to show (or bury) an estimated 65 million images.

KABUL, AFGHANISTAN, OCTOBER 7, 2001

As darkness falls over Kabul, the United States launches its first airstrikes against Afghanistan, including carpet bombing from B-52s flying at 40,000 feet, and more than fifty cruise missiles. President Bush describes the attacks as "carefully targeted" to avoid civilian casualties.

Just before launching the airstrikes, the U.S. Defense Department purchased exclusive rights to all available satellite images of Afghanistan and neighboring countries. The National Imagery and Mapping Agency, a top-secret Defense Department intelligence unit, entered into an exclusive contract with the private company Space Imaging Inc. to purchase images from their Ikonos satellite.

Although it has its own spy satellites that are ten times as powerful as any commercial ones, the Pentagon defended its purchase of the Ikonos images as a business decision that "provided it with excess capacity."

The agreement also produced an effective white-out of the operation, preventing Western media from seeing the effects of the bombing and eliminating the possibility of independent verification or refutation of government claims. News organizations in the United States and Europe were reduced to using archive images to accompany their reports.

The CEO of Space Imaging Inc. said, "They are buying all the imagery that is available." There is nothing left to see.

2002

IN THE DARK

When I awoke, the projection of the images had already begun. The cold metal of the neck-lock pressed into the vein under my right jawbone, causing my ears to ring, so the first images I saw—of barren, sun-blasted desert hills—were accompanied by a high-pitched, intermittent tone. Seeing the hills that way made it seem that the sound came from far away rather than from inside my head.

I could tell that the others were still asleep, from the sounds they made, and from the singularity of the images. These images were for my eyes only now. An apparitional fish floating above the hills recalled my dream of the night before, wherein a gigantic blue-green shark moved through the desert like a ghost. Then came the women—always in pairs, with the desert between them, as the reiteration of the night continued.

This is the way the images projected before us differ from the phantasmagory of dreams. Though they often reflect and invoke the dream images, these projected ones are always more pointedly relational—more direct, more beautiful, more cruel. They have sharp edges that cut like knives, separating us from them.

At night, when the images on the cave walls cease, I am often relieved. But from the moment I open my eyes in the morning, I revel in the images, soaking them up like rain. Dream images are one thing, but these wakeful ones are more terrifyingly real. I hear the sounds of the Players behind us, manipulating the machinery, and these sounds too fill me with dread and longing.

As a new trio of pictures appears on the wall, I close one eye and focus on the central image, of a child's eye, slanted in the frame, as the flanking images of a spiny plant become the child's hair, or

Miguel Rio Branco, *Between the Eyes, the Desert*, 1997

wings. The next triptych has a young man in camouflage fatigues in the center, resting his jaw in the crook of his thumb and forefinger and gazing out into space.

The seer on my right awakes just then, and when he sees the portrait of the young man, he begins to sob. "It's not good to begin the day weeping," I tell him. "Then tell me a story," he says. So I tell him about how Orpheus looked back too soon, and how the potter's daughter invented photography in the first century A.D., and about Teddy Roosevelt's expedition to Brazil in 1914, to map the River of Doubt. As I speak, the Players project images in rapid succession, in rhythm with my speech: a shopping cart upended in a red salt sea; a shoe last, lonely in a decrepit room; Paul Newman and Marilyn Monroe enraptured; a threadbare glove and a tangled bush; an open road, an open window, and an airplane on a stick. When I stop, the seer who'd cried falls silent for a time, and then begins to sing:

We're all see creatures, under the skin
Images appear before us, but we see them within

Horses, and apples, and sunlight on glass
Mattresses, cactuses, and airplanes all pass

Phantasms evoked for our pleasure and terror
Collected in secret, then projected on mirrors

Without them we'd perish, we'd cease to be
For we see to live and we live to see

We're all see creatures, under the skin
Images appear before us, but we see them within.

As he sings, the Players project images of noctilucent clouds reflected in ruined mirrors, of abandoned necklaces and dusty skulls. The arrangement emphasizes likeness over difference, as dissimilar objects let down their defenses and begin to recombine: tusks and fingers, bumpers and fins, eyebrows and fetlocks, cacti and shoe

leather. The effect is simultaneously unsettling and calming. Open your hearts. *Tristes tropiques*.

Then appears a series of eyes, and a triptych of a woman's face flanked by a car shadow and something red reflected in a chrome tailfin. When the woman's face appears, the seer on the right flinches so hard his neck-lock and chains rattle like bones, and he cries out as if he's just been stabbed. He twists around so violently then, trying to see behind him, that I think he will break his own neck.

It has been some time since the Players took him away and brought him back full of absurd tales about "the True Light," and the existence of objects apart from images. After he'd been locked in again and gone through several cycles of the images, he quieted down, and has spoken only rarely since. Now he views the images with a desperate look on his face, as if trying to see through them. His sleep, too, is troubled. Just after they returned him, he told us that when they dragged him up into the light, he struggled to turn back to the images, and had to be forced to leave.

I tell him that when we look at images we're like Orpheus looking back. Like him, we're looking back out of love and doubt—love for the subject we've left behind, and doubt in the laws of consequence—so our gaze is always both faithful and illicit. The seer on the right says that Orpheus was originally a god of darkness, and his rites were always practiced at night. Then he says that Eurydice was never really there at all, that the gods of the underworld fooled Orpheus by showing him an apparition of his beloved, and when this eidolon moved from darkness into light, it naturally disappeared.

One time we staged a revolt by closing our eyes, but the constant flickering of the images onto our eyelids made us dizzy and we relented. Another time the Players stopped projecting images for three whole days. At first we were pleased. We sang songs, told stories, and even made some philosophy. But by the third day we were delirious and starving, hallucinating dream images far more violent than the ones the Players projected. We imagined the Players then as louche and devious creatures, sadistically withholding sustenance.

We know that the Players have acquired a vocabulary of these images that can be combined and recombined in an endlessly shifting syntax of resemblances. We don't know why they do it. The recurring images—desert and fish, glowing scythe and blood-stained earth, gloved fist and face in ecstasy—build up a tremendous charge over time that discharges right between our eyes. Sometimes the images die into us and sometimes we die into them.

We three are united in our solitude, seeing the same images separately but together all these years. We talk about them incessantly, since we have nothing else to speak of. The seer on the left has devised a theory of origin for the images. He says that they are the remnants of a world that was destroyed long ago, that they are the only survivors of this ruined world, and that we are their only disciples.

2001

ACKNOWLEDGMENTS

My seminar in the Advanced History of Photography at New York University in Manhattan was scheduled to begin on September 11, 2001. When it did begin, a week later, my students had been utterly transformed by their experiences. Some of them were there when the Twin Towers collapsed, and some made their way there afterward. Most of them carried cameras. The split between those who photographed what they saw and those who didn't (who put the cameras away and did something else) became very significant.

The sadness in photographs, in their relation to death and remembrance, had never been so palpable to them. At the same time, the pointed political uses of photographic images in the print and electronic media became clearer than ever before, and these students began to ask difficult questions with a new urgency. This book is for them and people like them, in the hope that they will continue to ask questions of and through images.

I would like to thank my own first teachers in photography, Jeff Weiss and Sheppard Powell, at Goddard College, who encouraged my passion for looking at images and writing into them, and Nathan Lyons at Visual Studies Workshop, who showed me that photography is a language, among other things.

Everything I write is influenced by my studies with Robert Duncan and the other poets who formed the Poetics Program at New College in San Francisco from 1980–1983, and who conceived of poetics in its root sense, as the study of *how things are made*.

The essays in this book were written during a period of time when the social role of photographic images, both as propaganda and as art, changed dramatically. My way of trying to understand these changes was to write about them.

I want to thank all of the artists, other writers, editors, and publishers who made this possible. And I especially want to thank Melissa Harris, Diana Stoll, Michael Famighetti, Wendy Byrne, and everyone at Aperture who worked on this book and gave it their generous attention through difficult times.

John Berger has long been a model for me of how one can write far out into the world and still remain at home, in the heart. His Introduction to this book is a cry in the night, and I am humbled by its honesty and eloquence.

"The Documentary Debate: Aesthetic or Anaesthetic?" was first published (in a longer and slightly different form) in *Camerawork*, from San Francisco, in an issue that I guest-edited in Spring 1992. That issue also included pages by Susan Meiselas, Jim Goldberg, and Alfredo Jaar, and essays by John Brumfield, Thyrza Nichols Goodeve, and Beverly Dahlen. Thanks to Marnie Gillett at San Francisco Camerawork for her longstanding support.

"Photography and Propaganda" was awarded the Reva and David Logan Grant in Support of New Writing on Photography in 1986 (by jurors Nathan Lyons and Anne Tucker). It was the only top-ranking essay not published by the Photographic Resource Center in Boston (who administer the grants) in the history of the award. A section of it was published in *Propaganda Review* in San Francisco in Winter 1987/88, and it was finally published in its entirety in *Afterimage* in April 1988, thanks to David Trend, who was then the editor of *Afterimage*.

"Epiphany of the Other" was first published in *Artforum* in February 1991.

"An Alchemical Disturbance" was first published in *SF Camerawork Quarterly* in Spring 1986.

"Broken Wings: The Legacy of Landmines" first appeared in the book of that title, with photographs of landmine survivors in Cambodia and Mozambique by Bobby Neel Adams, published by

the Greenville County Museum of Art in South Carolina, in October 1997. Many thanks to Tom Styron, for his courage and support.

"A Threnody for Street Kids" was first printed as a flyer to accompany a photographic installation by Jim Goldberg at Art in the Anchorage in New York in 1990. It was then published as an essay in the *Nation,* June 1, 1992, thanks to John and Sue Leonard, who were then the literary editors of the *Nation.* Jim's work ultimately became a museum show and book titled *Raised by Wolves,* 1995.

"Photography and Belief" was published in an issue of *SF Camerawork Quarterly* that I guest-edited in Spring 1991. It also included essays by Bev Dahlen, Aaron Shurin, Amalia Mesa-Bains, Susan Thackrey, John Brumfield, and Robert Bowen. Excerpts from "Photography and Belief" were published at the same time in Polish translation in *6 x 9 Fotografia* in Warsaw.

"A Sea of Griefs Is Not a Proscenium" was first published in *Let There Be Light* (Barcelona: Actar and Centro d'Art Santa Monica, 1998) in separate English, Spanish, and Catalan editions. A section of it was also published in *Nka: Journal of Contemporary African Art,* edited by Okwui Enwezor, in Fall/Winter 1998.

"Beauty and the Beast, Right Between the Eyes" was written for the monograph *Miguel Rio Branco* (New York: Aperture, 1998).

"A Second Gaze" was first published in *Arts Magazine,* February 1989, edited by Barry Schwabsky.

"After You, Dearest Photography" was first published in French in *Francesca Woodman* (Paris: Fondation Cartier pour l'art contemporain and Actes Sud, 1998), edited by Hervé Chandès, and also including essays by Philippe Sollers, Elizabeth Janus, and Sloan Rankin. It was published in an English and German edition by Scalo in Zurich, in Portuguese by the Centro Cultural de Belém in Lisbon, and in Spanish and Catalan by TeclaSala in Barcelona, all in 1999.

"I Myself Will Be the Chisel" was first published in the monograph *Hannah Villiger* (Basel and Zurich: Kunsthalle Basel and Scalo, 2001), in English and German. Edited by Jolanda Bucher and Eric

Hattan, it also included essays by Griselda Pollock, Claudia Spinelli, Jean-Christophe Amman, Annelie Pohlen, and Bice Curiger.

"Where the Camera Cannot Go" appeared in *Aperture,* no. 162, Winter 2001.

"Can You Hear Me? Reimagining the Audience Under the Pandaemonium" was first published in German and English in *Can You Hear Me? 2nd Ars Baltica Triennial of Photographic Art* (Cologne: Octagon, 1999), edited by Kathrin Becker.

"A Ferocious Philosophy" first appeared in *Camerawork,* in an issue I guest-edited in Fall/Winter 2000 as a response to Margaret Crane and Jon Winet's *The Last Campaign* project. The issue also included a portfolio by Margaret Crane/Jon Winet and essays by David Trend and Roberto Tejada.

"The Highest Degree of Illusion" was written to accompany works by Daniel J. Martinez in the Lima Bienial, and was first published (in a different form) in Spanish, in the catalog for the 3rd Bienal Iberoamericana de Lima in Peru in April 2002.

"Three Image-Texts" was written for Alfredo Jaar's installation "Lament of the Images," first shown at Documenta 11 in Kassel, Germany in 2002.

"In the Dark" was first published in Portuguese and English in *Entre os Olhos, O Deserto* (São Paulo, Brazil: Cosac & Naify Editions, 2001), a book of photographic triptychs by Miguel Rio Branco.

INDEX

Art Center College of Design
Library
1700 Lida Street
Pasadena, Calif. 91103

Art Center College of Design
Library
1700 Lida Street
Pasadena, Calif. 91103

DAVID LEVI STRAUSS is a writer and critic in New York, where his essays and reviews appear regularly in *Artforum* and *Aperture*. He is the author of *Between Dog & Wolf: Essays on Art & Politics* (1999) and *Broken Wings: The Legacy of Landmines*, with photographs by Bobby Neel Adams (1997). His essays have also appeared in monographs on artists Carolee Schneemann (2001), Leon Golub, Miguel Rio Branco (Aperture, 1998), Alfredo Jaar (1998), Francesca Woodman (1998), and Daniel J. Martinez (1996), and in exhibition catalogues on the works of numerous artists. Before moving to New York in 1993, he edited the literary journal *Acts* (1982–90) in San Francisco and published his first book of poems, *Manoeuvres*.

JOHN BERGER is a novelist, storyteller, poet, screenwriter, and essayist. He is the author of many works of fiction and nonfiction, including *To the Wedding*, *About Looking*, *Ways of Seeing*, and *G.*, for which he was awarded the Booker Prize. His most recent publications are the novel *King: A Street Story* (1999) and two books of essays: *The Shape of a Pocket* (2002) and *John Berger: Selected Essays*, edited by Geoff Dyer (2001).

23 Oct 07 Aragon 14:00 103342

Art Center College of Design
Library
1700 Lida Street
Pasadena, Calif. 91103